thriving

as an

Artist

in the
church

ALSO BY RORY NOLAND

The Heart of the Artist

hope and *help*
for you and your ministry team

Thriving
as an
Artist
in the
church

rory **noland**

ZONDERVAN™

GRAND RAPIDS, MICHIGAN 49530 USA

WILLOW
Willow Creek Resources

We want to hear from you. Please send your comments about this book to us in care of zreview@zondervan.com. Thank you.

ZONDERVAN™

Thriving as an Artist in the Church
Copyright © 2004 by Willow Creek Association

Requests for information should be addressed to:
Zondervan, *Grand Rapids, Michigan 49530*

Library of Congress Cataloging-in-Publication Data

Noland, Rory.
 Thriving as an artist in the church : hope and help for you and your ministry team / Rory Noland.—1st ed.
 p. cm.
 Includes index.
 ISBN 0-310-25732-8 (pbk.)
 1. Church musicians—Religious life. 2. Artists—Religious life. 3. Christian life. I. Title.
BV4596.M87N654 2004
248.8'8—dc22
 2004015683

Interior design by Tracey Moran

Printed in the United States of America

04 05 06 07 08 09 /❖ DC/ 10 9 8 7 6 5 4 3 2 1

Contents

List of Illustrations

preface:

How to Use This Book

After I wrote *The Heart of the Artist*, it was gratifying to hear of the many ministry teams that had studied the book together: choirs, artist small groups, dance troupes, as well as worship, drama, and technical teams. I even received a letter from a group of chefs who had studied the book together—culinary artists, of course.

This new book, *Thriving as an Artist in the Church*, is also conducive to group study, and I have a few suggestions along those lines. As in *The Heart of the Artist*, each of the main chapters in this book begins with a scenario that illustrates a specific problem that artists in the church often encounter. While fictitious, each story is based on real-life experiences that I've observed throughout the course of my ministry.

Following each scenario is a set of ten "Questions for Group Discussion." If you're going through this book with a friend or as a group study, these questions can help everyone identify with the issues that each chapter addresses and even help team members start thinking about solutions. The first few questions are somewhat general, but the following questions delve progressively deeper. If your meeting time is limited and you can't get through all ten questions, choose the ones that best suit your purposes.

At the end of each of the main chapters is a list of ten "Follow-up Questions for Group Discussion." These questions highlight the major principles of the chapter and challenge each group member to apply them to his or her everyday life.

The "Personal Action Steps" at the end of each chapter should be done during a time of prayerful reflection, on your own, outside of group time. These action steps often involve spiritual practices like journaling, prayer, and Scripture memory, and they also emphasize some of the major points in each chapter. Though some of the steps are sequential, and therefore necessitate doing them in order, others are presented as a menu from which you can pick and choose.

If you are using this book as a group study, I would recommend spending two meetings on each chapter. During the first meeting, read the opening scenario and go through the "Questions for Group Discussion." Then have everyone go home, read the ensuing chapter, and tackle the "Follow-up Questions for Group Discussion" at the next meeting. That would be an ideal plan, but feel free to tailor your approach to the needs of the group as well as any time constraints you might be facing.

As gratifying as it was to hear about all the arts teams that studied *The Heart of the Artist*, I was equally moved by the number of letters and emails I received from individuals. At one particular conference, a young man—sixteen years old—came up to me and asked me to sign his copy of the book. As he handed it to me, the book nearly fell apart. As I leafed through it to get to the front page, I couldn't help but notice how often he had underlined or highlighted certain passages. In a shy but assured voice he simply said, "I've read your book three times. It changed my life. Thanks." As I signed his book, I couldn't help dropping a few tears on the page because I was so impressed that a person his age would be as serious about his own character growth as this young man obviously was. I wish I had been as spiritually "on the ball" when I was his age.

If you're reading this book on your own and not as part of a group study, I suggest you journal through the group discussion questions as well as the personal action steps. I also encourage you to share with a close friend how the material in each chapter is affecting your spiritual journey.

Whether you go through this book alone or as part of a group study, I pray that it will minister to you, encourage you, and inspire you to greater fruitfulness as an artist in the church.

introduction:

It's Not Easy Being an Artist in the Church

Could you reach deep in yourself to locate that organ containing delusions about your general size in the world—could you lay hold of this and dredge it from your chest and look it over in daylight—well, it's no wonder people would rather not.

Leif Enger, *Peace Like a River*

In music school, I studied composition with an accomplished composer whom I deeply admired and respected. He knew I was involved in the music ministry at my church, but we rarely talked about it. Except, that is, for one brief moment near the end of my college career. During one of my lessons, several sheets of score paper accidentally fell out of my folder and onto the floor. As I gathered them up, my professor quickly noticed there was music he didn't

recognize written on these sheets. When I explained the music was something I was working on for church, he grimaced and said, "I thought you would have gotten this church thing out of your system by now." I shrugged my shoulders because I didn't know what to say. Then he asked, "Why would anyone waste their time doing church music?"

That's an interesting question, isn't it? It's one I've asked myself often over the years. Why *would* an artist opt to share his or her talents with the church? After all, that's not usually the first place people think of when it comes to excellence or innovation in the arts. It's certainly not the place most artists think of when they dream about where they hope to express their talent. In fact, many artists are apprehensive about the church. They're afraid it might stifle or limit them, and they are concerned that church people won't accept or even understand them. Or that they won't fit in. Artists tend to be free spirits and nonconformists, and let's face it—that doesn't go over well at most churches.

One of the most tragic examples of an artist mismatched with the church is the Dutch painter Vincent van Gogh. As a young man, van Gogh desperately desired to follow his father into the ministry. He trained for it, but he was not a good student. Nor was he good at public speaking—a definite problem for a potential preacher. Because of his dedication, an ecumenical Protestant organization gave him an opportunity to serve as a lay evangelist in a poor coal-mining town in what is now southwestern Belgium. While there, van Gogh became deeply concerned about the plight of these downtrodden people. He began to draw pictures of them, depicting their everyday chores, their work in the mines, and the hopelessness etched in their faces. Although van Gogh's superiors expressed admiration for the way he cared for his flock, they withdrew his appointment after six months, citing his deficient preaching skills. He tried to continue without their support but was soon living in abject poverty. Bitterly disappointed, van Gogh gave up his dream of becoming a minister and never set foot in a church again. He spent the rest of his life in extreme emotional, relational, and financial turmoil, which drove him to suicide at the age of thirty-seven.

In 1889, a year before he died, Vincent van Gogh painted *Starry Night* (plate 1). Many regard this as his most spiritual work of art. To van Gogh, the evening sky symbolized God's presence, and the prominent cypress bush in the foreground appears to be reaching heavenward with fiery zeal. If you look closely

at the buildings in the foreground, however, you'll notice all of them have light coming from the windows except one—the church. Furthermore, from an architectural standpoint, the Dutch Gothic steeple, similar to the one on the church van Gogh grew up in, is incongruous with the French countryside the painting represents. In another painting called *Church at Auvers* (1890), a cathedral is featured on a bright sunny day. But the church is dark and also appears to have no door. Van Gogh's feelings about the church are obvious—it's a cold, dark, close-minded place.

One can't help but wonder how different van Gogh's life might have been had the church encouraged him to be what God obviously made him to be—an artist. I wish a caring Christ-follower had come alongside him and said, "Hey, Vince, maybe preaching is not your thing. But God gave you this amazing ability to paint and draw, so why not serve God with your art instead of trying to be a preacher?"

I think that might actually have happened today, as the arts are playing an increasingly greater role in the ministry of the church. More and more artists are getting involved and experiencing the rewards of ministry. Still, we are also discovering just how difficult church work can be. Whenever I speak at a conference, it's not uncommon for an artist to pull me aside between sessions and ask me for advice on how to handle a troublesome situation at church. At some point in the conversation the person invariably says something like, "I don't know how much more of this I can take. If things don't change, I don't know if I can survive another year." I receive many similar desperate cries for help through letters, emails, and phone calls from leaders and volunteers. They are overwhelmed by the challenges, worn down by the conflicts, and discouraged by the adversity involved in doing ministry in the church.

It's hard enough being an artist, but being an artist in the church can be extremely challenging. In this book, we tackle those challenges head on. I don't have all the answers, but I have some experience to share that I hope you'll find encouraging and helpful. This is not a self-help book, however, with quick-fix formulas. It's more like a guide, a resource for your journey as an artist in the church. You will most likely work out your frustrations and issues within the context of your church community and your relationship with God. As you do, I hope this book encourages you through the difficult times and equips you to enjoy more of the good times.

Throughout this book, whenever I use the term *artist* I purposely cast a wide net. Basically, I'm referring to anyone who performs, creates, produces, or enjoys anything artistic. This includes writers, poets, painters, visual artists, performers, musicians, dancers, dramatists, producers, photographers, and more. It also includes those who work in technical areas including sound, lighting, video, and staging as well as computer graphics and design. If you enjoy doing anything artistic, you're an artist at heart.

Whether you're a professional or an amateur, whether you're a serious artist or a casual dabbler, whether or not you consider yourself to be one of those "artsy types," there are unique challenges for those of us who serve the church through the arts. These are the issues I address in this book. Paul wrote that one of the purposes of Scripture is to guide people in how to "conduct themselves in God's household" (1 Timothy 3:15). So together we're going to examine some scriptural principles related to the challenges we face—principles that are relevant whether you're part of a small church or a megachurch, a traditional congregation or a contemporary one.

You've probably already noticed I make no distinction between the universal church (the "big C" Church) and the local church (the "small c" church). Most often I refer to the local church, but I use the word interchangeably in an effort to keep the church from being an abstract concept that does not inspire a feeling of ownership. In Paul's greeting to the Corinthians he writes, "To the church of God in Corinth, to those sanctified in Christ Jesus and called to be holy, together with all those everywhere who call on the name of our Lord Jesus Christ" (1 Corinthians 1:2). Paul addresses a church that is both local and worldwide, so apparently it's all one church in God's eyes anyway!

YOU NEED THE CHURCH

If it is so difficult to be an artist in the church, why should the artist who's a Christian give the church a second thought? First of all, Jesus loved the church so much he gave his life for it (Ephesians 5:25). In light of that high a sacrifice, no serious Christ-follower can afford to be indifferent toward the church. Therefore, every artist who truly loves Christ must also love the church. Aside from that, you *need* the church. In fact, you need the church more than it needs you.

For Spiritual Growth

You and I need the church for the sake of our spiritual growth. Scripture exhorts us to grow up in all things in Christ (Ephesians 4:15). Our spiritual growth is even more important than our artistic growth. Through teaching and corporate worship, the church offers spiritual nourishment we can't get anywhere else. Left to our own devices, we could easily get off track spiritually. We need the church to help us grow and to keep us centered theologically.

For Accountability

In addition to spiritual growth, artists also need the church for accountability. I have a friend who suffers from depression and battles addictions. By his own admission, the main reason he's been able to stay on the straight and narrow is that he meets with a small group of men every week who pray for each other and hold each other accountable. He told me recently he's never before had friendships this deep, and he's never been as honest with any other group as he is with these men. Where else but in the church could he find this kind of community? "Let us not give up meeting together, as some are in the habit of doing, but let us encourage one another—and all the more as you see the Day approaching" (Hebrews 10:25).

For Fellowship

If you're an artist, you will greatly benefit from fellowship—rubbing shoulders with the great variety of people at your church. Some will be fellow artists—people of like-minded temperament with whom you can exchange ideas as you spur each other on. Most are likely to be nonartists, people who are totally different than you, but from whom you can learn a great deal. As you listen to their life journeys and hear their diverse views, your world will be enlarged.

I love the way Steve Turner captures the unique benefits of fellowship in his book *Imagine*:

> The church humbles us. It is one of the few places in our societies today where we sit with rich and poor, young and old, black and white, educated and uneducated, and are focused on the same object. It is one of the few places where we share the problems and hopes of our lives with people we may not know. It

is one of the few places where we sing as a crowd. Although the church needs its outsiders to prevent it from drifting into dull conformity, the outsiders need the church to stop them from drifting into individualized religion.[1]

For Serving Opportunities

The church offers each of us an ideal context in which to carry out the biblical mandate to serve others. First Corinthians 12:7 encourages us to offer our talents for the "common good" of the church. I'd like to expound on this briefly, because of all the character traits needed to survive as an artist in the church, the hardest ones for us to come by are humility and servanthood. Throughout history, as the role of the artist in society has increased in importance, we have moved further away from the biblical model of a servant artist. Let's briefly trace this progression, starting with the artists in the Old Testament.

The Old Testament

In the Old Testament, artists were known as "the skillful ones" (Exodus 35:10). We know a few of them, like Bezalel and Oholiab, by name (Exodus 36:2), but for the most part, artists worked anonymously. Since they were primarily craftsmen or artisans, their talent didn't give them a higher social standing or make them better than anyone else. Musicians, for example, were included in the same category as carpenters, stonemasons, and metalworkers. Artists were ordinary people who were uniquely skilled to perform specific functions.

The New Testament

The New Testament church introduced the concept of the "priesthood of believers," in which all disciples of Christ, not just the professional clergy, are considered ministers of the church. First Peter 4:10 (TNIV) says, "Each of you should use whatever gift you have received to serve others, as faithful stewards of God's grace in its various forms." Thus, the idea of the servant artist was born. Just like everyone else in the church, servant artists offer their gifts and talents to the ministry of their local church. This was the example Christ gave us as well. "For even the Son of Man did not come to be served, but to serve, and to give his life as a ransom for many" (Mark 10:45).

The Renaissance

At the dawn of the Renaissance, the early 1300s, artists began to lose their anonymity. The best painters became local heroes—Giotto in Florence and Duccio in Sienna, Italy. During the Renaissance, the artist's lot began to improve, as rich patrons commissioned paintings and sculptures for their homes and palaces. At the height of the Renaissance, in fact, the Roman Catholic Church was a major benefactor of the arts. Such interest prompted successful artists to set up studios and employ apprentices to keep up with the demand for their work, as it was now possible to make a good living in the "fine arts." Music history's first known composers—Machaut, Dunstable, and Dufay—also emerged from this era. The Venetian painter Titian was so successful and famous he employed what we would call agents and public relations people. The artist even began to enjoy some status as an intellectual during this period. When Leonardo da Vinci interjected science into art, he elevated artists to an even greater place of honor, and artists continued to gain prominence into the Baroque era.

The Romantic Period

By the Romantic period, in the early 1800s, the role of the artist had evolved to its highest pinnacle, a zenith from which it has yet to descend. As Hans Rookmaaker wrote, "Art became Art with a capital A, a high, exalted, more humanist than human endeavor."[2] As art gained a higher profile, so did the artist—who, by the way, became Artist with a capital A. Artists were now more than mere mortals. For the first time in history, a successful artist was more likely than a scholar, priest, or scientist to be labeled a genius. The artistic temperament was viewed as a wild-eyed, mysterious, godlike quality bestowed on a chosen few who were then capable of doing superhuman things. Artists were not of this world, people thought, but above and beyond it, which explains why all sorts of eccentric, antisocial, and immoral behavior on their part was not only overlooked, but actually celebrated.

Musicologist David Ewen wrote that as Beethoven grew in notoriety, he "became increasingly irritable, unreasonable in his demands on friends, given to rages and suspicions. A little incident would be enough for him to break a friendship of many years' standing. Yet many of his friends and wealthy patrons

were remarkably tolerant to his moods and tempers, recognizing him as a giant, and ever ready to help him in every way they could."[3]

No one exemplified this exalted view of the artist more than the English poet Percy Bysshe Shelley. In his 1821 essay entitled "A Defence of Poetry," he asserted that poetry acts in a divine manner that "awakens and enlarges the mind itself by rendering it the receptacle of a thousand unapprehended combinations of thought." He believed poetry had real potential to change the world because it "is at once the centre and circumference of knowledge."

Not surprisingly, the artist reigned supreme in Shelley's view of the world: "But Poets [note the capital *P*], or those who imagine and express this indestructible order, are not only the authors of language and of music, of the dance and architecture and statuary and painting; they are the institutors of laws, and the founders of civil society." Further, Shelly preached that poets "are the unacknowledged legislators of the world." And he didn't hesitate to share his conviction that the artist was superior to everyone else: "A Poet, as he is the author to others of the highest wisdom, pleasure, virtue, and glory, so he ought personally to be the happiest, the best, the wisest, and the most illustrious of men."

Shelley was a great poet, but he was an egotistical, heartless human being. As Paul Johnson reports in his book *Intellectuals*, Shelley was "astonishingly single-minded in the pursuit of his ideals but ruthless and even brutal in disposing of anyone who got in the way. . . . He loved humanity in general but was often cruel to human beings in particular."[4] Shelley was one of those deceptive fellows who appeared to be nice when he got what he wanted, like money. But when crossed in any way, he would turn venomous and write scathing letters to and about the offender. For instance, he disapproved of the young man his sister Elizabeth married, so he wrote a letter to his own mother accusing her of having an affair with the man and using her daughter's marriage to cover it up!

In 1811 Shelley eloped with sixteen-year-old Harriet Westbrook but left her three years later for another woman. Harriet committed suicide shortly thereafter. Throughout both marriages he was known to have had multiple affairs, to engage in group sex, and to promote wife swapping among his circle of friends. He wrote letters to friends demanding money even as he was

defaulting on his personal loans. Few people would be allowed to behave like Shelley without facing serious consequences, but because he was an artistic genius, his lack of character was excused.

Today

It took only a couple hundred years for the artist to go from anonymity to preeminence. But this overly inflated view of the artist, and the tolerance for whatever abhorrent behavior that comes with it, is still very much with us today. Our society idolizes entertainers and rock stars. They have become the new philosophers of our day, and the world waits with bated breath for their opinions on every topic ranging from religion to politics. A few years ago, a major magazine featured a famous Hollywood couple eager to offer marriage and family advice. Within a year they were divorced. Other celebrities tout the cults they belong to or advocate misinformed methods for achieving world peace. Yet our society emulates them and puts them on a high pedestal simply because they are artists.

THE CALL TO HUMBLE SERVANTHOOD

Unfortunately, every artist inherits this self-aggrandizing mind set to one degree or another, and those of us who are Christians even carry it with us into the church. Part of that old nature rears its ugly head from time to time, and it can greatly hinder our effectiveness in ministry. It also explains why servanthood and humility don't come easily to us. The great missionary Jim Elliot wrote the following in his diary one night: "I see tonight that in spiritual work, if nowhere else, the character of the worker decides the quality of the work. Shelley and Byron may be moral free-lancers and still write good poetry. Wagner may be lecherous as a man, and still produce fine music, but it cannot be so in any work for God."[5]

This book is a call for artists to return to being servant artists. That's the biblical model. I hope you'll answer that call with a resounding yes. If you approach every issue we tackle in this book with a humble heart, you will do much more than just survive as an artist in the church. You will thrive and flourish. You will be mighty in spirit, and you will be used by God in ways you've never dreamed possible.

I doubt that you would have picked up this book if you weren't already involved in some capacity at your church. Whether that involvement is casual or committed, I highly commend you for using the talents God has given you to serve through the local church. And I hope this book helps you to experience your ministry to the fullest.

chapter one:

How to Keep Your Passion Alive

Dare you see a Soul at the "White Heat"?

Then crouch within the door—

Red—is the Fire's common tint—

But when the quickened Ore

Has sated Flame's conditions—

She quivers from the Forge

Without a color, but the Light

Of unannointed Blaze—

Least Village, boasts its Blacksmith—

Whose Anvil's even ring

Stands symbol for the finer Forge

That soundless tugs—within—

Refining these impatient Ores

With Hammer, and with Blaze

Until the designated Light

Repudiate the Forge.

Emily Dickinson

Ken is driving to worship team rehearsal with a sense of dread. Although he has nothing better to do tonight, he'd still rather be headed somewhere else. He's supposed to sing a solo this Sunday, but he's not even looking forward to that. Sure, he's been singing on the team for more than ten years, but his heart is just not in it anymore. It hasn't always been like this. Singing at church used to be the highlight of his life—so much fun, so effortless, and so uplifting. In the "good old days," he was always the first one to arrive and the last one to leave. He was always on the lookout for new music. He recruited new singers and discipled a couple new in the faith. He led devotions at the end of rehearsals. He even took voice lessons and practiced on his own between rehearsals. But now he could take it or leave it. When the church asks him to do anything, he feels overwhelmed, as if it's one more thing on an already crowded plate. Yet truth to tell, he's less involved at church than ever before.

In the church parking lot, Ken sits in his car working up the motivation to go inside. *What's wrong with me?* he wonders. *Everything I do feels like such a chore these days. How did I get this way? I'm just going through the motions.*

While Ken continues to delay opening his door, Dave's car pulls up. They wave politely. Dave is a new vocalist on the team, and he's on fire for Christ. He started the team's prayer chain and organized a concert at the nursing home last year. When he sings, the Holy Spirit moves mightily. In other words, Dave is exactly like Ken used to be.

At that moment Ken realizes something he's been afraid to admit. He's lost his drive. With a lump in his throat he says out loud, "I've lost my passion for God, my passion for ministry, and my passion for singing." Those somber words hang in the air like a dirge. All he can think to say is, "God, help me."

A few minutes go by. The silence is getting more and more painful. He looks at his watch, opens the car door, and slowly walks up the front steps of the church. He meets Dave at the door. They shake hands and Dave says, "Hi, Ken, how are ya doin' tonight?"

Ken smiles back and replies, "Just fine."

Questions for Group Discussion

1. Why did Ken say he was "just fine" when he really wasn't?

2. Why do the "good old days" look so much better to Ken than his present-day reality?

3. What are some signs Ken has lost his enthusiasm for church ministry?

4. What are some indications Ken has lost his excitement for music?

5. When Ken sings his next solo in church, do you think anyone will be able to detect he's not in a good place these days? Why or why not?

6. What words of advice would you have for Ken?

7. What might cause a Christian to lose his or her passion for God?

8. What might cause artists to lose passion for their art?

9. Does the word *passion* have any negative connotations for you? If so, why?

10. Do you identify more with Ken or Dave these days?

THE POWER OF PASSION

For me, passion has always meant giving your all to something that's important. That concept was drilled into me by my favorite conducting teacher in college who would often tell us, "You must give yourself over to the music and do it with passion!"

Passionate people seem more alive. They're exuberant and dynamic. They have a compelling vitality, an abiding joy. They look toward the future expectantly because they always believe the best is yet to come. The lives of passionate people appear to have meaning and purpose, and people want to be around them because their zest for life is contagious. That's exactly how God intended for us to live. Jesus said, "I have come that they may have life, and have it to the full" (John 10:10). God desires us to be fully alive—to live lives that are exciting and deeply enriching.

Some Christians may object that I'm encouraging more passion in our lives. After all, we may have grown up hearing sermons that condemned our "sinful passions." And rightly so. Galatians 5:24 says, "Those who belong to Christ Jesus have crucified the sinful nature with its passions and desires." Carnality-indulging sinful desire is wrong (James 1:14–15). That's misdirected passion.

On the other hand, there is such a thing as a holy and wholesome passion. Deuteronomy 6:5 exhorts us to "love the Lord your God with all your heart and with all your soul and with all your strength." People who are on fire for Christ are passionate for the things of God. They are mighty in Christ because Christ is mighty in them (2 Corinthians 13:3).

The Bible is dripping with passion. The psalmist wrote, "As the deer pants for streams of water, so my soul pants for you, O God. My soul thirsts for God, for the living God. When can I go and meet with God?" (Psalm 42:1–2). Listen to Paul describe his devotion to Christ: "For to me, to live is Christ and to die is gain" (Philippians 1:21). He drives the point home with an exclamation point a few pages later: "I consider everything a loss compared to the surpassing greatness of knowing Christ Jesus my Lord, for whose sake I have lost all things. I consider them rubbish, that I may gain Christ" (Philippians 3:8). These are the words of a deeply passionate person.

Even though Peter the disciple was frighteningly impulsive, Jesus nicknamed him "the Rock" and built his church upon him. What did Jesus see in

Peter that could engender such trust? I suspect it was his passion. Peter is the one who said to Jesus, "Even if all fall away on account of you, I never will. . . . Even if I have to die with you, I will never disown you" (Matthew 26:33, 35). Of course, he later denied even knowing Jesus, so he wasn't able to back up those boastful claims. But it's clear Peter had a lot of heart. He was the only disciple to step out of a boat in the middle of a storm and try to walk on the swirling waters toward Christ. After the resurrection, we also see Peter giving one impassioned plea after another for lost people to come to a saving knowledge of Jesus Christ (Acts 2–5, 10–12).

If you're still uncomfortable with my advocacy of passion, let me ask you this: what do we traditionally call our Lord's last week here on earth? "Passion Week." For centuries, Christ's suffering from Gethsemane to Golgatha has been called "the Passion." Jesus had a passion for doing God's will. Christ went to the cross because he loved us with overwhelming devotion.

Passion can be a powerful form of motivation. In the past, whenever I found myself lacking passion for ministry, for music, or for life, I thought it was because I was tired. I reasoned that if I took care of myself physically and emotionally, it would be enough to prevent me from losing my passion and enthusiasm. While it is important to take care of ourselves by exercising, eating healthfully, and getting enough sleep, it takes more than that to live life with fire in the belly.

I recall many periods in my life when I pushed myself to the point of fatigue and I expected my passion to wane. But it didn't. In fact, rediscovering my passion is what kept me going. Similarly, the Bible says that during one of Gideon's more difficult battles, he and his men were "exhausted yet keeping up the pursuit" (Judges 8:4). *The New American Standard Bible* reads that they were "weary yet pursuing." Because these were men of fortitude, they were able to reach down deep and find enough passion to push through their weariness.

Passion also helped the apostle Paul overcome adversity. In 1 Thessalonians 2:2 he writes, "We had previously suffered and been insulted in Philippi, as you know, but with the help of our God we dared to tell you his gospel in spite of strong opposition." In the face of persecution, Paul still preached the gospel because he had a passion for lost people.

Passion is also one of the marks of a great artist. In fact, Ephesians 5:19 informs us that there is a connection between one's heart and one's art: "Speak to one another with psalms, hymns and spiritual songs. Sing and make music *in your heart* to the Lord" (emphasis mine). Art is an expression of the heart. If your heart is not vibrant, your art will have very little life to it. The greatest artists in history were known for their passion. That's what compelled Handel to sequester himself for twenty-four straight days with little food, water, or sleep while he wrote *The Messiah*. Passion is what motivated Michaelangelo to spend four years of his life painstakingly suspended on scaffolding to paint the Sistine Chapel.

One of the most powerful combinations on the planet is artistic talent residing in a heart that's on fire for God. Exodus 36:2 reveals that the artists who worked on the tabernacle were talented and passionate: "Then Moses called Bezalel and Oholiab and every skillful person in whom the Lord had put skill, everyone whose heart stirred him, to come to the work to perform it" (NASB). When a calling from God is tendered by those who not only are talented but who also approach their art with passion, God uses them in a mighty way.

PASSION KILLERS

Unfortunately, life is full of passion killers that threaten to suck the life right out of us. They can bog us down, right out of the starting gate. I like the way James Joyce puts it: "When the soul of a man is born in this country there are nets flung at it to hold it back from flight."[6] If you feel like you're just going through the motions in any area of your life, look for one of the following passion killers as the culprit.

Bogged Down by the Same Old Routine

Serving at church week after week can be draining. No matter how wonderful something may be, we eventually grow tired of doing it over and over. It can start to feel relentless. A worship leader who left his church after four years on staff later confided to me that perhaps he had left too hastily. "I think I was just tired of doing the same thing week in and week out," he said. "I think I just needed a month off." Indeed, if you rarely get a break from weekly services, you may find your passion slowly ebbing away.

Bogged Down by the Pressures of Life

Modern life is pressure packed, sometimes involving serious issues like ongoing health, financial, or relational problems. It can be difficult to maintain your enthusiasm for life when you're barely surviving its dark side. There are also the less serious but greatly exasperating frustrations of everyday life. There's traffic and computer malfunctions to contend with and people who make unreasonable demands on you. Many of us feel pressured by our schedules; parents have to juggle not only their own schedules but their children's schedules as well. Plus, isn't there always something around the house that's broken and needs to be fixed? Life can be hectic for most of us, with too much to do in too little time. Considering all the irritations, worries, and pressures we face every single day, it's amazing we have any passion or drive at all.

Bogged Down by Hairballs

For artists, working within a highly bureaucratic framework can be debilitating. Gordon MacKenzie was an artist who worked for Hallmark. In his book *Orbiting the Giant Hairball*, he chronicles the hassles of being an artist in a corporate environment. In his view, Hallmark, which is dependent on its artists to succeed, actually stifles their creativity. MacKenzie points out several obstacles in a corporate setting that can smother artists: excessive paperwork, too many meetings, nitpicking processes, unreasonable demands, sterile objectives, and unproductive busywork. MacKenzie calls them *hairballs*. Every organization, including the church, has its hairballs. They distract us from doing our art and they clog the creative process. The bigger the organization (or church), the more hairballs you are likely to encounter.

Bogged Down by Perfectionism

Artists who are extreme perfectionists eventually lose their passion and joy for their art. Winston Churchill was best known as a statesman, speaker, author, and soldier, but he was also an avid painter. He once told a fellow artist, "Now don't go out and imagine you are going to paint a masterpiece, because you won't. Go out and paint for the fun and enjoyment of it."[7] Is being an artist fun for you? If not, is it because you're striving for perfection instead of doing the best you can with what you have?

HOW TO SUSTAIN PASSION

Many of us in the church have been bogged down by pressures, hairballs, or perfectionism for so long we don't even realize that the passion and joy of our ministry and our art have left us. If you're digging down deep these days for motivation, meaning, or joy and yet feeling like nothing is there, it's time to get your passion back.

Artists are, by nature, passionate people. Our feelings run deep and we tend to wear them on our sleeves. Living a life of passion, however, is more than just feeling deeply. Romans 12:11 commands us to "never be lacking in zeal." God wouldn't expect us to never be lacking in something that fully depended on whether or not we felt like it. Passion is not an emotion we should have to work up. It stems from a dedication to live the adventure God has for us and to experience the deep riches of the inner life. Let's look at how those two essentials— a sense of adventure and the inner life—can give you a renewed zest for life.

Live the Adventure God Has Planned for You to Live

If you're just going through the motions as a Christian or as an artist, you're missing out on the adventure God means for you to live. Everyone needs adventure. That's why we're all fascinated by heroes and celebrities. They're doing something dramatic and thrilling with their lives. To get in touch with your innate desire to experience meaningful excitement in your life, try answering the following questions:

- If you could do anything you wanted with your life, what would you choose to do?
- What would be the ideal job for you?
- If you could have any special talent or ability, what would you choose?
- What would you do with a million dollars?
- If you had unlimited resources and power, how would you impact the world?

I bet those questions prompted some exhilarating visions. It goes to show that it doesn't take all that much to awaken a sense of adventure. It's always with us.

Don't believe for a second that Christians are not allowed or are above needing adventure. First Corinthians 2:9 says that "no eye has seen, no ear has heard, no mind has conceived what God has prepared for those who love him." God never intended our lives to be drab and boring. People who try to suppress their desire for adventure easily become restless. They may catch themselves daydreaming about accomplishing something spectacular or achieving the impossible. (Of course, I am almost fifty and I still daydream about playing major league baseball—batting .400 and leading my team to the World Series!)

Sadly, people who deny their need for adventure are more likely to turn to artificial stimulants or carnality to satisfy their longings. Addictions to alcohol or pornography typically start off as attempts to dispel boredom. A college student told me the other day that he and his friends are thinking of "chucking the whole Christianity thing because it doesn't work." They had given up sex, smoking, drinking, and swearing and now felt like they were missing out on all the fun that's supposedly associated with doing those types of things. They were missing out all right. This group of young people had never replaced the misadventures of their old lives with the scintillating adventures of their new lives in Christ. They talked about their Christianity with so little passion because for them, it lacked excitement, meaning, and adventure.

The Christian life should never be reduced to a stodgy set of rules and regulations. Rather, it is a stimulating adventure that the Lord invites us into. Whether you're young or old, male or female, rich or poor, God has adventures tailor-made to suit your personality and temperament.

High-Intensity Adventure (for the Highly Active Person)

For those of us who like a lot of fast-paced activity, this is usually the kind of adventure God has in store. The apostle Paul's life was spiced up by world travel, high-sea adventure, danger, rescue, and international intrigue (2 Corinthians 11:23–27). Hollywood action movies pale by comparison. I have a friend who, like Paul, thrives on being where the action is. He has a high capacity for work, activity, and relationships. He's a devoted family man, successful at his job, and involved in ministry at his church. If he didn't do all these things so well, I'd say he's moving too fast. But he's not. He especially enjoys being active because he's found something meaningful to do in his life.

Low-Intensity Adventure (for the More Contemplative Person)

For those who are more contemplative by nature, the adventurous Christian life may be less intense but just as eventful and exciting. The adventures may be more evenly paced. But while there may be fewer fireworks, there is just as much excitement. These thrills might include the discovery of a new insight from God's Word, an answer to prayer, an unexpected miracle, or an opportunity to witness. Those adventures may not make for a great Hollywood action movie, but they are still extremely meaningful and inspiring.

The prophetess Anna led a low-key, evenly paced kind of adventure as a prayer warrior. Widowed early in life, Luke tells us "she never left the temple but worshiped night and day, fasting and praying" (Luke 2:37). The highlight of her adventurous life was to hold the baby Jesus in her arms and prophesy concerning him. A woman who's more contemplative by nature recently told me that her greatest life adventure is her ministry at church and raising her two boys to be godly men. Going for long walks, painting, taking personal retreats, and having deep conversations with friends perfectly fulfill her needs for an adventuresome lifestyle.

Artistic Adventures

Whether you're a highly adventurous person, a more contemplative person, or somewhere in between, your sense of adventure (because you're an artist) will also include what you do with your artistic skills and talents. We want to sense that our talent is being used for something exciting and significant. In Exodus, God gives specific instructions on what he wants Aaron's priestly attire to look like and who should make those garments. "And you shall speak to all the skillful persons whom I have endowed with the spirit of wisdom, that they make Aaron's garments to consecrate him, that he may minister as priest to Me" (28:3 NASB).

If you're a nonartist, you might not see anything exciting in that verse. But if you're an artist, your heart skips a beat because you realize that when the God of the universe had something important he wanted done, he called upon the artists—"the skillful ones"—to do it. He wanted the project done right, and he could entrust it only to the artists, who were, in turn, given the opportunity to do something significant with their talents. If you're an artist, you live for

times when your talent can be used in a meaningful way. That's part of the adventure we all long for.

Find Out What God Is Up to and Give Yourself to It

In their book *Experiencing God*, Henry Blackaby and Claude V. King suggest we find out where God is working and adjust our lives to join him in that work. In other words, we need to find out what God is up to and give ourselves to it.

Realizing God is at work all around me and that he regularly invites me to be a part of that work has given me a heightened sense of anticipation that something extraordinary might happen right before my eyes. At various times throughout the day, I find myself wondering, *What is God up to in my immediate circle of influence?* I'll be driving to meet someone for lunch and I'll eagerly start wondering, *God, what are you up to in this person's life, and how can I help?* Maybe God is working to bring this individual closer to him. Maybe he's trying to convey that he loves this person and he just needs someone to deliver the message. Maybe my friend is on the verge of a significant breakthrough or close to accepting Christ. Whatever the case, I would jump at any chance to be a part of God's work, because there is no greater joy than knowing that he has used me to impact another life. I've also begun to look at distractions and interruptions differently. Could they be from God?

Seeing the Lord at work in people's lives energizes me. It's why I have as much, if not more, passion for ministry today as I did when I started thirty years ago. I am often reminded of God's words to young Samuel, "See, I am about to do something in Israel that will make the ears of everyone who hears of it tingle" (1 Samuel 3:11). That's what I'm living for these days, to "tingle" at God's work in our midst.

The early church certainly witnessed the supernatural activity of God. In fact, during the first century, many Jewish leaders were trying to figure out how to cope with the growing popularity of Christianity. A Pharisee named Gamaliel cautioned his peers against using physical force against the fledgling church because if God was in it, they'd end up fighting God (Acts 5:39). Gamaliel was sharp enough to realize that God was up to something, but he was not courageous enough to get involved. It's not enough to recognize God is at work. You've got to jump in with both feet. That's where the real adventure is. Ecclesiastes

9:10 says, "Whatever your hand finds to do, do it with all your might, for in the grave, where you are going, there is neither working nor planning nor knowledge nor wisdom." Life is short, so look for something meaningful to do and give it all you've got.

The Further Adventures of an Artist in Ministry

As an artist, you'll find yourself asking, "Lord, what are you up to, and does it call for my talents?" When God invites you to use your talent for him, don't hesitate. Say yes to whatever artistic adventures the Lord brings your way. I'm not suggesting we should agree every time the church asks us to do something. We should, however, prayerfully consider such requests, as the possibility exists that they might be part of an adventure God has in store for us. All too often when the church asks us to get involved, our first thought is whether or not our talent will be suitably on display. Instead, our prayer should always be, "Lord, what are you up to, and what can I do to help?"

At this point you might be wondering, *How will I know if the adventure is from God?* First of all, an adventure may well be coming from God if it involves ministering to others. God is constantly drawing people into relationship with him, and he invites you and me to play a part in this "ministry of reconciliation" (2 Corinthians 5:18). Paul says "our hope is in the living God, who is the Savior of all people, and particularly of those who believe" (1 Timothy 4:10 NLT).

An adventure may also be from God if there's a sense that you and he are partnering together. God is "able to do immeasurably more than all we ask or imagine, according to his power that is at work *within us*" (Ephesians 3:20, emphasis mine). The fact that we can partner with God in his work here on earth makes for the greatest adventures we can ever know. In Mark 6, five loaves of bread and two fish feed five thousand people. The miracle is always referred to as "Jesus feeding the five thousand." That's inaccurate. It should be called "Jesus and his disciples feeding the five thousand." In fact, when the disciples advised Jesus to send the people home so they could all eat, he coyly replied, "You give them something to eat" (Mark 6:37). Jesus was trying to include them in the adventure. He could have handed out the food himself, but instead he had the disciples do it. As they put food in the hands of every man, woman, and

child, they got to see everyone's eyes light up. They undoubtedly realized that they were actively involved in a most improbable miracle.

One thing that continually thrills me about church ministry is that at any service, God could be working to bring people closer to him. In Isaiah 55:11, God says, "So is my word that goes out from my mouth: It will not return to me empty, but will accomplish what I desire and achieve the purpose for which I sent it." Any time God's Word is preached, hungry souls can be fed. Any time the gospel is presented, there is the potential for someone's destiny to be changed forever. Any time true worship is raised heavenward, we can connect with our God.

Sometimes we're oblivious to the work of God in our midst because we're so focused on the task. When God is in the picture, music is more than just notes on a page, drama is more than just lines in a skit, and mixing sound is more than just turning knobs and moving faders. When my passion wanes it's usually because I've lost sight of God's big picture. Philippians 2:13 says that God is working in the lives of people all around us all the time. Don't miss it.

God at Work among Us

In Acts 4:30 Peter and John pray for the Lord to stretch out his hand and work mightily in their midst. It's a prayer of great expectations, because whenever God is involved in anything, exciting things happen.

Recently the high school ministry at my church invited our adult church orchestra to play at a student worship service. Because the young people's music is a little edgier, I was surprised that they wanted to partner with us old fogies, but their worship leader at the time, Aaron Niequist, assured me it would work. When he and I met to discuss the service, we came up with a wild idea. Why not put the word out to the students and see if any of them who play an orchestral instrument would like to join us? Thinking we'd only get a handful of kids, I thought, *What could it hurt? Let's try it.*

The next week Aaron told me that the response was overwhelming and that thirty students wanted to play with the adult orchestra at this worship service. His words, plus his enthusiasm, sent shivers up and down my spine. I thought, *Lord, what in the world are you up to?* Then I realized that most of these students played in high school or youth symphonies and had never had the chance to

use their talents in a worship service. Maybe the Lord wanted to give these young people, some of whom were new believers, a glimpse of what music ministry is like. At that moment I realized God had something special in mind and this was going to be more than just your average youth worship service. We had no time to audition the students, and we had instruments doubled that I normally prefer not to double in an orchestra, but I was flexible with my artistic preferences because it was obvious God had bigger plans for this service than we had realized.

We did some of their edgier stuff, and they did some of our music, but it was a sight to see young and old sitting together onstage raising their instruments in worship. I heard afterward from many of the student musicians that it was the best musical experience they had ever had. Some of them realized for the first time in their young lives what it was like to use their talents for God. We all knocked ourselves out doing the service, but everyone walked away from it convinced we had been a part of something significant. That's what I live for— to see God at work among us.

That story also reminds me that sometimes we're afraid of God's adventures because he may lead us into unfamiliar territory. We often clutch our talents to ourselves because we have a serious aversion to taking chances, yet it wouldn't be an adventure if it didn't involve some risk. Be open to the possibility that the Lord may ask you to use your gift in ways you never considered. He may ask you to use your gift in a way that seems menial to you or even seems like a compromise of your artistic standards. Remember, if you're faithful in small things, God will give you more (Luke 16:10; 19:17).

Be Ready for an Adventure

In addition to saying yes to God's adventures, artists need to be ready when he calls. David was ready with his harp when King Saul needed the ministry of music. In fact, the Lord used this "harp gig" to position David closer to the throne. So it's a good thing David was practiced up and had his chops in shape when he was summoned to play for the king (1 Samuel 16:17). Artistic opportunities most often go to those who are ready for them. So whether you're an amateur or a professional, regularly set aside time to practice, write, paint, draw, or read. No matter whether you devote thirty minutes a day or thirty minutes

a week, never let your skills get rusty, and always push yourself to grow as an artist. First Peter 1:13 tells us to prepare our minds for action.

I do a fair amount of composing and arranging for orchestra. To keep my skills sharp, I try to listen to one piece of orchestral music a week, preferably with score in hand. One of my dreams is to someday write large-scale works for full orchestra. I don't know whether I'll ever get the opportunity to do that, but by studying scores, I believe I'm increasing my chances of being ready. An artist is on call seven days a week. Be ready when opportunity knocks.

The psalmist compares his enthusiasm for God to that of an eager writer ready to express the desire of his heart. "My tongue is the pen of a skillful writer" (Psalm 45:1). The *New American Standard Bible* reads, "My tongue is the pen of a ready writer." My fellow artist, let's keep our skills sharp so we can be ready when the Lord has a mission for us to accomplish.

Plumb the Depths of Your Inner Life

The quickest way to lose your passion is to settle for superficiality in your life. There's nothing exceptional about life if we go through each day on a steady diet of shallow thoughts, superficial relationships, and trite entertainment. Passionate people love to go below the surface. They're fervent about their values and convictions because they have rich inner lives. That's the kind of depth Paul fervently prayed for the Ephesians to know: "I pray that out of his glorious riches he may strengthen you with power through his Spirit in your inner being" (Ephesians 3:16).

People with artistic temperaments may be drawn to the deeper things in life, but we too often settle for skimming the surface. The result is artistic suicide because we're the ones who are supposed to speak truth to our culture, and truth doesn't grow on trees. It's buried beneath the hustle and bustle of everyday life. God's thoughts are so much deeper than our thoughts (Isaiah 55:8–9), so you and I have to dig deep and uncover the truth our culture is starving to hear. The Russian abstract painter Wassily Kandinsky wrote: "It is important for the artist to gauge his position correctly, to realize that he has a duty to his art and to himself, that he is not a king but a servant of a noble end. He must search his soul deeply, develop it and guard it, so that his art may have something on which to rest and does not remain flesh without bones."[8]

33

In order to plumb the depths spiritually, start by feasting on God's Word regularly. Read it, memorize it, and meditate on it. The Bible is full of wisdom and insight that can change your life. Its truth can inspire you in the same way it has inspired artists for centuries. Psalm 119:54 says, "Your decrees are the theme of my song wherever I lodge." Biblical truth has been the theme of some of the greatest artistic expressions known to humankind. Western civilization's greatest authors, poets, musicians, and painters all knew their Bible. So take Scripture deep into your soul—not only for your own personal benefit, but also for the sake of your art. Make sure your prayer life has depth as well. The more you pray, the deeper your prayer life will become.

Lastly, always push for depth in your work as an artist. Your most memorable performance, your freshest creativity will come from deep inside you. If you're an actor, push yourself to understand everything you possibly can about the character you're portraying. If you're a singer, push yourself to personalize the lyrics. Take the lyrics from one of the songs you're singing and have a devotional with them. If you write, push yourself to express your ideas in fresh new ways. When you think you've gone as deep as you can go with your work, go deeper still. Strive to be a person of spiritual depth and your art will be substantive.

Make Room for "Soulish" Experiences

Some time ago, I identified a disturbing trend in my life. Once past my quiet time in the morning, I wouldn't think about the Lord much during the remainder of the day. My spiritual life was becoming disconnected from the rest of my life.

If a husband and wife talk to each other only once a day, their relationship isn't going to be very deep at all. Similarly, I realized I needed to have soul-enriching experiences scattered throughout my day to deepen my relationship with God. These "soulish" experiences can be any activities that put us in a position to encounter God in a personal way, like taking a time-out at work to pray or taking a walk around the block for a few minutes of solitude. Some people say more than just "grace" at meals. They talk to the Lord in depth about any challenges they're facing. Others set the alarms on their watches to go off at certain times as a reminder to pray.

I have found some of my best soulish experiences are the ones I purposely attach to a regular, mundane activity. For example, when I make my lunch every morning, I go through a set of Bible verses I have memorized over the years. I put these verses on note cards—a different set for every day of the week—and I lay them on the kitchen counter. Then I go over them as I'm preparing my lunch. There have been hundreds of times when my mind has wandered away in some new thought about a verse that I never noticed before. I find myself meditating on Scripture without even trying to meditate.

The Bible tells us to be still and know God (Psalm 46:10), and indeed, solitude is vital if you and I are going to experience the Lord in a personal way. Many people who attempt solitude quickly give up because the thought of sitting still and doing nothing is completely foreign to them. They approach their times of solitude expecting to discover deep spiritual insights previously unknown to humankind, and the added pressure hinders them from experiencing anything at all. What I'm suggesting is a middle-ground approach that is very doable. Look for a manual task you do regularly that could act as a springboard for solitude, meditation, or worship. The more menial the task, the better. Some people like to fish and bring a Bible along. Some people enjoy a hobby like woodworking with a worship tape playing in the background. Some go for long drives in the country. Some people pray while doing household chores. When the task is quiet and not too demanding mentally, you can clear your head and connect with God.

Given our frantic schedules, most of us try to avoid mundane activities. Yet some of those activities can take on a surprisingly spiritual dimension with little effort. Kathleen Norris writes: "It is a paradox of human life that in worship, as in human love, it is in the routine and the everyday that we find the possibilities for the greatest transformation."9

Doing ordinary, routine tasks also opens us up to be more creative. Have you ever heard someone say that they get their most creative ideas while taking a shower? It's because they're doing something that requires little thought. If you're an artist, you need time for the creative side of your brain to be free and play. So make sure you have enough mundane activities in your life. They can replenish you creatively and spiritually.

Linger in the Lord

I remember going through a difficult period in my life. Ministry was tough, life was difficult, and I felt dry spiritually. I woke up one morning thinking, *There isn't anything about my life I'm enjoying these days.* I felt unmotivated and passionless. In an effort to fix my unhappiness, I decided to make a list of the things I enjoy most. I wrote down everything I could think of, like music, sports, and seeing movies with my wife. When I was done, I looked at the list and confidently thought, *These are the things that bring me joy, so in order to shake my doldrums, I need to do more of these fun-inspiring activities.*

The next day, I took out my calendar and, with the list in hand, started to schedule in those things I most enjoy doing. Then it hit me like a ton of bricks—God wasn't on my list. The God whom I have pledged to love with all my heart didn't even come to mind when I thought of what I enjoy the most in this life. Jesus was not my deepest joy. He wasn't even a consideration, let alone my greatest pleasure. How did my heart grow so cold? How did I lose my passion for God?

I had fallen victim to the most lethal passion killer man has ever known—hurry. I was reading the Bible every day, but my mind was so preoccupied I wasn't hearing the Lord speak to me. My prayers had degenerated into rapid-fire one-liners that were thrown heavenward while on the run between appointments. So I was praying, but I was talking *at* God, not *to* him, and that's certainly not the kind of conversational prayer Christ died to make possible. You see, even though I was having my quiet time, I wasn't connecting with God personally. I was too preoccupied to linger in his presence.

In the book of Luke, Jesus admonished Martha—not because she was too busy, but because, unlike her sister Mary, she was caught up in things that weren't as important as sitting at the feet of Jesus. He said, "Martha, Martha, . . . you are worried and upset about many things, but only one thing is needed. Mary has chosen what is better, and it will not be taken away from her" (Luke 10:41–42). Along these same lines, Brennan Manning wrote, "In essence, there is only one thing God asks of us—that we be men and women of prayer, people who live close to God, people for whom God is everything and for whom God is enough."[10]

It's easy to get so caught up with the busyness of church work that you don't experience intimacy with God. The psalmist wrote, "In Your presence is fullness

of joy; In Your right hand there are pleasures forever" (Psalm 16:11 NASB). If we don't linger in God's presence, we will not experience him as our deepest joy or our greatest pleasure.

In 1 Kings 19, we read that Elijah reached a point at which he was so drained from doing the Lord's work that he wanted to die. He ran away into the wilderness, desperately needing a touch from God. He was told to stand on top of a mountain because the Lord was passing by. As he stood there, a strong wind came up.

Quite often in Scripture, a strong wind is symbolic of God's presence (2 Samuel 22:11; Psalm 104:3; Acts 2:2). Elijah must have thought, *This is it! Here comes God!* But God wasn't in the wind. Then an earthquake occurred. Many times an earthquake is associated with God's presence (Psalm 68:7–8; 97:4; Matthew 27:51, 54). Elijah must have thought, *Oh great! God's coming!* But God wasn't in the earthquake. Then a fire came. Very often fire accompanies a visit from God (Exodus 13:21; Psalm 97:3; Acts 2:3). Elijah probably thought, *Certainly this is God!* But not this time. God wasn't in the fire. Instead, God came to Elijah as a still, small voice in the gentle breeze. Wind, earthquakes, and fire were public manifestations of God's presence that were appropriate at many other times, but what Elijah really needed was a private encounter with the living God.

That still small voice Elijah heard still beckons us to experience God in a personal way today. If you only know God in the spotlight of public ministry, if that's the only time you know his presence, you're missing out on opportunities for deeper intimacy with him.

Recently I was shocked to hear a worship leader say that he didn't think spending personal time with the Lord was necessary because he felt God's presence strongly all the time while on the platform leading worship. Corporate worship is wonderful, but it's never meant to be a substitute for spending one-on-one time with the one who made us and knows us better than we know ourselves. Jesus had a very public ministry, yet he "often withdrew to lonely places and prayed" (Luke 5:16). We would do well to turn off the TV more often and sit quietly in the presence of God. Being alone with our thoughts often puts us in the path of a personal encounter with the Lord.

In order to linger in God's presence, slow down and pause. In Psalm 37:7 David wrote, "Be still before the Lord and wait patiently for him." When you

read God's Word, read it slowly. Pause after a couple verses and let what you read sink in. Wait before going on to see if any further insights come to mind, insights about God's character or about how you can apply what you just read to your life. When you pray, take your time. Say a few things to the Lord and then be quiet. See if he says anything back to you through your accompanying thoughts and feelings. Again, the psalmist concurs, "My soul, wait in silence for God only, for my hope is from Him" (Psalm 62:5 NASB).

Many times during prayer I've asked, "Lord, is there anything you want to say to me right now?" Then I just sit back and listen. Sometimes something has come to mind; sometimes it hasn't. So if you don't always "hear" something, don't be alarmed. The important thing is that you give the Lord every opportunity to say something personal to you. That's what lingering in the Lord is all about.

When you start to linger in the Lord, you will encounter distractions. Don't get discouraged. If you're having your quiet time and all of a sudden you start thinking about how the lawn needs to be mowed or about an upcoming meeting you're preparing for or that you need to RSVP to Aunt Clara's birthday party, don't fret. Sometimes what appears to be a distraction is actually a prompting by the Holy Spirit. Maybe your beautiful lawn is a prompting to praise God for the beauty of his creation. Maybe your anxiety about the meeting is a good reminder to pray that it will go well. Maybe the Lord brought Aunt Clara to mind so you could pray for her or call her to see how she's doing.

Of course, our receptivity to the Holy Spirit is not infallible. Not every thought that pops into our heads is from God. Nevertheless, deal with distractions and then return to focusing on the Lord as soon as you can. Remember, the purpose of lingering in his presence is to experience deeper intimacy with him. Our God is eager to have a close, personal, and interactive relationship with each of us. He promises we do not look for him in vain. "You will seek me and find me when you seek me with all your heart" (Jeremiah 29:13). When we draw near to him, he draws near to us (James 4:8).

In conclusion, if you want to be a passionate person, someone who is fully alive, live out the adventure God has for you and plumb the deep riches of the inner life.

Follow-up Questions for Group Discussion

1. On a scale of one to ten (with ten being high), how would you rate your passion for God these days?

2. Is there any area of your life in which you feel as though you're just "going through the motions"?

3. Are any pressures, "hairballs," or perfectionist tendencies stifling your zest for life?

4. Would you say you're an activist, a contemplative, or a combination of both?

5. Is your life more exciting or more boring since you've become a Christian? Are you satisfied with the amount of adventure you have in your life?

6. What do you think God is up to in the lives of the people you know?

7. What do you think the Lord is up to in your church these days?

8. What can you do to keep your artistic skills sharp and to keep growing as an artist?

9. What are some specific ways you can go deeper in your relationship with the Lord?

10. What is the most passionate artistic expression you've ever experienced, and how did it affect you?

Personal Action Steps

1. After prayerful consideration, write down how you think the Lord might be working amid your ministry team or in your church. Then record what you believe the Lord might be doing in the lives of your family, friends, and any non-Christians in your life.

2. Write down what you can do to help out and be a part of God's work in each of the examples above.

3. Set aside fifteen minutes a day or fifteen minutes a week for you and your art (practicing, creating, or learning). Increase the amount of time after three months.

4. Identify a mundane task that you'll be doing this week and attach a specific spiritual practice to it (such as prayer, worship, Scripture memory, or solitude).

5. Schedule some unhurried quiet time for you and the Lord in the next few days. Make it a point to linger in his presence, to try to hear him speak to you, and to seek his face.

chapter two:

Five Relational Skills Every Artist Needs

"My nerves are bad to-night. Yes, bad. Stay
 with me.
"Speak to me. Why do you never speak. Speak.
 "What are you thinking of? What thinking?
What?
"I never know what you are thinking. Think."

T. S. Eliot, "The Waste Land"

Tiffany is the director of art ministries at Christ Community Church, a church that Maria, a painter, recently joined. When she saw an announcement in the weekly bulletin about an art gallery the church was sponsoring for the Lenten season, Maria called Tiffany to find out how she should go about submitting something. The two women agreed to meet for lunch the next day and discuss it. Once they were seated in the restaurant, Tiffany started the conversation. "I am so pleased to meet you, Maria. I think this art gallery is going to be one of

the best things our church has ever done for Easter. We've had such a great response already that I wouldn't be surprised if it becomes an annual event. What were you thinking of submitting?"

Maria considered the question, then answered, "I haven't had time to give it much thought. I guess I've been preoccupied with a painting I'm working on for my fiancé. You know how some people write a love song and sing it at their wedding? I want to paint something that captures the beauty and the joy of our wedding day. I think—"

"You'll love marriage!" Tiffany interrupted. "I've been married for five years. It's great. In fact, this whole art gallery was my husband's idea, and he's not even an artist. Do you do calligraphy?"

Maria was caught off guard at the abrupt change in subject but managed to ask, "What do you mean?"

Tiffany explained, "I thought it would be neat if we had some of that cool calligraphy like what's-his-name does. I can't remember the artist's name, but he's really good. You know who I mean?"

"I think so," Maria replied.

"Can you do that?" Tiffany asked eagerly.

"Well, I don't know. I've never really tried," Maria answered.

"Well, if you could," Tiffany continued, "that's the kind of thing I'm looking for. We could use that in our worship services too. I bet you could do it if you gave it a shot. I never thought I could lead an arts ministry in a church, but God thought otherwise. I kept praying, 'Lord, we need an arts ministry here at Christ Community,' and he said, 'We sure do. When are you going to start one up?' The Lord moves in mysterious ways indeed . . ."

Suddenly there was a crash—the sound of plates and glasses hitting the floor followed by a man's voice yelling obscenities. Tiffany and Maria, along with everyone else in the restaurant, tried to see who was getting bawled out. Tiffany, in a low voice like she was about to betray a deep, dark secret, asked Maria, "Have you ever worked as a waitress?"

Maria confessed she had not. "Well, let me tell you," Tiffany went on, "that is one tough job. I used to work twelve-hour shifts when I was in college. It was murder being on my feet all day."

Just then the waitress, looking flustered, set two ice teas before Tiffany and Maria. Maria noticed that the waitress's eyes looked watery, and she couldn't help but ask, "Are you okay?"

The waitress was so upset she couldn't speak, but instead pointed to a badge she was wearing that neither of the women had noticed. It read "Trainee."

"Are you new, honey?" Tiffany asked cheerfully. When the waitress nodded, Tiffany tried to encourage her. "I was a waitress once and I know what you're going through. It's a thankless job. At least you didn't drop all that stuff on a customer. That's what I did—a full plate of spaghetti and meatballs—all over a couple of businessmen on their lunch break. I was fired on the spot. Don't worry, it could always be worse."

The waitress, who had grown increasingly uncomfortable during the exchange, nodded as she left.

The rest of the lunch went pretty much the same. Tiffany shared her vision for the ministry, why she hates cold weather, her favorite TV shows, and more. Maria didn't say much. She decided not to participate in the art gallery that year because of the wedding, but said she might be open to participating the following year.

Questions for Group Discussion

1. Why do you think Maria didn't talk much during this meeting?

2. How do you think Maria felt by the end of her time with Tiffany?

3. In spite of the fact that Tiffany and Maria were Christians, their conversation never went below the surface. What kept that from happening?

4. Given what you already know about these two women, what deeper things could they have talked about? In other words, what opportunities to have a meaningful conversation were missed?

5. Tiffany is obviously not a good listener. Why is it that most of us struggle to become good listeners?

6. Why do you suppose Tiffany was unsuccessful at encouraging the waitress?

7. What potential impact might it have on an artist's confidence and creativity to ask him or her to look, sound, or create like someone else?

8. What are some positive characteristics of how Tiffany relates to others?

9. What are some of the negative aspects of Tiffany's relational style?

10. How can we benefit by developing our relational skills?

RELATIONAL SKILLS FOR THE REAL WORLD

When I was in college, a music professor named Harold Kupper often took large segments of class time to give us tips on how to act when we were on a gig. He would offer principles like, "Always show up early for a gig and be sure to thank whoever booked you for the job," or "Always do what the conductor says, even if he's wrong." My favorite one, though, was how he instructed us to respond to a new contemporary work that we absolutely hated. He said, "Tell

the composer he writes 'interesting' music, and then when you get home you can tell your spouse that it was horrible."

Professor Kupper's intentions were noble. He was trying to impart some street smarts to us rookies. And what I couldn't help but notice was that all his advice was about dealing with people. It had nothing to do with music. This wise professor knew that if we didn't develop a certain amount of relational savvy, we'd never make it in the music business.

As a matter of fact, I've known more than a few artists who owe their success more to their people skills than to their talent. And I've known some extremely talented artists who never advanced because they had a low relational IQ. Even if you don't consider yourself a people person, it's essential to develop a certain amount of relational ability. In fact, the most regrettable mistakes I've made in life and in ministry have resulted from poor judgment in dealing with people. Indeed, I wish I had learned the relational skills I'm about to offer much sooner in my own life. I guarantee these five skills will improve your relational world and enable you to contribute more effectively to the depth of fellowship at your church.

Skill 1: Initiate Meaningful Conversation

Even though many of us who possess artistic temperaments are introverts who are often self-conscious around people, we still want to know and be known on a deeply personal level. The problem is that we too often settle for "small talk." Christians, of all people, should be able to talk about more than just the weather and sports. Second Timothy 2:16 says simply, "Avoid godless chatter." Hebrews 10:24 describes the quality of fellowship that we're meant to have as being so stimulating that it moves us to be better people. Community that is highly enriching is attainable only through meaningful conversation. Certainly, we don't have to talk about heavy spiritual things all the time, but we should look for opportunities to take our conversations to deeper, more meaningful levels.

Artists who are so self-absorbed that all they talk about is themselves or their art will never experience intimacy. That's because the true art of conversation lies not in filling the air with empty words but in our ability to draw others into deeper discourse. That's something Jesus constantly modeled. He was always reaching out to people by initiating meaningful dialogue. During his encounter

with the Samaritan woman at the well, he gently nudged her toward deeper discussions, ranging from theological issues to personal revelations. It's obvious she felt known on a deeper level, because after the conversation she ran back into town and shouted, "Come, see a man who told me everything I ever did" (John 4:29). It's hard to tell whether she was more excited about finding the Messiah or the fact that she had connected deeply with another person. (Maybe both.)

The next time you're with friends at church, try to take the conversation deeper. Don't wait for someone else to do it. You can take the initiative by posing thoughtful or gently probing questions—preferably ones that don't encourage easy yes-or-no answers. Proverbs 20:5 (NLT) says, "Though good advice lies deep within a person's heart, the wise will draw it out." If you're a good listener, people will feel comfortable opening up to you—and you will enjoy a rich relational world.

You can develop a set of questions you're comfortable with, but here are five that have worked well for me in initiating meaningful conversation:

- What has been the highlight of your week so far?
- What is the biggest challenge facing you these days?
- How can I be praying for you?
- Are you happy (at your job, in school, with your ministry)? Why or why not?
- How are you and God doing?

Someone once asked me if those questions might be too personal. They're supposed to be personal, but I don't believe any of these inquiries are invasive. They all allow their recipients to go as deep as they're comfortable going, so the ball is always in their court. Of course, you should never try to force someone to open up to you. If the individual stops talking or abruptly changes the subject, you'll know that's as deep as he or she is comfortable going for the time being. Don't push any further. Perhaps next time you can pick up where you left off and go deeper.

Skill 2: Listen Attentively

One time, before an orchestra rehearsal, a group of women right in front of me was talking and I heard them say something about having "female

problems." "Yeah, I'm having terrible problems," I heard one of them say. "And so are Carol and Linda." "Me too," another woman added. Meanwhile, I had my head down as I studied my rehearsal notes. Then one of the ladies said, "So, Rory, what do you think we should do?" I looked up, but I had no idea what to say. *I suppose we could pray*, I thought. *But what if they ask me to lead that prayer?* I felt myself blush. I stood motionless, eyes glazed over until one of them spoke up. "If we don't get the emails you send out, we're not going to know what's going on with the orchestra." Then it dawned on me. *They had been talking about email problems, not female problems!* I obviously wasn't listening closely.

Marriage has taken me to school on the art of listening. Early on, my poor wife had to break the news to me that listening means more than just sitting there facing in her direction. She needs me to be fully engaged: to make eye contact, nod in agreement, and acknowledge her with a smile or at least a grunt. She needs to see body language that assures her I am really "there." Like many people, especially artists, my mind can wander during a conversation to the point where I'm no longer listening. Rather, I'll be thinking about some music I'm working on or about how things are going at church. Instead of being quick to listen and slow to speak (as James 1.19 instructs), I'm more apt to be very quick to speak and very slow to listen.

I've since learned that attentive listening involves more than just the ears. You must also pay attention to your body language during a conversation. A blank look on your face or glazed-over eyes is a dead giveaway you're not really paying attention. When the other person is talking, make sure your face registers some kind of response. You may even want to learn the art of repeating back what you understand the other person to be saying.

I also had to learn to stop trying to "fix" people. My wife would become understandably frustrated because as she began sharing a problem, I'd interrupt and tell her how to solve it. She didn't *need* me to solve her problem; she's very capable of solving her own problems as the Lord leads her. She needed me to listen. Christians often try to fix each other instead of truly listening. Or we offer up pious platitudes instead of a much-needed shoulder to cry on. In fact, sometimes we're barely listening at all because we're too busy thinking of what we want to say next. I do that way too often.

Jesus said, "Consider carefully how you listen" (Luke 8:18). Your physical response not only shows the other person you really hear them, it helps you stay focused on what he or she is saying. Listen especially for *handles*, words or phrases people use, often subconsciously, that open the door to deeper things they'd be willing to talk about. For example, if someone tells you, "The year after my parents divorced, I started my first job flipping burgers at McDonald's," your astute listening would pick up on the divorce. You might say something like, "I'm sorry you and your parents went through a divorce. How old were you? Was that a difficult time for you?" Asking questions like that shows that you're listening closely.

In our opening scenario, Tiffany missed several handles: Maria's wedding, how she met her fiancé, the painting she was working on, her training, her art, how she came to Christ, and why she started coming to the church. Tiffany didn't ask about any of those things, and that's the main reason their conversation did nothing to further their relationship.

Artists have the potential to develop into great listeners. Because we're so tuned in to emotions, we can often perceive what others are feeling. As a result, we may be able to empathize more easily or identify more closely with others. We may also demonstrate an ability to read between the lines and "hear" what someone *isn't* saying. Being a perceptive listener can prove to be a relational asset, but there's one drawback we need to be aware of. Make sure what you're sensing intuitively is exactly what's being communicated. For example, when I'm talking with someone, I can often tell how the person is feeling. I also know how I'm feeling about what he or she is saying. The problem is that I can get so tuned in to someone's emotional dynamics that I miss exactly what it is the person is trying to tell me. Or I might misread *what* is being said because I'm so tuned in to *how* it's being expressed.

Skill 3: Bless Others Verbally

A verbal blessing includes those words of encouragement, affirmation, or affection we bestow on others. Whether part of a well-thought-out speech or an impromptu word in passing, the point is that we say the words that will bless someone else. It's never enough to have warm feelings or thoughts about others. We need to tell them. If we don't, we deprive them of a valuable blessing. Even

if you didn't grow up hearing words of encouragement, affirmation, or affection, you can still develop this important relational skill. The only way to become good at this is to practice. You don't have to be eloquent. Keep it simple. When it comes to blessing others, people will treasure what you say, not how you say it.

I know a gifted musician who has written some deeply moving songs. He has spent most of his life onstage, pouring his heart out through his music. Yet when it comes to expressing any poignant feelings toward those close to him, he clams up. Meanwhile, his wife and daughter are starving for any morsel of affection they can get from him. Don't let that happen in your relationships. The people in your life, especially those close to you, need to hear how you feel about them—and they don't know for certain until you tell them.

In order to bless others verbally, we need to be sensitive to the people in our lives. I find it ironic that those of us with artistic temperaments, who are more sensitive by nature, can at times be some of the most insensitive people I know. What good is our sensitivity if it's always turned inward? We need to turn our sensitivity toward others. Philippians 2:4 says, "Each of you should look not only to your own interests, but also to the interests of others." We need to put the needs of other people ahead of our own. Love is not self-seeking (1 Corinthians 13:5). Romans 12:10 (NLT) tells us to "love each other with genuine affection, and take delight in honoring each other." A more literal translation of that verse would be, "Outdo one another in showing genuine affection to each other."

In her book *Amazing Grace: A Vocabulary of Faith*, Kathleen Norris describes her efforts to be more aware of the needs of others:

> If I care to pay attention, which I usually do not, I can find all too many ways in which I transgress regularly against the great commandment, to love God with all my heart and soul, and my neighbor as myself. On a daily basis, I fail to keep the balance that this commandment requires of me: that I love and care for myself, but not so well that I become incapable of loving and serving others; and that I remember to praise God as the author of life itself, but not so blindly that I lose sight of the down-to-earth dimensions of my everyday relationships and commitments.[11]

We all know what a blessing it is to receive verbal affirmation. It makes us feel supported and believed in. In fact, many of us are artists today because of

some affirmation we heard when we were young. Proverbs 16:24 says, "Pleasant words are a honeycomb, sweet to the soul and healing to the bones." When giving affirmation, always try to be as specific as possible. Recognizing the specific work someone has done goes further than merely saying, "Nice job." We should be eager to affirm one another's character strengths, accomplishments, talents, and skills. Here are some examples of verbal affirmation you could try:

- Something I've always liked about you is your (fill in the blank with a character trait).
- You're good at (fill in the blank with something the person does well).
- I think your personal strengths are (list them).
- I appreciate all the hard work you put in to accomplish that. (Specify what the accomplishment was and its importance.)
- I'm proud of who you are and what you're doing. (Then specify what exactly prompts your compliment.)

We all thrive on encouragement. Proverbs 12:25 (NLT) says, "Worry weighs a person down; an encouraging word cheers a person up." When you see someone discouraged, frustrated, or in pain, go out of your way to encourage him or her. Sometimes all you need to say is, "I'm praying for you." Or "I'm behind you all the way." Your encouragement will go a long way in helping the recipient of those words persevere.

Skill 4: Listen to How You're Coming Across

Some time ago I received a CD in the mail from a gentleman I did not know. I listened to it. Then I wrote him what I thought was a polite letter thanking him for the CD, affirming his talent, but stating that our church wasn't looking to bring in any guest artists at that time. Within a week I received an angry voice mail from the man. Apparently I had misunderstood his intentions for sending me the CD. He didn't want to come and sing at our church; he was giving us the CD as a gift.

He proceeded to read my letter back to me, stopping every other line to criticize my church for being "shallow" and "preaching an easy gospel" or accusing me of being arrogant and condescending. Upon hearing my own words read back to me, albeit in a sarcastic and belligerent tone of voice, my

first reaction was, *Hey, this guy took me the wrong way.* But I had to admit I was hearing my own words, and even though he obviously had some preconceived notions about our ministry, I could see how someone in his position could take me the way he did. I called and apologized. The whole incident reminded me that sometimes when we communicate, we may not come across exactly the way we think we do.

Have you ever been perceived as pushy, insensitive, or apathetic when you had no intention to convey that attitude? While it's not a sin to be perceived in a negative light, it can strain relationships and cause misunderstandings. For example, if our attempts at humor come out as cutting sarcasm, people will be repelled. If we dominate and control a meeting, those around the table will eventually stop participating. Our nervous laughter may inadvertently have the effect of irritating people. This is not about image control. This is about becoming more self-aware. It's about being alert to any personal idiosyncrasies you and I have that could hinder our rapport with other people.

In the Old Testament, Joseph turned out to be a godly man and a gifted leader, but he sure committed some serious relational gaffes early on. One of twelve brothers, he was far from discreet in describing the destiny that lay before him (Genesis 37:5–11). As he sat with his siblings, Joseph said, "Hey, guys, I had the wildest dream. We were out in the field binding grain and my sheaf of grain stood proud and upright, and all of yours gathered around mine and bowed down to it." The brothers instantly picked up on what he was saying. "So you think you're going to rule over us and boss us around some day, huh?" They despised their cocky little brother.

Oblivious to the ill will he was creating, Joseph tried out another dream on them. "Hey, guys, I dreamed that the sun, the moon, and eleven stars all bowed down to me." The brothers had no problem figuring out who the eleven subservient stars represented. Joseph's dreams eventually came true, but had he realized how obnoxious and egotistical he was sounding, I'm sure he would have communicated differently.

Once I was in a meeting where things got a little tense between two of my coworkers. After the meeting, the person whose quick temper had been responsible for most of the tension in the room asked for my advice. We replayed the discussion and analyzed what was said. To this man's credit, he invited me to

be totally honest about how he had contributed to the negative dynamics in the room. I delicately said to him, "My friend, you probably didn't mean for this to happen, but most of what you said had an angry edge to it that caused everyone else to shut down." He had no idea he had come across that way.

Listening to how we're being perceived by others is not an easy skill to master. It requires us to get out of ourselves and look objectively at how we're communicating. If a conversation is meant to be innocuous and you sense the other person is feeling awkward and uncomfortable, you may have said something that was more provocative than you meant it to be. Or perhaps without realizing it, you said it with an edgy tone. It can be helpful to monitor the other person's face and body language as you speak. If you see a furrowed brow or a backward step, your listener may be put off by your manner or by something you said.

If you're unsure of how you're coming across, you might want to ask for reactions during a conversation. Ask the other person how he or she is feeling about what you're saying. If you want more general observations, ask a trusted friend what kind of effect you usually have on others. How do people generally perceive you? Do you have any irritating mannerisms that turn people off? It can be advantageous to you relationally to know such things.

Some people are great at reading a room. They can sense the slightest bit of tension. The rest of us, on the other hand, might never realize that we're coming across unfavorably. I have a good friend, a colleague, who is very astute about relational dynamics. Whenever I have insecurities along these lines, I seek her out after a meeting and get her impression of how I was being perceived. It's always good to get an objective viewpoint.

Lastly, beware of word choices that make you sound like a jerk. Proverbs 12:18 says, "Reckless words pierce like a sword, but the tongue of the wise brings healing." If you're questioning a decision someone made and in an exasperated voice say something like, "What were you thinking?" you're guaranteed to get a defensive reaction. It would be better to say something like, "I don't understand why you did that." Or "Can you help me understand why you did that?"

The apostle Paul had a sticky situation on his hands. A man named Onesimus had converted to Christianity and was assisting Paul with his ministry.

The problem was that Onesimus was a runaway slave who belonged to Philemon, a man whom Paul had previously led to Christ. In spite of Paul's conviction that we are all one in Christ, that "there is neither Jew nor Greek, slave nor free, male nor female" (Galatians 3:28), and regardless of how much Paul needed Onesimus, he concluded that the right thing to do was to return Onesimus to his owner.

Paul didn't want Onesimus to be punished, so he wrote Philemon a letter encouraging him to welcome the former slave back with open arms. In this letter, Paul's tone and choice of words are very noteworthy. He could have been gruff. He could have made threats against Philemon if he harmed his friend Onesimus. He could have tried to coerce Philemon into letting Onesimus stay so he could do the Lord's work instead of being a slave. Instead, Paul chose his words carefully. The letter opens respectfully: "To Philemon our dear friend and fellow worker" (v. 1). Paul commends him by stating that Philemon's love has given him "great joy and encouragement" (v. 7). Then Paul tells Philemon that he trusts him to do the right thing in this matter by saying, "I appeal to you on the basis of love" (v. 9). Paul was careful about how he approached this sensitive situation. His words were "aptly spoken," like the kind of words Proverbs 25:11 tells us are like "apples of gold in settings of silver." He used words that build bridges instead of burn them.

Skill 5: Follow Through on Your Basic Adult Responsibilities

A friend of mine, a psychologist, once shared with me that many of the artists he had treated over the years were habitually late in paying their bills. He shrugged and said, "Well, you know, they're artists," as if that excused their irresponsible behavior. If that had been an isolated incident, I wouldn't even mention it. But over the years, I've often witnessed artists who didn't pay their bills on time or didn't show up on time for appointments. They too blamed this habit on the fact that they're artists. In their minds, that somehow excused them from being responsible adults.

The reason I count following through on our responsibilities as a relational skill is that there is always someone on the other end of our irresponsibility, suffering the brunt of it all. Whether it's a roomful of people waiting for you to show up for rehearsal or a spouse who's frustrated because another check

bounced, your irresponsibility affects others. Don't think for a second that you're incapable of carrying out basic adult responsibilities just because you're an artist. I'm not talking about being super-organized to the point of alphabetizing the spice rack or color coding the toolshed. I'm talking about the bare minimum amount of discipline needed to function as a responsible adult. Even if being organized is the most recessive gene in your body, you must be sufficiently responsible to avoid sabotaging your art, your marriage, your ministry, or your life.

Be on Time

I have found tardiness to be the most common example of irresponsibility among artists. It may not bother you if you're habitually late, but it is inconsiderate of others. It sends a subtle message that other people's time is not as important as your personal schedule. It also communicates that what they're doing is not worth your being on time. It's not okay to keep people waiting for you. It's a basic human courtesy to show up when you say you will. "Let your 'Yes' be 'Yes' and your 'No,' 'No'" (Matthew 5:37). If you want to be taken seriously as a leader or as an artist, be a man or woman of your word. No matter how talented you are, it eventually wears thin if your lack of punctuality becomes a habit.

If tardiness is a problem for you, buy a calendar or some kind of daily planner. Write down appointments and frequently check your schedule. Invest in a watch and always give yourself enough time to get wherever you're going. Rehearsal at 7:00 means that by then you're in your seat ready to go, not just pulling into the church parking lot. I used to attend meetings conducted by a leader who was a stickler for punctuality. If any of us were late, we had to stand up and apologize to the whole group, promising it would never happen again. If you struggle with punctuality, take a cue from that scenario and whenever you're late, apologize to everyone you've kept waiting. It'll help cure you of this lazy habit.

Write It Down

I've dropped enough balls in my day to know I need to write things down, including dates, appointments, reminders, and errands. Unfortunately, if I don't

write something down, it's probably not going to happen. Furthermore, my male ego is permanently bruised by the fact that unless I've been someplace several times before, I have to write down directions to ensure I get there. But that's the truth about me. I can't trust those kinds of details to memory. If you can relate to that, do yourself (and others) a big favor—swallow your pride and put things in writing.

Do Your Chores

At both work and home, there are always plenty of chores that need to be done. Sometimes we're intimidated by these chores because we've allowed them to become bigger than they really are. If you don't think you can balance your checkbook because you're not good at math, I have good news for you: calculators come with simple directions. I used to abhor having to return phone calls. Because I didn't enjoy talking on the phone, I convinced myself that calling people back was too time consuming and too much of a hassle. Meanwhile, the list of calls I needed to make grew. Once I actually timed a few of these calls and discovered that they didn't last anywhere near as long as I had feared. I realized that by putting them off, I was allowing the time spent dreading the return calls to last longer than the calls themselves.

Mind Your Money

Artists are notoriously bad with money. When it comes to earning it, saving it, or managing it, artists often make unwise choices that subject their marriages and families to unnecessary financial stress. First of all, if you have the responsibility to support your family, then get a job and work hard. First Timothy 5:8 (NLT) says, "But those who won't care for their own relatives, especially those living in the same household, have denied what we believe. Such people are worse than unbelievers." Don't be lazy and blame it on the fact that you have an artistic temperament. In 2 Thessalonians 3, Paul is adamant that Christians should have an honorable work ethic and should not be slothful. "For you know that you ought to follow our example. We were never lazy when we were with you. We never accepted food from anyone without paying for it. We worked hard day and night so that we would not be a burden to any of you. . . .

Even while we were with you, we gave you this rule: 'Whoever does not work should not eat'" (vv. 7–8, 10 NLT).

I know a young lady whose parents were in the ministry but divorced when she was very young. Her father never provided child support. The divorce not only scarred her emotionally, but it also created excruciating financial hardship for her and her single mom. Her father eventually ended up back in ministry, leading worship at an out-of-state church. But still he never offered any support. You can imagine the dissonance such a situation would create for any young person. She recently asked me, "How can my dad lead worship and neglect his own daughter?" I didn't know how to answer.

The best financial advice I ever received was put simply: avoid debt, especially credit card debt. Don't put anything on a credit card that you can't pay for when the bill comes. The interest on credit card bills is so high it's like flushing money down the drain. I've known several couples who spent money extravagantly and ran up high credit card bills. Trapped by financial pressure, these couples tended to argue a lot over money. Many of them were forced to find second jobs, which in turn left them no time or energy for building their relationship.

In addition, many couples take on mortgages that are way over their heads. One couple I know has such a high house payment that it has limited their freedom to hear and follow God's direction for their lives. They both have to work long hours to make enough money to afford their expensive home. If the Lord wanted to lead them into a new adventure or a new ministry, their first reaction would have to be, "Lord, if what you're calling us to do pays us enough to cover all our current expenses, then we'll do it. Otherwise, we can't even consider it."

Proverbs 24:27 contains practical advice along these lines. "Finish your outdoor work and get your fields ready; after that, build your house." In other words, make sure you're in a good place financially before you buy a house so you don't get into a mortgage that's beyond your means. If you're not good with money, seek advice from someone who is wise in this area. Ask that person to help you set up a budget and to hold you accountable for sticking to your budget and avoiding debt. There are also many good books available from

your Christian bookstore that can help you become a better steward of your financial resources.

Because financial pressures can sometimes contribute to divorce, I'd like to offer a bit of marital advice for young artists. Make sure the standard of living you envision for yourself is acceptable to your spouse, especially if you intend to make a living as an artist or be in ministry (or both). Couples who go into marriage with different economic expectations are setting themselves up for disaster.

Before my wife, Sue, and I were married, we had long conversations about what our future together might look like. I didn't know much about marriage, but judging from the mistakes I saw others making, I at least knew Sue and I had to be on the same page financially. I was a youth pastor at a small Baptist church, and I knew the Lord was calling me to be in church music ministry. I didn't make much money. I had no wealthy relatives and no promising future to offer her. I didn't know if I would ever own a home. We also had to take into consideration the fact that Sue's preference was eventually to be a stay-at-home mom. So I popped the question (the financial one, that is) on a stretch of highway outside Denver, Colorado. I asked my future wife, "Could you really be happy being married to someone who can't guarantee you anything more than a modest standard of living?"

After discussing our future at length, she said yes (fortunately). Living off the single income that ministry affords has forced us to live frugally, depending on the Lord for all our needs. But he has been faithful beyond our wildest dreams, and as a family, we've seen him provide for our material needs in truly miraculous ways. It hasn't always been easy, but we both knew what we were getting ourselves into. That's why financial pressures have never driven a wedge between us. Make sure you and your spouse share compatible financial expectations for your marriage.

Follow-up Questions for Group Discussion

1. Which one of the five relational skills presented in this chapter do you most need to work on?

 _____ Initiating meaningful conversation

 _____ Listening attentively

 _____ Blessing others verbally

 _____ Listening to how you're coming across

 _____ Following through on your basic adult responsibilities

2. Why do you think most people, Christians included, often engage in small talk instead of going below the surface?

3. What factors make it difficult for most people to initiate meaningful conversation?

4. What hinders people from listening attentively to each other on a regular basis?

5. What body language or facial expressions (for example, eye contact, nodding, smiling, and so on) would you feel comfortable using to demonstrate that you're fully engaged as a listener?

6. Why is it important to listen for handles during a conversation?

7. What were the most meaningful words of encouragement you received in your youth, and who said them?

8. Why do you think it is difficult for some people to verbally express encouragement, affirmation, and affection?

9. Are you convinced that it's important to pay attention to how you come across to others? Why or why not?

10. Are there any basic adult responsibilities you consistently fall short on? How does your irresponsibility affect others? What steps can you take to improve on the adult responsibilities you feel need the most attention?

Personal Action Steps

1. Ask a close friend to give you a letter grade for each of the five relational skills listed in this chapter and see how they match up with your own assessment.

2. After identifying the relational skill that needs the most development, think of someone you know who exemplifies that skill, make an appointment with that person, and discuss how she or he became proficient at that particular skill.

3. Select any one of the questions I suggested to initiate meaningful conversation and see how often over the course of the next week you can slip it into conversations. After some practice, come up with additional questions you can use.

4. Next time you're with friends at church, look for someone who you perceive needs a word of encouragement or affirmation. Be sure to verbalize those words in a timely way.

5. Is there anybody in your life whom you would trust to give you a good read on how you're coming across to others? Get together and discuss this.

chapter three:

Coping with Rejection and Failure

For probably the thousandth time, I wondered what advice Professor von Kempen would have given me if he were still alive. I remembered that once, when I became frustrated that my fingers were not long enough to reach a certain extension, my frail teacher edged forward on his hard pine chair until I was afraid he would slide right off. "Every musician," he said as if reciting a prayer, "discovers that God has given him faulty equipment. That's where the difference between an ordinary musician and a great artist lies—how they face their shortcomings."

Mark Salzman, *The Soloist*

Gloria has been on pins and needles for the last few days. She hasn't slept well, eaten much, or been able to concentrate at work. She's all geared up for choir rehearsal tonight. To be more exact, she can't wait for the *end* of choir rehearsal, because that's when they'll announce the results of the worship team auditions. Gloria felt really good about her audition. She has been taking voice lessons for three years and making a great deal of progress. In fact, Gloria's teacher encouraged her to audition and coached her through every detail of the process. Every day Gloria prayed the Lord would help her do her best. On the day of the audition, she woke up with a slight cold, but by the time the audition rolled around, she felt great. She saw that as an answer to prayer and perhaps even a sign it was God's will that she be on the team.

Gloria has been serving faithfully in the choir for seven years. She loves the choir but would also relish an opportunity to sing on the worship team, which is smaller, more challenging, and more "up front." So when the auditions were announced, Gloria was one of the first people to sign up. Since the auditions a few days ago, Gloria has watched for any hints from the director that would indicate whether or not she made it. When she saw him at church on Sunday, he stopped to talk and was very friendly. She couldn't help but take that as a good sign.

As Gloria drives to choir practice, she catches herself biting her nails. Then she's struck with a dreadful thought: what if she doesn't make it? Maybe she's not good enough after all. Maybe the director doesn't like her. Maybe there's politics involved. She dismisses these thoughts and at a stoplight prays, "Lord, if I don't make it on the worship team, it'll be hard, but I'll just interpret that as your will for right now. I'll still serve you and worship you no matter what happens."

Gloria tries to be attentive during rehearsal, but she's pretty worked up and the time goes by at a painfully slow pace. Finally, rehearsal ends and the director sits down on a stool in front of the choir. He tells them how difficult the decision was and how he wishes he could add everyone who auditioned to the worship team. He thanks everyone and then reads the names. There's applause for each name accompanied by shrieks of elation. The director gets to the end of the list and then closes the meeting with prayer. He has not named Gloria. She bites her lower lip. She doesn't hear anything the director says in his prayer.

She's heartbroken. Before she leaves she congratulates everyone who made it, though she fights back tears the whole time.

The next day, Gloria calls her voice teacher and terminates her lessons. Then she calls the choir director and announces that she's quitting the choir. She vows never to sing again.

Questions for Group Discussion

1. What were some indications that making it onto the worship team meant a great deal to Gloria?

2. What are some examples of Gloria's behavior that indicate a healthy response to anxiety?

3. What are some examples of Gloria's behavior that indicate a negative or unhealthy response to anxiety?

4. Do you think Gloria did the right thing when she quit singing? Why or why not?

5. Is there anything Gloria could have done differently to avoid the pain of rejection? If so, what?

6. Is there anything the director could have done differently to make it easier for those who didn't make it? If so, what?

7. If you had any advice for Gloria about how to cope with her disappointment, what would that be?

8. Have you ever tried out for something and not made it? How did you feel at the time?

9. Have you known individuals who became so discouraged from failure or rejection that, like Gloria, they completely quit using their talents? Were they better off after quitting? Did they seem happier?

10. Some arts ministries don't hold auditions, preferring instead to include anyone who wants to serve. What are some of the advantages and disadvantages of that approach?

ARTISTS ARE VULNERABLE

Whenever you audition, create a work of art, or perform in public, you're putting yourself in a vulnerable position. You could fail. You could be rejected. It happens—even to the best of artists. You may put an obscene amount of work into something only to have it turned away. You may be criticized. You may receive a bad review or hear a negative comment from someone whose opinion is important to you. There's no way any of us can completely avoid those risks.

For the purposes of this discussion, I'll lump rejection and failure together—because whether you experience one or the other (or both), the effect is the same. You're left discouraged. You may begin to doubt your creative instincts or artistic abilities. You may even consider quitting the pursuit of your art. I know a good songwriter who gave up writing completely because the rejection letters he constantly received from publishers drove him to despair. His reaction is far from unique. Not knowing how to cope with rejection and failure has been the demise of many artists.

Once while visiting a family friend, I couldn't help but notice the beautiful photographs on the walls of her home—mostly pictures of flowers. My host seemed surprised by my admiration for the photographer's attention to detail and sense of light and line. She took me into the den and showed me box after box of beautiful pictures. It turned out she was the photographer, and I later

learned she had experienced a great deal of rejection concerning her art. Even her husband criticized her work and derided her for wasting her time (and their money) on photography. No wonder she was starving for encouragement. My few minutes of appreciation were the only support she had felt in a long time. She later sent me a nicely framed photograph from her collection, which now hangs in my office as a reminder that artists need encouragement because we're all vulnerable to rejection.

LISTEN TO YOUR DISAPPOINTMENT

Unfortunately, on this side of heaven, life is full of disappointment and sorrow. Jesus said it plainly, "In this world you will have trouble" (John 16:33). No matter how hard you try or even how deserving you are, life will not always turn out the way you want it to. Whether it's a marriage that fails, a child who goes astray, trouble at work, financial failure, deteriorating health, or some setback with your art, life can sometimes be discouraging.

What do you do with your disappointment? Some of us try to ignore it, hoping it will go away. Others try to spiritualize their pain with Christian clichés or pious platitudes, which only serve to temporarily bury their pain. Remember that ignoring your disappointment never makes it go away. Instead, it can evolve into deep depression or leak out as harsh anger, even when you don't realize it. You may be able to hide what you're unhappy about, but you'll never be able to completely hide your unhappiness.

Nehemiah was the cupbearer to Artaxerxes I, king of Persia, which meant he had to taste the king's wine to make sure it wasn't poisoned. Part of the protocol of being the royal bartender was never to look sad in the presence of the king. To do otherwise could result in severe punishment or even execution. Nehemiah, however, was heavyhearted over the plight of his fellow Jews who were trying to rebuild Jerusalem. He couldn't hide his grief (Nehemiah 2:1–3). The story eventually leads to a happy ending, but it serves as an illustration that on some occasions it may be impossible to completely suppress our feelings. Nehemiah's life depended on it, yet he couldn't do it.

Christians can be the most disingenuous people because we think we need to have it together all the time. That's a lie. No one has it all together, but for some reason, we believe we have to appear that we never have problems. We

ignore what's going on in the innermost parts of our being, especially our pain and disappointment. If our art is going to embody truth, though, we need to start with the truth about what's really going on inside us.

Be honest about what you're feeling. In *The Awakened Heart*, Gerald May writes:

> This is a secret known by those who have had the courage to face their own emptiness. The secret of being in love, of falling in love with life as it is meant to be, is to befriend our yearning instead of avoiding it, to live into our longing rather than trying to resolve it, to *enter* the spaciousness of our emptiness instead of trying to fill it up.[12]

Your discontentment might have something to do with your art. Maybe you've wanted to use your talents in church, but for one reason or another, that hasn't worked out. Instead of suppressing that disappointment, ask yourself how it makes you feel. It's time to let yourself grieve over the pain and loss you're experiencing.

Entering your discontent may be wrenching. That's to be expected, but Ecclesiastes 3:4 assures us that the appropriate response to the difficulties of life is not to ignore our pain but to weep and to mourn. No matter how painful or threatening it may be, I encourage you to listen to your disappointment. Though it may feel like you're opening Pandora's box, acknowledge your feelings. You'll never resolve your dissatisfaction until you get it out into the open where you can deal with it. Scripture encourages us to draw near to God with a sincere heart (Hebrews 10:22). God already knows you're in pain, so be honest with him and with yourself about what's really going on inside. If you listen to your own dissatisfaction, it could be the start of a great work of God in your life—but only if you pay attention.

HOW TO RESPOND TO REJECTION AND FAILURE

The playwright Anton Chekhov wrote this sobering bit of advice in a letter to an aspiring young actress (whom he later married, by the way):

> You must stop worrying about success or failure. Your business is to work step by step, from day to day, steadily, and to be prepared for inevitable mistakes and failures, in a word, to follow your own path and leave competition to others.[13]

Since rejection and failure are inevitable for the artist, the sooner you and I learn how to deal with them, the better off we'll be.

Don't Ever Quit

Every artist who has ever had his or her confidence shaken is tempted to quit. Don't do it. No matter how difficult things get, don't ever put your talent on the shelf. Having any artistic ability is a great privilege; not everyone can do what you do. In fact, many people would give their eyeteeth to be able to perform or create so well. Don't take that ability for granted. Please remember that your talent is a gift from God and you are accountable for what you do with what you've been given. In Jesus' parable about the talents, the servant who was given one talent had the biggest obstacle to overcome. Humanly speaking, this servant had every right to give up, and unfortunately, that's exactly what happened. The one-talent servant buried the talent in the ground (Matthew 25:24–25). As a result, that talent was taken away from the unfaithful servant and given to somebody who would develop and use it.

We dishonor God when we take for granted what he's given to us, no matter how small or insignificant we think it is. People who have been artists for a long time may not be any more talented than you are. They've just learned not to quit. Certainly, there may be periods when you take a break from your art. That's much different from stopping altogether. The writer of Hebrews implores us not to give up but to "run with perseverance the race marked out for us" (Hebrews 12:1). Determination is an essential trait for an artist, and it becomes more ingrained in us every time we refuse to give up.

Quitting Will Not Make You Any Happier

I wonder if the apostle John felt like quitting. He was banished to the island of Patmos where he lived his last days in exile. God revealed some extraordinary visions to John, and an angel kept telling him to record what he saw. In fact, twelve times the angel said, "Write this down." Why did the angel keep nagging John? Was it because he was reluctant? Was he thinking, *Why? What's the use? Writing this stuff down will only bring more pain and trouble into my life. Besides, no one's going to read this, let alone believe it.* If John hadn't written down what God showed him, we wouldn't have the glorious and triumphant book

of Revelation today. I think God still whispers in the ears of a lot of artists, urging us to write, sing, play, dance, act, paint, draw, and perform all to his glory. Instead of quitting, let's faithfully steward the gifts and abilities God has so graciously given us.

In their book, *Art and Fear*, authors David Bayles and Ted Orland point out:

> In the end it all comes down to this: you have a choice . . . between giving your work your best shot and risking that it will not make you happy, or not giving it your best shot—and thereby *guaranteeing* that it will not make you happy.[14]

My experience from years of working with artists tells me the authors are exactly right. If you think you're unhappy now as an artist, just think how much unhappier you would be if you gave up your art.

You Need Your Art

My fellow artists, whether you realize it or not, you need your art. Your skill level is not important. For most of us, playing our instruments, singing, writing, or painting is like therapy. When David wrote, "My soul yearns, even faints, for the courts of the Lord; my heart and my flesh cry out for the living God" (Psalm 84:2), he was using music to express the depths of his soul. As it was with David, our art can be cathartic. It can help us sort out our deepest thoughts and feelings, and it is critical for our spiritual health and well-being. It can sustain us through struggles and hardship. When Beethoven died in 1827, the eulogy delivered at his funeral emphasized, in the grand oration style of that day, how much his art had been a refuge throughout the great composer's difficult life:

> The thorns of life had wounded him deeply, and as the castaway clings to the shore, so did he seek refuge in thine arms, O thou glorious sister and peer of the Good and the True, thou balm of wounded hearts, heaven-born Art![15]

I recently toured Buchenwald, the former Nazi concentration camp outside Weimar, Germany. It was a sobering experience. Take all the atrocities you've ever heard about what went on in those concentration camps, and multiply it by a thousand to get a sense of the depth of evil that pervaded these camps.

Before the tours, everyone watches a video that features World War II survivors talking about their experience while interned at Buchenwald. One of them

mentioned that on Sunday afternoons the prisoners would gather together, recite poetry to one another, share their drawings, and sing. I quickly pictured them reading their poems or singing in hushed tones so as not to be overheard by the guards. I imagined them sharing their crude pictures made with makeshift pencils and paper. With their lives hanging in the balance, these desperate people turned to their arts as a source of strength and comfort. The quality of the art didn't matter, but the pursuit of art preserved their sanity and gave them hope in a disparagingly insane world. Hearing how the inmates at Buchenwald drew courage from their arts made me extremely proud to be an artist.

If you've put your talent on hold for one reason or another, I invite you to take it up again, if for no other reason than the fact that you need your art. Once, while teaching a workshop in the north woods of Wisconsin, I challenged the artists present to do something artistic during the week and to share that experience with another person. As I was leaving the next day, a man from the workshop swaggered up to me and said, "I did it."

"Did what?" I asked.

"I did the assignment already," he proudly replied. He then went on to explain that he had been in a rock group in the '60s, but that after the group had disbanded, he'd taken a job in the marketplace and never went back to his music. In fact, he hadn't touched a piano since. "Last night," he enthused, "I shut the door because I didn't want my wife to hear, and I sat at the piano and played all night. I loved it! I had the time of my life." One night at the piano was all it took for this man to rediscover the joy and meaning that music could add to his life.

Keep Feeding the Lake

Another reason you need your art is because it gives you an opportunity to give of yourself to others. The following advice to writers from author Anne Lamott pertains to all artists:

> You are going to have to give and give and give, or there's no reason for you to be writing. You have to give from the deepest part of yourself, and you are going to have to go on giving, and the giving is going to have to be its own reward. There is no cosmic importance to your getting something published, but there is in learning to be a giver.[16]

To borrow an analogy from Madeleine L'Engle, the arts are like a big lake from which people throughout history have drawn life. In fact, civilization would die without the water from that lake. Whether you're a professional or an amateur, a performer or a creator, greatly gifted or nominally talented, you need to do your part to keep that lake full and alive. Citing an interview with the French writer Jean Rhys, L'Engle writes:

> If the work comes to the artist and says, "Here I am, serve me," then the job of the artist, great or small, is to serve. The amount of the artist's talent is not what it is about. Jean Rhys said to an interviewer in the *Paris Review*, "Listen to me. All of writing is a huge lake. There are great rivers that feed the lake, like Tolstoy and Dostoyevsky. And there are mere trickles, like Jean Rhys. All that matters is feeding the lake. I don't matter. The lake matters. You must keep feeding the lake."[17]

It takes courage to be an artist, so don't give up. Let God give you the strength to go on. And keep feeding the lake.

Let Your Setbacks Make You a Better Artist

If your work or talent is rejected, don't let bitterness and pessimism set in. People tend to avoid artists who mope around all the time, like the sullen songwriter who's perpetually upset because he can't get his songs performed, or the angry actress who develops a martyr complex because she doesn't get the lead parts she wants. It is not becoming for artists to walk around with a chip on their shoulder. When Jesus gave the disciples some tips on ministering to people, he talked about how they should respond when they experienced rejection (Matthew 10:11–14). He suggested that they shake the dust off their feet and move on with no hint of bitterness or anger. If your work is rejected, don't pout. Don't wallow in self-pity. Move on to the next opportunity or the next project.

Ask, "What Can I Learn?"

The other night I had dinner with one of the drummers in our ministry. A few months before, we had told him we wouldn't be calling him to play as often because he wasn't as strong musically as we needed him to be. When he had auditioned, we communicated to him that his playing wasn't quite at the level we needed it to be, but we accepted him hoping that his playing would improve

over time. Instead, it grew worse. (By the way, don't ever assume that leaders take such situations lightly. It is far more typical for us to agonize over every one of them.)

That evening I expected I'd need to comfort and encourage this drummer, but I also braced myself for potential criticism of our ministry and our music staff. Instead, he told me he wanted to use this rejection to make him a better drummer and a better man. The reason he wanted to meet was because he wanted to ask for any advice that would help him learn from this experience. Needless to say, I walked away from our time together extremely impressed with this young man's character. In Isaiah 41:10 God says, "Do not fear, for I am with you; do not be dismayed, for I am your God. I will strengthen you and help you; I will uphold you with my righteous right hand." Don't be afraid to fail. It can make you better.

There's a theory that many weight lifters subscribe to that's known as "lifting to failure." They do reps at a heavy weight until they can't possibly lift anymore. It's that last rep—when they're straining and struggling, they can't push or pull any harder, they're shaking, and their muscles are burning—that produces the most benefit. You can't build up muscles without first tearing them down, and you don't do that without reaching the point of failure. I think that's true for an artist as well. Failure can bring growth and renewal into our lives if we can learn from our mistakes.

The most important question you and I can ask after a setback is "What can I learn from this that can make me a better artist in the future?" Sometimes it has taken me weeks to fully answer that question, so please don't give up if nothing comes to you right away. I'll often pray, journal, talk to a friend, or all of the above to help me take away something positive from a negative experience. I've encountered small failures that have made me work harder or prepare differently the next time, and I've endured big failures that forced me to redefine myself as an artist. Attempting to learn something from my failures has liberated me from my natural tendency to berate myself for my past failures and has allowed me to reach forward enthusiastically to what lies ahead (Philippians 3:13).

Discerning what you can learn from failure and disappointment is meant to be a constructive exercise. Be careful not to use it as an opportunity to vent

anger. If you end up saying, "What I've learned from this experience is not to trust people anymore," you've missed the point.

Aim for Growth over Success

Winston Churchill said, "Success is moving from one failure to another with no loss of enthusiasm." Every artist fails, but the great ones don't see themselves as failures. They learn how to use failure as a stepping-stone to their next success. They see it as part of the process that eventually brings success.

Always remember that your development as an artist is more important than your success. In fact, sometimes success can hinder your progress. There's an old saying that goes like this: "Don't let your successes go to your head. And don't let your failures go to your heart." If you let success become unduly important to you, you will eventually become deathly afraid of failure. You will stop learning. You will stop taking risks. You will stop growing. Kathleen Norris addresses writers with a similar warning, but it's great advice for all artists: "To keep bearing fruit one must keep returning, humbly, to the blank page, to the uncertainty of the writing process, and not pay much heed to the 'noted author' the world wants you to be."[18]

Find God in the Midst of Your Disappointment

I know a man who used to dread silence. If he was alone in his car, the radio had to be blaring. When he returned home after work, the first thing he did was turn on the TV. Even if he went for a walk, he'd insist on taking his portable CD player and his cell phone. Any time there was a quiet moment during worship at church, he became nervous and fidgety.

When I asked him about this, he said he felt driven to fill up any silence in his life because he didn't like what happened to him when he was quiet. "Why, what happens?" I asked. Without hesitating, he answered, "Silence forces me to face all the disappointments in my life."

"Is it working?" I asked.

"What do you mean?" he replied.

"Has ignoring your disappointments made them go away?"

"No," he admitted, "but I don't know what else to do."

I suggested that instead of ignoring his pain, he listen to his own dissatisfaction and try to find God in the midst of it. I challenged him to find a quiet

place with no distractions, read Scripture, pray, and listen for what the Lord might say. He came back the following week and said that as soon as he had entered into quietness, he had been flooded with disappointment. His marriage was good but not great. He had many unmet needs. His job was frustrating. Though he wanted to quit the solitude assignment, he hung in there. He kept praying and reading Scripture. One of the verses he read was Psalm 34:18, "The Lord is close to the brokenhearted and saves those who are crushed in spirit." At that point, my friend had dissolved in tears and said, "Okay, Lord, you are near. I'm listening. Please speak to me."

God spoke all right, and several times thereafter. Sometimes it was a nugget of wisdom straight out of the Bible. Often it was a word of encouragement. Other times the Lord gave him a fresh perspective. Occasionally the pain and disappointment went away, but frequently they didn't. What matters most is that this man found God in the midst of the process. Today he no longer feels threatened by silence. In fact, the silence that he used to fear has become a source of hope and strength.

White Crucifixion by Marc Chagall (plate 2) is a work of art that inspires me always to look for God in the midst of my pain. It was painted in 1938 in response to the horrific wave of anti-Semitism that was beginning to sweep across Europe.

At the center of the piece is Jesus hanging on a cross wearing a Jewish prayer shawl as a loincloth. All around him are scenes of Jews being persecuted. To the right, a soldier ransacks a burning synagogue, desecrating the Torah and the other sacred symbols of worship. Below, survivors flee for their lives. The one on the left, having lost a shoe, glances back at the burning synagogue in horror. Also on the left, a hostile army raids a Jewish village and turns the houses upside down. A boatload of refugees—men, women, and children— escape but have no place to go. They've been disenfranchised by hatred. At the top of the painting, the prophets of old look on all this brutality in total dismay, crying out in laments of deep sorrow and anguish.

It is interesting that Jesus is depicted at the center of all this suffering. Because Chagall was Jewish, he saw Jesus as just another suffering Jew. But for Christians, this painting goes far beyond that to an even greater truth: Jesus can be found in the midst of our pain and suffering. Since he knows what anguish

is like, he is sympathetic whenever we suffer (Hebrews 4:15–16). In Exodus 3:7, God said to Moses, "I have indeed seen the misery of my people in Egypt. I have heard them crying out because of their slave drivers, and I am concerned about their suffering."

Don't think for a second that the Lord isn't concerned about your distress. You may feel as though God has forsaken you, but he hasn't. In Isaiah 49:15–16, God again states that he is for us, not against us:

> Can a mother forget the baby at her breast and have no compassion on the child she has borne? Though she may forget, I will not forget you! See, I have engraved you on the palms of my hand; your walls are ever before me.

God cares about you, so bring your discontent, your sadness, and your pain and lay it all down at his feet. You can pray, write a letter to God, or record your thoughts and feelings in a journal. Journaling is a practice that always forces me to face my disappointments. Whenever I write my thoughts down, it becomes easier for me to sort through, articulate, and process my feelings. When that happens, I find it much easier to pray about my disappointments.

I have often begun journal entries with, "Lord, I'm upset about . . ." Or "Lord, I'm sad about . . ." When you reach out to God in the midst of your pain and disappointment, no fancy prayer is necessary. There's no need for eloquence. Just tell God what you're feeling and know that he listens to every cry for help with loving concern (Psalms 18:6; 66:19; 116:1).

If you only get as far as "Dear God" before you're overwhelmed with emotion, that's okay. The psalmist concurs that crying can also serve as prayer. "I am worn out from groaning; all night long I flood my bed with weeping and drench my couch with tears" (Psalm 6:6). If you have been carrying around large amounts of pain and frustration for a long time, you need to put this book down now and pour your heart out to the Lord. When you look for God in the midst of your disillusionment, you will find his comfort. In the Old Testament, Hannah poured out her disappointment and anguish to God and then went away no longer sad (1 Samuel 1:18). Jesus said, "Blessed are the poor in spirit, for theirs is the kingdom of heaven. Blessed are those who mourn, for they will be comforted" (Matthew 5:3–4).

Let the Wrong Doors Close So the Right Ones Can Open

In the book of Jeremiah, God says, "For I know the plans I have for you, plans to prosper you and not to harm you, plans to give you hope and a future" (Jeremiah 29:11). God has great aspirations for you. That doesn't mean there is only one possible script, predetermined down to the last detail, and if you miss it, you're out of luck. God's plans are more general and flexible than that, and your talent most likely plays some part in those plans. The Lord can't reveal his design for our entire life all at once because we wouldn't be able to handle it. Or, if we could, we'd probably bypass every route he wants us to take in an effort to get there by our own means and in our own timing.

Interestingly, Jesus didn't reveal at once all the aspirations he had for Peter. He let those plans unfold gradually. When the two met for the first time, the Lord gave Peter a new name but didn't tell him why (John 1:42). Then after Jesus told Peter that he was going to build his church upon him, the name Peter, "the Rock," started to make sense (Matthew 16:18). Finally, when Jesus told him to "feed my sheep," Peter's purpose in life became crystal clear (John 21:15–17).

Similarly, God's direction for each of our lives unfolds over time, and sometimes God uses rejection and failure to guide you into the areas of service for which you are better gifted. In other words, if a door shuts, perhaps the path you were on wasn't the option for which you are best suited. Perhaps God is trying to steer you toward something that's a better fit. No matter how spiritual or noble your intentions, there is no guarantee all your ambitions line up precisely with your personality, passions, and abilities. In his book *The Road to Daybreak*, Henri Nouwen shares how God used failure to close some doors on opportunities for which he was ill suited:

> My trips to Latin America had set in motion the thought that I might be called to spend the rest of my life among the poor of Bolivia or Peru. So I resigned from my teaching position at Yale and went to Bolivia to learn Spanish and to Peru to experience the life of a priest among the poor. I sincerely tried to discern whether living among the poor in Latin America was the direction to go. Slowly and painfully, I discovered that my spiritual ambitions were different from God's will for me. I had to face the fact that I wasn't capable of doing the work of a missioner in a Spanish-speaking country, that I needed more emotional support than my

fellow missioners could offer, that the hard struggle for justice often left me discouraged and dispirited, and that the great variety of tasks and obligations took away my inner composure. It was hard to hear my friends say that I could do more for the South in the North than in the South and that my ability to speak and write was more useful among university students than among the poor. It became quite clear to me that idealism, good intentions, and a desire to serve the poor do not make up a vocation.[19]

It's important that we do what God is truly calling us to do. When I was in my late teens, I got involved in a ministry called Son City, the youth group that eventually started Willow Creek Community Church. At one of our Son City retreats, the guest speaker, Dr. Gilbert Bilezikian, said something that has always stayed with me. "Dr. B," as we called him, looked out at all of us wide-eyed teenagers and said, "Always do what God wants you to do and let someone else do what you want to do."

Now in our age of "feel-good" Christianity, those words may sound quaint and archaic. We're more apt to hear that we should do what we want to do and that God will make all our dreams come true. However, it's unrealistic to think we can become anything we dream of being or accomplish any objective. What if we're not talented enough to make all our dreams come true? What if our dreams aren't from God after all? What if those dreams aren't as good a fit for us as we thought? There's nothing wrong with having ambitions about what you want to do with your talent, but it is unwise to always presume it's God's will.

In Colossians 4:17 Paul says, "See to it that you complete the work *you* have received in the Lord" (emphasis mine). In 2 Timothy 4:5 Paul says it again, "Fulfill your ministry."

Commenting on this verse in his book *Courageous Leadership*, Bill Hybels writes:

> Fulfill *your* ministry—nothing more, nothing less.
> What does Paul mean when he says, "Fulfill your ministry"? He means fulfill the exact ministry that God *gave you*. Not the ministry you dreamed up during a bout of personal grandiosity. Not the one that makes you feel responsible for the salvation of the entire world. Not the one that forces you out of the basic wiring pattern that God gave you. Not the one that pushes you so far beyond your measure of faith that fear and anxiety dominate your daily life.

Fulfill *your* ministry. The one that flows out of a sincere spirit of humility and submission; the one that matches the exact role God assigned you in the worldwide redemptive drama; the one that corresponds with your true spiritual gifts, passions, and talents; the one that is proportionate to the measure of faith that God has given you.[20]

Like most of the Jews in his day, Peter dreamed about a messiah who would throw off the yoke of Roman oppression and reestablish the glory of Israel. So when Jesus started talking about suffering and dying, Peter took him aside to set him straight. That's when Jesus said, "Get away from me, Satan! You are seeing things merely from a human point of view, not from God's" (Mark 8:33 NLT). Peter imagined a messiah as a superhero who would ride in and save the day. God had something bigger and better in mind—a Savior who would save humankind for all eternity. In the same way, if you develop tunnel vision about God's will for you and your talent, it will take longer for you to discover the arenas for which your talent is best suited.

Since those youth group days, Dr. Bilezikian's words have come back to me on many occasions. Quite often, when I've encountered rejection and failure in a specific area over a long period of time, I've thought, *Maybe this is something I'm not as good at as I originally thought I was. Perhaps I should let somebody else do this and I should move on to do something I'm better equipped to do.*

When I realized I wasn't going to make it as a piano player, for instance, it freed me up to consider writing music. When I understood that leading worship was not one of my strengths, I was able to pour myself into building and leading a comprehensive music ministry. Throughout my life, God has used rejection and failure as tools to close some doors and open others. In the process, I've learned to let go of those dreams that aren't from God and embrace the ones that are—the ones more accurately aligned with my gifts and passions. I like the way Parker Palmer describes this process of letting go:

> The truth is that every time a door closes behind us, the rest of the world opens up in front of us. All we need to do is stop pounding on the door that is closed, turn around, and see the largeness of life that now lies open to our soul.[21]

By accepting the fact that the Lord closes some doors and opens others, I eventually discovered my place in the world and was able to come to terms

with how my art fits into my life purpose. In fact, much of what I do today encompasses many of the same things I originally wanted to do, just in a slightly different form. When I look back on my life to this point, I realize I didn't get to do what I wanted to do. Instead, I'm doing what I know God wants me to do, and my life has turned out to be so much better than I ever could have dreamed.

Follow-up Questions for Group Discussion

1. What are some examples of unhealthy ways people sometimes deal with rejection and failure?

2. Why do you think it's difficult for Christians to be honest with ourselves and with others when we face life's disappointments?

3. Are there any areas of disappointment or dissatisfaction in your life these days? If so, what are they?

4. Are you aware of anything the Lord might be trying to teach you in the midst of your dissatisfaction? If so, what?

5. Why do you think quitting is such a common reaction to rejection and failure?

6. What do you think life would be like without the arts?

7. What do you think your church would be like without the arts?

8. What can you do this week to help "feed the lake"?

9. Can you think of a time in your life when you experienced a setback that, in the end, made you better? What did you learn from that experience?

10. Can you think of a time in your life when God closed a door and soon opened another?

Personal Action Steps

1. Write down any negative comments that you've been carrying around from your past concerning you or your talent.

2. Write down any part of those negative comments that may have been true at the time and what you've learned from each setback.

3. Next, pray over every one of those negative incidents from your past. Thank the Lord for any amount of truth that was spoken to you and ask him to help you forgive those whose negative feedback has contributed to your insecurity or fear as an artist.

4. Recalling your most recent setback as an artist, talk to someone you trust about what you could learn from the experience and how you could have responded differently.

5. Is there anyone you know who has recently experienced failure or rejection? Make it a point this week to encourage that person in some tangible way.

chapter four:

Working Through Relational Conflict

So they went through the inspection without a word of enmity, yet the enmity was there as always. He could have said to the sergeant, let me humble myself, and declare that I am no longer your enemy, and let you yourself forgive me for my words. But how can one say such a thing?

Alan Paton, *Too Late the Phalarope*

The setting is a church sanctuary, and the time is "t-minus thirty-five." It's the sound check rehearsal before the service, which is to begin in just over half an hour. The band is behind schedule. The singers arrived late and the sound technician is trying to locate a low hum coming through the monitors. The drama team is pacing the aisles, rehearsing lines as they wait for their turn on

the platform. Meanwhile, the stage crew frantically runs around checking all the microphones.

Ben, the music director, is growing tenser by the minute. The music isn't quite where it needs to be, and he knows that thirty-five minutes is not enough rehearsal time to get it there. To make matters worse, the guitar is so loud it's overpowering the vocals. Ben is under a lot of pressure these days from the elders to make sure the music isn't offensively loud, so he knows he has to ask Rick to turn down the volume on his amp, but he's dreading that conversation. Ben and Rick don't have a good relationship. In fact, they avoid each other as much as possible. It's hard to tell when the tension started. Somehow they just got off on the wrong foot and never recovered. If it weren't for the sarcastic barbs they mutter to each other during rehearsal, they'd barely be on speaking terms.

The sound technician announces he needs everyone to be quiet for a few minutes so he can fix the bad hum. Ben takes advantage of the break in the action, walks over to Rick, and sounding annoyed, whispers, "Rick, would you mind turning it down? We're having trouble getting the vocals to cut through."

Rick rolls his eyes and shakes his head in disgust, grumbling, "I can hear them just fine."

"I'm serious," Ben says, becoming more agitated. "If people can't hear the vocals, they're not going to be led in worship like they need to be led."

Rick has heard this before, and he doesn't buy it. "Yeah, but they're not gonna be able to worship if they can't feel the power of the music," he says angrily.

Ben's face starts to flush. "Look, Rick," he starts slowly, "if you don't turn your amp down, I'll turn it down myself." Then without giving Rick time to answer, Ben continues loudly enough for everyone to hear, "I'm tired of you fighting me on this all the time. I want the amp turned down and I want it done now."

By now the entire sanctuary is deathly quiet. With all the sarcasm he can muster, Rick replies, "Fine, I'll turn it down if that's what you want, but worship time will be dead . . . as usual." Sweat beads up on Rick's forehead as he continues, "I don't need this. I'm tired of the way volunteers get treated around here—and you call this a church? You know, I was playing here long before you got hired. I think I know what works for worship and what doesn't. This

music ministry has been nothing but a joke since you took over. We're all about ready to quit."

Ben folds his arms across his chest, totally exasperated. "That would be just fine with me," he says through clenched teeth. By now the two men are nose to nose.

"Okay, Mr. Boss Man, have it your way." With that Rick unplugs his guitar, puts it in its case, grabs his amp, and storms out of the church.

There is an awkward silence, and then the pastor walks in and says, "Hi, everybody. How does the worship time look this morning?"

Questions for Group Discussion

1. What factors caused the conflict between Ben and Rick to get out of hand?

2. What could have been done to prevent the tension between these two men from erupting into an ugly scene?

3. What do you think Ben could have done differently to avoid blowing up at Rick?

4. How could Rick have handled the situation differently?

5. How common would you say relational conflict is in church work?

6. This scenario takes place during a stressful sound check rehearsal where the potential for conflict is high. What part of your team's process carries the greatest potential for relational conflict?

7. How did the family you grew up in resolve relational conflict, and how might that affect the way you resolve conflict now?

8. Is it acceptable for two believers to be so at odds with each other that they no longer speak?

9. Is anger wrong?

10. What ultimately happens to a ministry if its members fail to resolve relational conflict?

WHERE TWO OR MORE ARE GATHERED . . . THERE WILL BE CONFLICT

As a teenager, when I started volunteering in the music program at my church, I assumed that because we were Christians we'd all get along. Church was the last place I expected to encounter people problems. Boy, was I wrong. Since then, I've learned my initial experience was not all that unusual. Veterans of church work often kid each other about the acrimony we witness, and it's not uncommon for someone to say tongue in cheek, "You know, ministry would be so much easier if it weren't for the people."

Conflict is inevitable because we are imperfect people living in an imperfect world. Jesus said, "It is not the healthy who need a doctor, but the sick" (Matthew 9:12). The church may have a few saints here and there, but the rest of us are still individual works in progress. We are in the process of becoming Christlike, but we're sure not there yet. When you throw all of us forgiven sinners together, we're bound to step on each other's toes. I've told my volunteers numerous times that relational conflict doesn't alarm me because it indicates that we're having authentic community. What *does* bother me is any unwillingness on our part to work toward resolution.

The basic principle for resolving relational conflict is quite simple: go to the person you're in conflict with and talk it out. That's what Jesus taught. "If another believer sins against you, go privately and point out the fault" (Matthew 18:15 NLT). Keep in mind that this process to work through a relational conflict

may take more than one meeting. I've seen Christians get discouraged and give up trying when a conflict isn't resolved in one meeting. Sometimes it takes several face-to-face discussions. If a conflict has been unresolved for a long time, it may be unrealistic to expect anything more from the first meeting than putting the issues on the table. When a first meeting becomes highly emotional, it is often helpful for the parties to separate, think through some of the issues on their own, come back together very soon, and continue talking. If the two of you reach an impasse, you might need to call in an elder to help mediate reconciliation.

Make sure the Matthew 18 principle becomes part of your team's vernacular. Encourage each other to "do a Matthew 18," to go straight to the person at the other end of the problem and talk it out. If we don't learn how to resolve relational conflict, our ability to work together as the body of Christ is in grave danger. We're going to spend all of eternity with the people at church, so we might as well learn how to get along with them now. That can happen only if everyone on the team makes it a priority to resolve relational conflict whenever it occurs.

Even though the Matthew 18 principle is simple, it's not easy. Most of us are averse to conflict—it seems risky and scary. Sometimes we're afraid that if we approach those we're having problems with, the situation will turn into a shouting match or an ugly confrontation. I'd like to offer four suggestions to help you in your efforts to resolve the relational conflicts you will inevitably encounter at church. If you adhere to them, I believe you'll find the Matthew 18 principle a far more positive experience than you ever thought it could be.

1. Express Your Anger without Antagonism

What do you do when you're angry? Do you hold it all inside, or do you pick a fight? Do you lash out and say things you later regret? Do you seek revenge? If you can express anger without resorting to such hostility, you will have greater success at resolving conflict.

As an emotion, anger is neither right nor wrong. However, what you do with your anger quickly becomes a matter of right and wrong. Ephesians 4:26 says, "In your anger do not sin." If you hurt somebody physically, emotionally, or psychologically, you have misappropriated your anger. You can be angry

without raising your voice. You can be angry and still choose words that are not harsh, judgmental, or vindictive.

First Timothy 5:1–2 puts just about everyone you relate to into four categories, with a special consideration for each. The first category is men who are older than you: "Do not rebuke an older man harshly, but exhort him as if he were your father." In other words, give the older men in your life respect. The next group is men who are younger than you: "Treat younger men as brothers." Be accepting of them. You are advised to treat older women with the kind of appreciation you would show to your mother and relate to younger women as if they were your sisters (v. 2). Although the categories help us to identify the various people in our lives, the main point here is that we must treat people with respect, acceptance, and appreciation. We should have pure motives. These kinds of approaches are important and especially wise when confronting others about something that has made us angry.

In our opening scenario, Rick was angry about how volunteers were treated and how worship was being led. Ben was antagonized by his previous encounters with Rick. Their "stage rage" could have been avoided had they talked through their issues as they came up. Because they didn't, each of them had a closetful of anger that exploded into a venomous outburst. What should have been a harmless dialogue about guitar volume turned out to be a showdown of issues and emotions that had been pent up for far too long. Unresolved anger can deteriorate into bitterness and resentment very quickly.

In my years as a ministry leader, I've unfortunately made decisions or treated people in ways that made them angry. Some have approached me in a humble, gentle spirit that made it easy for me to listen. Others have approached me accusingly with a great deal of malice, which threw up barriers before our conversation even began. Ephesians 4:31 instructs us to "get rid of all bitterness, rage and anger, brawling and slander, along with every form of malice."

In order to express anger without being malicious, it's important to scale back the emotional intensity. Ecclesiastes 7:9 says, "Do not be quickly provoked in your spirit, for anger resides in the lap of fools." James 1:19 tells us to be "slow to anger" (NASB). Proverbs 16:32 says, "It is better to be patient than powerful; it is better to have self-control than to conquer a city" (NLT). According to 1 Corinthians 13:5, a truly loving person is "not easily angered."

Parenthood has taught me that out-of-control anger always does more harm than good. When my two boys were very young, I could get angry when those "little sinners" blatantly disobeyed or rebelled. Sometimes I lost my composure, and my anger overwhelmed them to the point that they could barely understand what I was trying to say to them. All they could hear, see, and feel was that this big adult in their lives had become frighteningly volatile. No wonder Ephesians 6:4 tells us fathers not to exasperate our children with our anger. My overwrought anger had become a worse offense than whatever act of disobedience my kids had committed in the first place. That's what James 1:20 refers to when it says that impulsive anger never yields positive results.

The big discovery for me has been that I can be angry without letting it control me or overtake the situation, and I can choose not to lose my temper. If I can express my anger in as calm a voice as possible, the results are far better. Learning how to express anger without malice has become a valuable tool that has served me well in my marriage as well as in my relationships at church. Proverbs 15:18 (NLT) puts it this way: "A hothead starts fights; a cool-tempered person tries to stop them."

Expressing anger without being nasty is less likely to put the person you're talking to on the defensive. It also helps you think straight so you don't say something you'll later regret. "Don't talk too much, for it fosters sin. Be sensible and turn off the flow!" (Proverbs 10:19 NLT). So don't go on the attack. Don't assault the other person's character and don't use an accusatory tone of voice. Instead, try to use more neutral-sounding words. Remember that how you say something is just as important as what you say.

That principle should apply from the beginning of the conversation, because when it comes to expressing anger, those first words out of your mouth are extremely important. You don't have to sugarcoat your words. You don't have to walk on eggshells. But at some point you have to articulate the fact that you're angry or offended. Here are some examples of statements that, if spoken in a firm but calm voice, can communicate anger in a manner that paves the way for constructive dialogue:

- I'm angry about something that happened between us yesterday. Can we talk about it?

- It upset me when you said (blank) this morning. Would you be open to discussing it right now?
- Something you did yesterday offended me. Could we schedule a time to get together and talk?
- Did you mean anything behind what you said the other day about (blank)?
- I was wondering if there was any reason you did (blank) yesterday.

2. Respond to Anger with a Soft Answer

How do you respond when someone is upset with you? Do you withdraw and become a doormat? Do you become defensive and vindictive? Do you get sarcastic or cynical?

The Bible says, "A gentle answer turns away wrath" (Proverbs 15:1). The King James Version refers to it as the "soft answer." Either way, the question begs to be asked: does it really work? Is a gentle or soft answer really the best response when someone is angry with you? It is if your concept of the gentle answer is accurate and realistic. The gentle answer is not weak, timid, or even necessarily soft-spoken. The art of the soft answer is not in the volume of one's voice: it's in the tone.

When two people start bickering, angry words usually escalate the tension. That's how arguments get out of hand, and it's exactly what the Bible describes in Galatians 5:15: "If you keep on biting and devouring each other, watch out or you will be destroyed by each other." Referring once again to our opening scenario, both Ben and Rick immediately took a combative tone. They responded to each other's anger with pent-up anger of their own, and that quickly escalated to the point where they were practically screaming at one another. Be careful not to get drawn into others' anger. Just because their temper flares doesn't mean yours has to as well. Don't respond to anger with more anger.

If what someone says really does make you angry, then you need to express your feelings without being antagonistic. However, all too often we return anger with anger without even thinking. Proverbs 15:28 says, "The heart of the righteous weighs its answers, but the mouth of the wicked gushes evil." The soft answer is first of all not an impulsive one. It is a measured response. Instead of escalating tension, it diffuses it. Instead of inciting anger, it tempers it.

A keyboard player recently asked me for advice about how to respond to his worship leader's tense words during a sound check. They'd get no more than thirty seconds into a song and the leader would rush over to the keyboard player and anxiously say something like, "Did you hear that wrong chord in the guitar?" Or "The bass player is off." I asked my friend how he usually responded.

"I used to ignore him," he said, "but lately I've been snapping right back at him."

"What would happen," I asked, "if you answered the worship leader in a pleasant tone of voice?" I sensed his skepticism, so I continued. "What if you were to say, 'Yes, I heard the wrong chord in the guitar and I heard the bass player get lost. We'll be sure to work on that.'"

A light went on in this keyboard player's mind. "Ah," he exclaimed, "that would diffuse the tension, wouldn't it?"

"It sure would," I agreed. "The more gracious answer would have calmed your worship leader down and put you at ease at the same time." That's the power of the soft answer.

I should clarify that cases of violence or blatant verbal abuse warrant professional help or intervention more than any kind of soft answer. What I'm referring to are ordinary, nonviolent relational clashes. In those cases, the soft answer really can turn away wrath.

For Practice

Since many of us didn't learn how to resolve relational conflict as we were growing up, these skills need to be practiced. Take each of the situations below and come up with a couple of opening lines that express anger without being antagonistic. If you're going through this book as a group, have fun role-playing some of the responses. Choose an example below and have one person practice expressing anger as another group member responds with his or her own version of the soft answer. An exercise like this is especially helpful for those who claim they never get angry. Put

yourself into the shoes of the people in the following situations who, I think we would all agree, have every right to be upset.

1. You're on the drama team at church, and this Sunday you're performing a script that calls for two people. You worked hard to get to rehearsal on time tonight, but the other person (who often has a problem with punctuality) arrived forty-five minutes late. He didn't apologize or even offer an excuse. You're angry and you need to say so.

2. You called your ministry leader a week ago to say you had an important prayer request to share, but she never returned your call. You're angry and you need to express that.

3. You shared something very private about an issue you're struggling with and you asked your friend to keep it confidential. But instead, the person you confided in told a couple of people. You're angry and you need to say so.

3. Verbalize Your Hurt as Soon as Possible

If you're sitting in church some Sunday and the face of someone you're at odds with comes to mind, you need to get up out of your seat and go to that person and work it out. That's what Jesus taught (Matthew 5:23–24). Notice the urgency here. If someone has offended you, go to that person right away. Don't put it off.

When we're "dinged" our tendency is to try to suppress our hurt. That's not only foolish; it's impossible. The more we try to suppress our hurt feelings, the more they fester and grow. That's why we need to keep short accounts with each other. My pastor has taught on a number of occasions about the importance of saying "ouch" when we're hurt.

Saying "ouch" has never been easy for me. Because my natural response is to suppress pain, I tend to overanalyze my reaction. I may even try to talk

myself out of being hurt or bothered. *Is this matter worth bringing up?* I wonder. *Maybe I'm just being overly sensitive.* If an incident occurs and I quickly forget it, then it was just a passing irritation. But if I keep replaying it in my mind, if I'm starting to keep a record, it needs to be dealt with (1 Corinthians 13:5). Or if I see somebody at church and it feels awkward (or I try to avoid them altogether), it's time to talk. Romans 12:18 says, "If it is possible, as far as it depends on you, live at peace with everyone." The part that depends on you is the part where you go to someone who has hurt your feelings and talk it out.

Once again from our opening scenario, think how different Rick and Ben's relationship would be if Rick had gone to Ben the first time Ben asked him to turn down his volume. Imagine how much pain these two men could have avoided if Ben had told Rick early on that he was hurt by Rick's apparent distrust of his leadership.

Sometimes I'll hear someone say, "Why should I even try to talk to so-and-so? She'll never change anyway." The reason we reconcile is not to change the other person. That's not our job anyway—that's the Holy Spirit's work. Instead, we should work through conflict so we can arrive at a better understanding of each other. When we understand each other better, we can accept and love each other more genuinely. At this point, we can also work together much better.

Tom Vitacco has served on our music staff at Willow Creek for many years. Early in our ministry together, I was taken aback by how frequently Tom needed to talk to me because something I said had hurt him. I remember thinking, *This guy is too sensitive. He takes everything so personally.* I eventually realized, though, that Tom was much healthier than I was in this area. When I felt slighted by someone, I withdrew from that person and bitterness and resentment eventually took root in my spirit.

Tom, on the other hand, would go to that person right away and talk it out. He was tactful and not the least bit vengeful. He was careful about not only what he said but how he said it. He would approach me with humility and say, "I don't want to give the Evil One an opportunity to hinder our ability to work well together, so I was wondering if we could talk about something you said that's been bothering me." I found this nonthreatening approach disarming. I think anyone would. More to his credit than mine, Tom and I have become great friends and have enjoyed working together for more than twenty years.

In large part, that's because we have worked through conflicts as soon as they have come up.

Very often, Tom, and others who do a good job of verbalizing their hurt, begin conversations with tactful openings like those that follow:

- Something you said yesterday made me feel bad. Can we talk about it?
- I took what you said last night personally and it hurt me deeply. Can we discuss it?
- Can I ask what you meant the other day when you said (blank)?
- I don't know if you meant to come across this way, but when you said (blank) the other day, it really bothered me.
- Can you help me understand why you did (blank) the other day? It really hurt my feelings.

4. Respond Sympathetically to Someone You Have Hurt

When somebody comes to you and claims you have been insensitive, be sure to hear that person out. Proverbs 18:13 (NLT) says, "What a shame, what folly, to give advice before listening to the facts!" So let the injured party speak, even though what he or she has to say may be hard to hear. The worst thing you can do is to tell someone you've hurt that there is no reason to be upset. That's very insensitive. Whether someone has a right to feel hurt is not for you to decide, so don't put someone down for having hurt feelings.

Instead, be tenderhearted. Sometimes I hear someone say they can't be tenderhearted because they're just not sensitive by nature. That may be true, but that reasoning should never be used as an excuse for a lack of kindness or compassion for each other. Scripture admonishes us to be gentle and sensitive even if we're not wired that way. In fact, when Paul tells us to walk in a manner worthy of our calling, he exhorts us to "be completely humble and gentle; be patient, bearing with one another in love" (Ephesians 4:2). Ephesians 4:32 admonishes us to "be kind and compassionate to one another." Colossians 3:12–13 says, "Clothe yourselves with compassion, kindness, humility, gentleness and patience. Bear with each other."

Instead of judging whether or not someone has a valid reason to have hurt feelings, extend grace to them. Colossians 4:6 says, "Let your conversation be

always full of grace, seasoned with salt, so that you may know how to answer everyone." Extending grace helps you to respond compassionately, so if you've hurt someone in any way, humble yourself and apologize. "I'm sorry" are the two words with the greatest potential to bring healing and closure to any conflict. Even if the other person is ninety percent wrong and you're only ten percent wrong, take responsibility for your ten percent and apologize for it.

Suppose that when Ben confronted Rick, Rick had said, "Hey, I understand you're under a lot of pressure to keep the volume under control. I'm sorry I gave you such a hard time about it." Or suppose that when Rick had confronted Ben, Ben had replied by saying, "Wow, I'm sorry, Rick. I realize now how bad you may have felt when I came down on you so hard in front of everyone."

Whenever you apologize, avoid using the words *if* or *maybe*. Someone who says, "I'm sorry if I hurt you," is not really apologizing. They're not taking responsibility for their wrong. Saying something like, "I'm sorry, maybe I was insensitive," is disingenuous. Either you were insensitive or you weren't. There's no "maybe."

Here are some examples of sympathetic responses that validate the other person's hurt in a way that leads more easily to reconciliation:

- I can see how much my words hurt you. I'm sorry.
- I understand how what I did would make you feel bad.
- That must have hurt you deeply when I said (blank).
- You have every right to be hurt. I'm sorry.
- If someone did that to me, I would be hurt too.

For Practice

Putting yourself in the situations below, write an opening line that tactfully communicates each person's hurt feelings. Then put yourself in the other person's shoes and write a sympathetic response. If you're in a group, divide into pairs and role-play. Have one person verbalize hurt and the other respond sympathetically.

1. Your best friend knows you're sensitive about being the oldest member of the worship team, yet the other day at rehearsal, your friend teased you about it in front of everyone. It hurt your feelings and you need to say so.

2. Your fellowship group planned a weekend picnic that included spouses and family. Because you're single, you weren't invited. Everyone was there but you. That hurt and you need to tell your small group leader about it.

3. Your church just finished an exhausting run of Easter services. At the celebration party afterward, the pastor acknowledges the contribution of all the different teams and their leaders. The pastor has each group stand and thanks them for a job well done. Everyone applauds. The problem is that the pastor failed to mention the audio team, of which you're a part. Though you're not in ministry for the glory, your feelings are hurt and you need to tell the pastor that.

IS COMMUNITY REALLY WORTH ALL THIS TROUBLE?

If you wonder whether working toward resolution is worth the trouble, consider the alternative. The pain from a broken relationship far exceeds any discomfort you might feel while working through relational conflict. Ministry teams that gloss over conflict or pretend nothing is wrong quickly deteriorate into "pseudocommunity" and become highly dysfunctional. On the outside, they might appear to be nice to each other, but it's all a facade. Just below the surface, bitter strife and resentment are waiting to sabotage the ministry.

When I'm tempted to withhold the effort to resolve a conflict, a painting by the Spanish artist Francisco Goya comes quickly to mind (plate 3). It's called *Fight with Clubs*, but I like to think of it as *Life without Matthew 18*. Painted during the early 1820s, it shows two men, probably neighbors, wildly swinging clubs at each other while mired in quicksand up to their knees. The action is intense; blood streams down one man's face. This is going to be a fight to the

death. Instead of helping each other out of the quicksand, each menacing blow sends both men deeper into it. Ironically, the two men are set against a rather peaceful-looking countryside. Goya gives us no indication as to why they are fighting. I think it's because he believed no possible reason could justify such a violent altercation. In effect, Goya is saying, "This is senseless. It doesn't have to be like this."

In the church, we may not go after each other with clubs, but our conflicts can be just as intense. Someone takes a verbal jab at someone else who, in turn, swipes back. Before you know it, a little feud starts brewing. Meanwhile, in the background, the pastor preaches about "loving thy neighbor" and the choir sings about being "one in the Spirit." It doesn't have to be this way among us. As brothers and sisters in Christ, we should sit down and talk through our problems.

We may joke that ministry would be so much easier if it weren't for the people, but here's the real truth: ministry would be terribly unfulfilling if it weren't for the people. The most gratifying part of my ministry has been the community, not the music. Some of our staff members have worked together for a couple of decades. We've been through thick and thin together. We've had our share of disagreements and differences, but we've worked through them all. As I've walked through life with some of my volunteers, I've watched them come to Christ, get married, and have kids. Now some of their kids are involved in our music ministry. Again, it hasn't always been easy to navigate the choppy waters of relational conflict we've experienced along the way, but we did it. In fact, our relationships have a profound permanency due to the fact that we've resolved our conflicts.

Keep in mind that genuine community is never easily attained. It can be draining and it takes hard work, but it is well worth the effort. You and I were created to be in community with God and with one another, so authentic community can be deeply satisfying to the soul. That's what inspired the psalmist to write, "How wonderful, how beautiful, when brothers and sisters get along!" (Psalm 133:1 MSG).

1. What has been the most gratifying part of being involved in your church? How much of what made it so special had to do with people?

2. How skilled are you at resolving relational conflict? Give yourself a letter grade from A to F for each of the relational skills listed below:

 _____ Expressing anger without antagonism

 _____ Responding to anger with a soft answer

 _____ Verbalizing your hurt as soon as possible (instead of suppressing it)

 _____ Responding sympathetically to someone you've hurt

3. In which relational skill did you grade yourself the lowest?

4. Read Matthew 5:23–24. Why do you think Jesus expressed such urgency about resolving relational conflict?

5. Think of the last relational conflict you experienced. Are you happy with the way you handled it? Is there anything you wish you had done differently?

6. Are you the kind of person who bottles your anger inside, explodes in anger, or stays somewhere in between?

7. How do you respond to someone who's angry with you?

8. Do you dread the thought of going to someone who has hurt you and talking about it? If so, do you know why?

9. How do you most often respond when someone informs you that you've hurt them?

10. What did you learn from the role-playing exercises in this chapter? Did anything surprise you as you went through them? Which one was particularly difficult for you?

Personal Action Steps

1. Write down the names of anyone with whom you're in conflict and evaluate whether you've violated any conflict resolution principles. Did you become antagonistic or mean-spirited? Were you defensive or insensitive? Have you owned up to the part you played in the conflict?

2. Write out what you would like to say to this person, making every effort to appropriately express your anger and hurt.

3. Think about the best way you can respond to the individual if he or she is angry or hurt.

4. Set up an appointment to talk to this individual face-to-face or over the phone.

5. After the conversation, write down in your journal what you learned from this encounter.

chapter five:

How to Develop a Genuine "Can-Do" Attitude

> We who lived in concentration camps can remember the men who walked through the huts comforting others, giving away their last piece of bread. They may have been few in number, but they offer sufficient proof that everything can be taken from a man but one thing: the last of the human freedoms—to choose one's attitude in any given set of circumstances, to choose one's own way.
>
> Viktor Frankl, *Man's Search for Meaning*

Gary owns a sound and lighting company. He hopes to build it into a thriving business someday, but for now it's literally a mom-and-pop organization. He and his wife, Laura, provide sound and lighting on a contract basis for small conventions, live shows, and recording projects in their community.

Gary and Laura are not churchgoers, but they've been hired to run sound and lighting for an Easter program at a local church. The program is pretty involved, so even though it doesn't start until 6:00 p.m., Gary and Laura show up at 7:00 a.m. to start setting up. Working quickly but methodically, it takes five hours to unload the truck and set up all their equipment. At noon, Laura pulls out the lunches she packed and they eat as they label the soundboard and test microphones. At around 1:00, the program director arrives. She met with Gary and Laura last week for a detailed discussion of the program, so now they only need to talk through a few last-minute details.

The band is supposed to be ready to go at 2:00, but by 1:45 only the guitar and bass players have arrived. Gary and Laura help them set up and get plugged in. The keyboard player shows up ten minutes later carrying a synthesizer under his arm. Laura doesn't see a synth listed on her list of instruments, so she asks the keyboard player if he intends to play the synth this evening. He gives her a perturbed look and asks, "Why do you think I brought it?" Laura takes that as a yes.

The drummer shows up right at 2:00 p.m. and as he's setting up his drums, Laura overhears the director ask him whether he knew the call time was 2:00. To emphasize her point she politely adds, "We wanted to start playing right at two, not still be setting up."

The drummer's answer is caustic. "Last week I got here on time and sat around because you weren't ready. So today I decided to get here when I felt like it." The director is taken aback and does not answer. By the time the rhythm section is ready to play, it's 3:00 p.m.

At about that time, the other participants start to arrive, dressed in all sorts of colorful costumes. Gary can hear the singers warming up in the hallway. They take the stage at 3:40, but there's an unclaimed wireless microphone; somebody with a lead part seems to be missing. When Gary asks about it, the director appears anxious. Apparently the woman playing Mary, the mother of Jesus, is upset that one of her solos has been cut from the program. She's crying in the bathroom. Even though the director explained that her song was cut because the program was too long, she's convinced it's because the director doesn't like her.

The group eventually coaxes her to return, and at 4:15 the dress rehearsal—which was supposed to start at three—is finally ready to begin. There is a great deal of tension in the air. Backstage a group of people attempts to console the woman playing Mary. When the director walks by, they give her the cold shoulder. She wonders whether there may be a mutiny before the night is out.

After rehearsal, the cast eats a light dinner together, but Gary and Laura snack on the fly so they can go over the script, making sure all their cues and sound effects are in order. Gary spots the director and asks if she's happy with the sound and lighting. Though obviously stressed, she smiles and tells Gary she's pleased with everything he and Laura are doing. However, she asks if they could have fewer drums and more vocals in the mix. A few of the singers cornered her after the dress rehearsal, she explains, and were cross with her about the volume.

The program goes pretty well—a few intonation problems here and there, a couple missed entrances by the Roman guards, and some lines of dialogue that fell victim to memory loss—but no problems from the technical side. Gary and Laura high-five each other during the curtain call. The director hugs them both.

It's close to midnight before all the equipment is packed and Gary and Laura are ready to leave. The director runs out to the parking lot and hands them a check. "Thank you," Laura says. "It was great working with you. Call us if you ever need our help again."

"Oh, I would," the director says, "but I don't see myself ever doing this again."

This catches Laura off guard. "Are you okay?' she asks carefully.

The director bursts into tears. "I don't know if I can take this anymore," she blurts. "There are so many attitude problems in this church, so much whining and complaining all the time."

In an effort to cheer her up, Gary and Laura take the beleaguered director out for coffee and end up talking with her until the wee hours of the morning.

Questions for Group Discussion

1. What are indications that some of the church artists in the story have negative attitudes?

2. How would you describe Gary and Laura's attitudes toward the Easter production?

3. How would you compare Gary and Laura's work ethic to that of the church artists?

4. How do you think attitude affects work ethic?

5. What kind of effect might the attitudes of those negative artists be having on the rest of the team?

6. If the negative attitudes aren't addressed, what do you think may happen to the arts ministries of this church?

7. What do you think will happen to the arts director if the negativity continues or increases?

8. What can cause someone to have a negative attitude or to be overly critical?

9. Have you ever caught yourself critiquing a worship service instead of worshiping? Or evaluating a drama sketch or sermon instead of listening?

10. How does a can-do attitude impact a church and affect those who aren't Christians yet like Laura and Gary?

THE DESTRUCTIVE POWER OF A NEGATIVE ATTITUDE

Nothing is more destructive to a marriage, a friendship, or any other relationship than a negative spirit. Such an attitude can be highly toxic, and it often leaves a great deal of pain and strife in its wake. For one thing, it can be draining to be around negative people for any length of time, because if anything goes wrong, they can be cynical, sarcastic, and harsh. I know a man whose critical spirit is driving a wedge between him and his wife. She feels she can do nothing right in his eyes, and she's growing weary of constantly having to prop up his gloomy disposition.

As we begin our discussion, I'd like to define what I mean by a negative attitude. Once while I was teaching on this topic, someone asked, "Does this mean I can never say anything critical about anyone or anything ever? Am I just supposed to look the other way when something's wrong?"

No, that's not what Scripture teaches. There are times when we need to speak out against heresy (Galatians 1:9). We need to rebuke sin (1 Timothy 5:20). We as the church are to judge the sins of other believers (1 Corinthians 5:12). The Old Testament prophets had to be critical, and Jesus himself denounced many of the religious leaders he encountered. In each of these examples, the critical word was true and the motivation was love. We are to "speak the truth in love" (Ephesians 4:15). A negative attitude, on the other hand, is a critical spirit unaccompanied by love and truth. Let's briefly analyze some of the telltale signs of a negative attitude.

Attitudes Rooted in Bitterness and Resentment

The drummer in our opening scenario was angry that he had showed up on time previously but had to wait, so he arrived at church in a foul mood.

Right before David slew Goliath, David's oldest brother, Eliab, belittled David for being on the battlefield. Eliab was obviously angry and spoke harshly to David: "Why have you come down here? And with whom did you leave those few sheep in the desert? I know how conceited you are and how wicked your heart is; you came down only to watch the battle" (1 Samuel 17:28). Eliab was jealous of David because the prophet Samuel had anointed David as the next king instead of Eliab. Hence the negative attitude.

Attitudes Based on Lies or Misconceptions

It's easy to develop a negative attitude toward someone based on false information. I don't know how many times I've jumped to a negative conclusion based on insufficient evidence or someone else's subjective observations. The singer playing the part of Mary in our opening scenario was convinced her song was cut because the director didn't like her, when in reality it was because the program was too long. She perpetuated this misconception among her friends, who in turn also took up an offense for her.

In the Old Testament, Jacob had a meltdown because he failed to get his facts straight concerning the welfare of his sons. Listen to the hopelessness in his voice as recorded in Genesis 42:36: "You have deprived me of my children. Joseph is no more and Simeon is no more, and now you want to take Benjamin. Everything is against me!" Even though Jacob felt all was lost, nothing could have been further from the truth. Benjamin wasn't dead. In fact, he was standing right there in front of Jacob. Simeon wasn't dead, and neither was Joseph. They were all about to be blessed beyond their wildest dreams. Jacob got sucked into believing a lie and despair set in.

Attitudes That Result in Chronic Grumbling

People will complain about anything and everything. Even those who have been blessed with abundance find plenty to whine about. After God miraculously delivered the children of Israel from the cruel bonds of slavery, you'd think they would have been so grateful that they'd never again dream of grumbling. They saw God part the Red Sea and had barely finished celebrating before they started to groan about not having enough water (Exodus 15:24; 17:2; Numbers 20:2–5). After they groused about being hungry, the Lord provided manna, but they got tired of manna and complained that God didn't include enough variety on his menu (Exodus 16:2; Numbers 11:4–6). Whenever they faced any kind of adversity, they became surly and turned on their leaders (Numbers 14:2; 16:11, 41), and these were people who had experienced unprecedented divine intervention. This story also demonstrates that chronic complainers are not the kind of people you want to have around in a crisis. Their negativity makes them agents of despair.

NEGATIVITY IN THE CHURCH

A negative and critical spirit frequently causes division in the body of Christ. Proverbs 6:19 says God hates it when we allow our complaining to stir up dissension in others. That's why God became so angry listening to the Israelites bellyache in the desert and decided to punish them. All those who grumbled were not allowed entrance into the Promised Land. Their children would get there, but an entire generation of chronic complainers was condemned to wander and die in the wilderness (Numbers 14:26–29). Notice that this severe punishment was not for idolatry, murder, or sexual sin. God punished them for grumbling. That's how serious an offense our negativity can be in the eyes of God. It's not some minor infraction, because it can be extremely destructive.

Jesus warns us that a house divided against itself cannot stand (Mark 3:25). Indeed, it can take just one negative person to agitate a segment of a congregation and eventually split the entire church. I've seen it happen, and it's never pretty. That's why Paul says, "Make every effort to keep the unity of the Spirit through the bond of peace" (Ephesians 4:3).

If you have an ax to grind, there will be no shortage of people to sympathize with you. People with negative attitudes tend to find one another and form the Fellowship of the Critical Spirit. When they get together, they gripe about all the bad stuff that's going on at church. That's why negative people always claim to know others who feel as disenchanted with the church as they do. Negativity loves company. In the workplace, people gather around the proverbial watercooler to grumble and complain. In churches, people often spew their grievances in what we ironically call the fellowship hall. For more of the gruesome details, let's take a look at four types of negative people in the church and observe how pernicious their negativity can be.

The Disgruntled Veteran

When a long-standing member of the church expresses opposition to something, it can send shock waves throughout the church. The Disgruntled Veteran, who often becomes self-righteous and cantankerous, commonly threatens to withdraw membership or financial support if things don't change. Such a spirit of entitlement follows wherever the Disgruntled Veteran goes. If this person is an artist, he or she feels entitled to be featured more often. Or perhaps

the person feels entitled to a more prominent leadership role in which his or her opinions will count more because of "all I've done for the church." When newer members hear a Disgruntled Veteran sound off, they are often shaken and assume, *Boy, if so-and-so is upset, there must be something worth getting upset about.*

Because Disgruntled Veterans have been around awhile, they make sweeping statements with an air of authority. These negative generalizations usually have the words *all, always,* or *never* in them. For example, "The drama director blows his stack at rehearsal *all* the time." "The production team is *always* the last to know anything." "The choir director *never* lets anyone but his wife sing solos." Those who say such things do so to bolster their claims; instead, they hurt their credibility when the hasty generalization is not true. To say the drama director blows his stack at rehearsal *all the time* is disproven the first time he makes it through rehearsal without becoming angry. The production team is not *always* the last to know, and can you honestly say the choir director *never ever* lets anyone else sing a solo? Ecclesiastes 5:2 says, "Do not be quick with your mouth, do not be hasty in your heart to utter anything before God."

Veteran status does carry a certain amount of power and authority, but it should always be wielded responsibly, with great care and wisdom. The Bible warns us not to do anything that would cause others to stumble, especially those who are younger in the faith (Matthew 18:6–7; 1 Corinthians 8:4–13). So if you're a veteran, don't let any negative attitudes you have about your church infect the minds of others. Of all people, veteran church members should be models of gratitude, humility, and joy.

The Pouting Thomas

When I hear individuals speak cynically of their church, I often suspect they failed to get their way. Maybe they took exception to a decision that was made. Maybe there were staff changes they refute, or perhaps things aren't being done the way they would do them. Instead of accepting these disappointments and moving on, Pouting Thomases withdraw and, well, pout. They tend to make sarcastic comments under their breath, and they may even threaten to leave the church.

One of the realities of church life is that almost none of us gets our own way all the time, and that's actually for the best. It builds character. According to

Isaiah, one of the reasons for observing a regular Sabbath is to teach us the benefits of not getting our own way all the time. "If you keep your feet from breaking the Sabbath and from doing as you please on my holy day . . . and if you honor it by not going your own way and not doing as you please . . . then you will find your joy in the Lord" (Isaiah 58:13–14). Many people consider abstinence to be one of the higher spiritual disciplines. We would do well to abstain from the need to get our way all the time—even when our way is right.

The Faultfinder

The Faultfinder is the person who is quick to point out everyone else's shortcomings, especially those of people in leadership. Faultfinders are highly judgmental, often jumping to alarming conclusions about someone's character based on one incident. Instead of believing the best, they assume the worst (1 Corinthians 13:7). They may voice their criticism openly or make subtle insinuations. They may even solicit prayer for something they're "concerned" about in such a way that it becomes gossip instead of prayer. Proverbs 16:27–28 (NLT) says, "Scoundrels hunt for scandal; their words are a destructive blaze. A troublemaker plants seeds of strife; gossip separates the best of friends." Faultfinders are on a mission to change everybody but themselves. Meanwhile, in Matthew 7:3–5 (NLT), Jesus asks us, "And why worry about a speck in your friend's eye when you have a log in your own? How can you think of saying, 'Let me help you get rid of that speck in your eye,' when you can't see past the log in your own eye? Hypocrite! First get rid of the log from your own eye; then perhaps you will see well enough to deal with the speck in your friend's eye."

I knew a man who became preoccupied with catching his pastor in any alleged misinterpretation of Scripture, no matter how trivial or esoteric. Though he was a layperson with no training in biblical studies, he still claimed it was his duty to police the pastor's theology. Titus 3:9 says we should "avoid foolish controversies and genealogies and arguments and quarrels about the law, because these are unprofitable and useless." Second Timothy 2:23 says, "Don't have anything to do with foolish and stupid arguments, because you know they produce quarrels."

The Faultfinder is always in evaluation mode. Sometimes as I sit through services at my own church, I can be an obnoxious faultfinder, one who evalu-

ates the music or critiques the drama instead of allowing the Lord to speak to me through them. On the way home from church, we often ask each other, "Did you like the service today?" The question we should be asking instead is, "Were you attentive enough to the Holy Spirit for God to speak to you during the service today?" The words of Ecclesiastes 5:1 come to mind: "Guard your steps when you go to the house of God. Go near to listen rather than to offer the sacrifice of fools, who do not know that they do wrong."

The Conspiracy Theorist

Conspiracy Theorists believe things aren't going their way at church because certain leaders don't like them. They accuse those leaders of being political and showing favoritism. These individuals have been known to start rumors about the church or its leaders, and they're inclined to take something a leader has said and read imaginary negative things into it. They often assume they know what the leader is thinking. Recently I visited a church and a woman said to me, "Our pastor thinks we old-timers don't belong here anymore." I asked her if she ever actually heard the pastor express that thought. "Well, no," she replied, "but I know that's what he thinks." Be careful not to make assumptions about what someone else is thinking. Unless you're a mind reader, you can't do it. So don't talk as if you know another person's hidden motives. We learn from Isaiah that God is inclined to withhold blessing unless we do away with "the pointing finger and malicious talk" (Isaiah 58:9).

Conspiracy Theorists also tend to talk about the church as if they are disconnected from it, often using the pronoun *they* instead of *we*. As in "*They* don't know how to worship in the Spirit at this church." Or "*They* don't really care about the arts in this church." The problem is not only that someone would say such things but also that there is an "us and them" mentality behind their disparaging remarks.

We are all in this church thing together, so if you share in its glory, you must also share in its struggles. Paul stresses that "there should be no division in the body. . . . If one part suffers, every part suffers with it; if one part is honored, every part rejoices with it" (1 Corinthians 12:25–26). So when there is a problem at church, pray instead of complain, and be assured that there is no Grand Conspiracy to keep you down. No one is against you or out to get you. If you

sense others withdrawing from or avoiding you, it may have more to do with your negative attitude than with any imaginary conspiracy.

THE NEGATIVE ARTIST

Before we cast judgment on the judgmental people at church, let's remember that the description often applies to artists. Do you know what nonartists most dread about working with us? It's our negativity. We artists have this analytical streak that enables us to make discriminating artistic choices, but it can also cause us to be harsh, judgmental, and woefully pessimistic. For many of us, maintaining a positive outlook, especially amid difficult situations, is our fiercest struggle in life.

Not only does a negative attitude cause unity to unravel, it is unbecoming and unprofessional. That is true of anyone—whether on staff or serving as a layperson—who goes about their ministry with a negative attitude. Professionalism in the marketplace is defined as reporting for work on time, treating coworkers with respect, and doing your job with a can-do attitude. We could use more of these attributes among artists in the church today. Sadly, I've worked with many non-Christian musicians who had better attitudes than some of their Christian counterparts in the church. You may argue that those in the marketplace are paid to have a professional attitude. While that may be true, Christians have a higher calling than monetary gain. We are here to please God in every way, bear fruit in every good work, and grow in our knowledge of God (Colossians 1:10). Of all people, we have every reason to serve God wholeheartedly and with can-do attitudes.

Besides being unprofessional, an overly critical spirit always puts us at an artistic disadvantage. Take two artists of equal talent, one of whom has a positive outlook while the other is consistently negative. Which artist do you think people prefer to work with? I know a music director who changes churches every two years because he always grows unhappy and restless. He starts each new job with a lot of energy and excitement, but within six months he's criticizing his colleagues and the pastor. Unfortunately, his reputation as a negative influence has grown to the point that few churches would now offer him a job.

Some people carry around a negative opinion about their church or its leaders but are proud of the fact that, according to them, they never leak their neg-

ativity to others. But even if you never say a negative word, people will still pick up on your attitude. We have to do more than just avoid being negative—we must develop positive, can-do attitudes.

HOW TO BE A CHEERFUL GIVER

Leading a ministry is like driving a bus, and if you're at the wheel, you may notice some of the passengers becoming unruly at times. The Disgruntled Veterans usually have their heads out the windows pointing out how much greener the grass is at all the other churches in town. They also describe how much better the ride was when the driver before you was at the wheel. The Pouting Thomases sit glaring at you with their arms folded across their chests. The Faultfinders run up and down the aisle every two minutes, tapping you on the shoulder and informing you that you didn't activate your turn signal at exactly 100 feet before the intersection. The Conspiracy Theorists talk in hushed tones to small pockets of passengers gathered in the back of the bus.

Then there are the few who sit right behind you all the way. They support you. They help you and they pray for you. Their loyalty is endearing, their commitment inspiring. Their words of encouragement prevail over the noise of the other passengers. They are the pillars of your ministry—those I call the Pillar People. I don't know where I'd be without my Pillar People. Their loyalty refreshes me. Their moral support sustains me. They're like David's "mighty men" (2 Samuel 23:8–39). They help shoulder the burdens of ministry with positive, can-do attitudes. Paul commended the Corinthians highly because their faithfulness and support had been such a deeply refreshing source of encouragement to him and his fellow leaders (2 Corinthians 7:13). It can never be overstated how much a cheerful attitude can minister to your leaders.

Second Corinthians 9:7 (NLT) says, "You must each make up your own mind as to how much you should give. Don't give reluctantly or in response to pressure. For God loves the person who gives cheerfully." God loves a cheerful giver, a person with a can-do attitude. That's the kind of person God uses mightily in kingdom work.

When my younger son, Joel, recently became a United States Marine, I began to devour all the books I could find about the Marine Corps. I learned that marines epitomize the can-do attitude. Recruits at boot camp constantly tell

each other to "stay motivated." They scream it to each other during physical training and whisper it to a buddy when the drill instructor isn't looking. They scribble it on notes and they even pray they'll stay motivated. "Stay motivated" is the most common advice a young recruit hears from an older one. A great attitude is essential—not only to make it through the rigorous training of boot camp, but also, perhaps, to one day save a marine's life.

Being self-motivated may sound like an archaic notion in today's society. More typically, we expect someone else to motivate us. A coach works up a speech to motivate the team before a big game. A boss announces a profit-sharing plan to motivate workers. We hire personal trainers whose praises motivate us to exercise. Somehow we've gotten the message that motivation is something someone else does *to* us. That's not how the marines think. They say, "*You*, stay motivated. *You* are responsible for your own motivation." That is also the spirit of Jesus' words from Mark 9:50: "Salt is good, but if it loses its saltiness, how can you make it salty again? *Have salt in yourselves*" (emphasis mine). It's your responsibility to stay motivated and maintain a positive attitude.

The opposite of a negative attitude is a can-do attitude. I should point out, however, that having a can-do attitude is different from being a "yes-man" or a "yes woman." A yes-man blindly follows someone else's orders to gain approval. That's not only dysfunctional; it's inauthentic. Those with can-do attitudes, on the other hand, work at tasks because they want to. They're not trying to impress someone or to get in the good graces of a certain leader. That's why my emphasis throughout this chapter is on the development of a *genuine* positive attitude.

I should also stress that having a can-do attitude is not synonymous with doing more church work. There are times when it is understandable and reasonable to turn down requests from church in order to balance all of life's commitments in a healthy way. If you can't do something the church asks because of family obligations or time constraints, that's okay. Simply decline humbly and graciously without slipping into a negative or guilt-ridden response.

A trombone player recently left me a voice mail that exemplifies how to decline with a positive attitude. I had asked him to fill in for someone else at our Christmas Eve services. He thanked me for the opportunity to play and said that although he would love to, it wasn't feasible because of previous family

commitments. This brother has proven to me over the years that he has a can-do attitude, so when he tells me he *cannot* do something, I know his reasons are legitimate. Having a can-do attitude doesn't mean you're never allowed to say no.

Proverbs 15:15 states, "A cheerful heart has a continual feast." Always remember that your attitude is one of the few things in life you have complete control over. Even if you're inclined to be negative, over time you can become a cheerful giver. To help you work at that, I offer the following suggestions, each of which can contribute to a genuine can-do attitude.

Never Minimize the Role You're Asked to Play

Many artists become frustrated or disillusioned when their talents aren't used in the way they think they should be used. If you are unhappy about the role you're asked to play at church, I encourage you to talk to whoever is in charge and let that person know how you feel. If leadership affirms that what you're already doing is important, don't minimize the value of your contribution. We artists can become so focused on our talents that we devalue any other serving opportunities the Lord gives us, especially the nonartistic ones.

That's what happened to me. Although I have a modest amount of leadership ability, there was a time in my life when I resented being asked to lead because it took time away from writing music, which is my first love. In my mind, music was more important, more visible, more glamorous, and much more exciting than most of the leadership assignments I tended to draw. When coworkers or volunteers complimented me on a leadership decision, I discounted their compliments as nothing special, reasoning that anybody could have made the same decision. Because I put writing music on such a high pedestal, I undervalued other roles I was asked to play.

The Bible clearly teaches us not to minimize our gifts. Like a well-tuned body, the church is made up of many parts that have different functions. "Just as each of us has one body with many members, and these members do not all have the same function, so in Christ we who are many form one body, and each member belongs to all the others" (Romans 12:4–5). Furthermore, Scripture teaches that our different functions work together for the common good. "The body is a unit, though it is made up of many parts; and though all its parts are

many, they form one body. So it is with Christ. . . . The eye cannot say to the hand, 'I don't need you!' And the head cannot say to the feet, 'I don't need you!' On the contrary, those parts of the body that seem to be weaker [or less important] are *indispensable*" (1 Corinthians 12:12, 21–22, emphasis mine). After reading this passage, I realized I was guilty of minimizing my nonmusical gifts. In effect I was saying, "Because I'm not doing something musical, I'm not contributing anything worthwhile." I was the eye saying to the hand, "I'm not necessary. I'm not doing anything important."

Even if the role you play doesn't feel important, it is an essential part of your church's ability to work together as the body of Christ. Even if few people recognize the significance of what you do, it is still important to God. The goal is not for us to feel important but for the church to work together in a vitally healthy way to do God's work. Ironically, when that happens we end up feeling fulfilled because we've contributed to something bigger than ourselves—the eternally significant work of God here on earth.

Paul told young Timothy, "Do not neglect your gift" (1 Timothy 4:14). Make sure you bring all your gifts to rehearsals and meetings, not just your artistic ones. In fact, there are times when your gift of wisdom, helps, knowledge, or faith may be needed more than your artistic gifts. Because the church is a priesthood of believers, all Christ-followers are ministers, not just those who are paid or on staff (1 Peter 2:5, 9; Revelation 1:6). We all have a responsibility to minister to the needs of the people around us wherever we are—at church, at work, at home, or at play. When we come to church for a service, a rehearsal, or a meeting, we need to walk through the front doors praying, "God, how can you use me to serve others here today?"

Those who minimize their gifts and abilities are also more susceptible to feelings of jealousy. They wish they had someone else's abilities or talents and communicate these wishes overtly or subtly. They may harbor deep-seated envy toward those who get to play the roles they wish they had. In fact, they can become so preoccupied with the roles they desire that they fail to discover, appreciate, and fulfill the roles they are given.

Asaph was a worship leader in the Old Testament. First Chronicles 16:37 says, "David left Asaph and his associates before the ark of the covenant of the Lord to minister there regularly, according to each day's requirements." Asaph

was someone David could depend on because he was willing to do whatever needed to be done for the sake of the ministry. What a great example of servanthood! My fellow artists, we should always be willing to do whatever it takes to serve the Lord. Besides, if we are faithful with whatever the Lord gives us to do, he gives us more (Matthew 25:23).

Matthew Henry wrote, "Wherever the Providence of God casts us we should desire and endeavor to be useful; and, when we cannot do the good we would, we must be ready to the good we can."[22] Sometimes an artist approaches me apprehensively and asks, "Can I really be fulfilled as an artist in the church?" If artistic gratification is your highest aspiration in life, I cannot guarantee you will be fulfilled doing church work. On the other hand, if you bring all your giftedness—not just your artistic talent—into play, and you offer those abilities with no strings attached, I guarantee you will be deeply fulfilled.

Do What You Do for the Love of It

In a book called *For the Love of It*, author Wayne Booth extols the virtue of amateur art. Booth is an English professor who took up the cello as an adult and discovered the joy of making music. In his book he describes a time when he and some friends were playing a Haydn string quartet. At one point all four players were so deeply moved by the sheer beauty of the music that they began to get tears in their eyes. This wasn't about their playing. They knew they didn't sound as good as a professional quartet. They were all amateurs. Yet that didn't prevent them from loving the music and being utterly inspired by its beauty.

The word *amateur* has come to have a negative connotation in our day, but the original Latin means "to love." Hence, amateurs don't do what they do for pay or glory. They do it for the *love* of it. I think many of us in the church today have lost the love we used to have for our art. Week after week we've been singing in the choir or running sound or lighting and it's become a chore, an obligation. You can't have a can-do attitude about doing something unless you love doing it. We need to use our talents at church because we love Jesus Christ and we love doing what he's gifted us to do.

Do you remember your first exposure to great art? Maybe your parents took you to an art museum or you heard somebody play an instrument or saw someone dance. I still remember the first time I heard a recording of a full orchestra.

Time stood still and I was forever hooked on the beauty and magic of orchestral music. For many of us, our first exposure to great art is what prompted us to become artists. Do you remember when you first started to perform or create? I remember the first song I wrote. It was awful. I was twelve years old, but the thrill of creating music was forever etched in my soul. Being an artist is a lifelong love affair with artistic things. Don't let the love affair die. Do your art for the love of it.

Avoid Being Pulled into Others' Negativity

Sometimes people attempt to pull us into their own negativity by involving us as a third party in a dispute. That's what Absalom did. He was angry with his father, King David, so he devised a plan to get back at him. Absalom stood by the side of the road that led up to the city gates and solicited those who had grievances against his father. After listening to their objections, he assured them they had every right to be upset. Then he added, "Isn't it too bad the king doesn't listen to you?" Posing as a sympathetic friend, Absalom succeeded in pulling a whole army of negative people together, and he led them in a rebellion against his father (2 Samuel 15:6).

My fellow artists, be careful, because every church arts ministry has its Absaloms. They may not even realize that their hidden motives are to pull you into their own negativity. They will say you have a wonderful singing voice and then add something like, "It's a shame they don't ask you to sing at church more often. They always ignore good people. The same thing happened to me." Or "Why don't they ever let you mix audio or be in charge of lighting? Are they playing favorites again over there at the church?"

Some artists are able to use all their gifts all the time. They're not frustrated by a lack of opportunities. The rest of us struggle. Sometimes the church uses our talents to the fullest, sometimes not. This is true for artists outside the church as well—it's a tension we all live with. So whether or not your talent is used and appreciated is already a sensitive issue for an artist. You don't need any Absaloms to fuel your grievances by hitting you where you're most vulnerable.

If the person who encourages you or sympathizes with you stirs up your own negativity, you're better off avoiding that particular topic. If that strategy

doesn't work, you may need to avoid the person. In Romans 16:17 (NLT) Paul says, "And now I make one more appeal, my dear brothers and sisters. Watch out for people who cause divisions and upset people's faith by teaching things that are contrary to what you have been taught. Stay away from them." Likewise, Titus 3:10 (NLT) says, "If anyone is causing divisions among you, give a first and second warning. After that, have nothing more to do with that person."

Scripture clearly states that if someone wrongs us, we should go directly to that person and work it out (Matthew 18:15–17). Often those who try to sort through their issues or vent their frustration with a third party do so to avoid talking to the person with whom they're angry. Remember, you don't have to be that third party if you don't want to. I've seen individuals jump into the middle of a conflict between two other people and do more harm than good. They have actually inhibited reconciliation. Instead of being pulled into a dispute between two other people, do everyone involved a huge favor by saying, "I think you'd be better off talking directly to the person you're having trouble with instead of me."

Be discerning, especially if you have mercy gifts. Don't let someone take advantage of your tenderheartedness by making you a party to gossip. Always remember that when someone airs his or her dirty church laundry, you are hearing only one side of the story. No matter how convincing that person is, you're still only getting one perspective. So be careful about drawing negative conclusions about anyone or anything based on a single point of view. That's why the best thing you can do for someone in the midst of conflict is encourage him or her to talk to the other person involved.

The composer Rossini was very sensitive to criticism. Once when he was sharply criticized by fellow composer Hector Berlioz, Rossini's wife got so upset she mailed Berlioz a package containing a pair of donkey ears! By way of contrast, one of the many things I've appreciated about my wife over the years is that she never takes up an offense for me when I experience conflict at church. I'm always careful not to gossip or disparage the ministry, and her response never fuels my discontent. She listens and empathizes, but then she'll say something like, "So what are you going to do about that?" Or "When are you going to talk to the person you're having this conflict with?"

Put Some Attitude Adjusters in Place

If you are by nature hypercritical and negative, you may have to work extra hard at maintaining a positive mind-set—and building some attitude adjusters into your lifestyle can help. I know people who struggle with negativity, so on their office walls they put up posters to help promote positive thinking or remind them of God's grace. I know others who have Bible verses on cards scattered around the house, mounted on their desks, or sitting on the dashboards of their cars.

The people you hang out with can also greatly influence your outlook and perspective. Proverbs 22:24–25 (NLT) warns that we're better off not spending too much time with those who infect our attitudes with their angry negativity: "Keep away from angry, short-tempered people, or you will learn to be like them and endanger your soul." On the other hand, positive people have a buoyant energy that is so contagious you can't help but be upbeat whenever you're around them. Make sure you spend enough time with the positive people in your life. They may not seek you out in the way negative people do because they're not constantly looking for someone with whom to share their misery. So you may need to take the initiative in order to spend time with those positive people.

Prayer can be a highly effective attitude adjuster. It's uncanny that when we are negative and extremely critical to each other, it sounds like whining, but when we express those same feelings, even using the exact words, to our heavenly Father, it becomes a prayer. Many of the psalms are laments—expressions of extreme negativity and pain. In Psalm 142:1–2 David wrote, "I cry aloud to the LORD; I lift up my voice to the LORD for mercy. I pour out my complaint before him; before him I tell my trouble." What if the wandering Israelites had prayed in the desert instead of complained? Prayer would have given them a different perspective and completely changed their outlook.

Listening to worship music or participating in corporate worship is also an excellent way to keep your spirits up. Paul and Silas were beaten and thrown into jail for preaching the gospel. Acts 16:25 says that "about midnight Paul and Silas were praying and singing hymns to God, and the other prisoners were listening to them." Imagine that. These men were in chains, bleeding from their wounds, yet worshiping God in the cold darkness of a prison cell. Notice that

the other prisoners didn't join in the singing. There was no hot rhythm section backing them up, no "thousand tongues to sing," no symphony orchestra behind them. Paul and Silas were alone. All they had was each other and their God. Yet they experienced joy and thanksgiving in the midst of adversity through worship. If you struggle with maintaining a positive attitude, be in church as often as possible so you can hear and sing praise music with your brothers and sisters in Christ. It's the ultimate attitude adjuster.

See the Obstacles *and* the Opportunities

One of my favorite Old Testament heroes is Caleb. He won my respect and admiration years ago because of one incident that's recorded in the book of Numbers. Moses sent twelve spies to check out the land of Canaan. They came back with glowing reports. The land was so fertile it took two men to carry a single cluster of grapes back to camp. This indeed was their Promised Land. But there was one problem. The area was populated by a savage race of giants known as the Anakim. When the people of Israel heard this, they were afraid to challenge such a formidable foe.

Caleb tried to dispel their fear. "We should go up and take possession of the land, for we can certainly do it," he said (Numbers 13:30). But the people wept all night and were on the verge of mutiny. Caleb and Joshua tried to reason with them, saying, "The land we passed through and explored is exceedingly good. If the LORD is pleased with us, he will lead us into that land, a land flowing with milk and honey, and will give it to us" (Numbers 14:7–8).

What impresses me about Caleb is that he saw both the obstacles *and* the opportunities. He was one of the twelve spies, and he had seen the giants. He also realized that this was the land they had been waiting to see for so many years. Life is rarely one-sided. The glass is always half empty *and* half full. Both statements are true, and the sooner you and I realize that, the better off we'll be in the attitude department. An optimist sees only the good. A pessimist sees only the bad. A realist sees both.

If you see only the opportunities, you won't plan for obstacles that can blindside you. You won't be prepared to solve the problems that arise. It's like starting a project without considering the cost (Luke 14:28). The opportunity may be from God, but if you're oblivious to potential pitfalls, you are more likely to fail.

If, on the other hand, you look at an opportunity and see only the obstacles, you will quickly give up. Because you are focused on the smallest problem, you'll miss the the big picture. A negative attitude will set in before you realize that this opportunity is from God and that God is in it.

The pessimist is not wrong for seeing obstacles; in fact, the pessimist sometimes has a better grip on reality than the rest of us. But where the pessimist goes wrong is in assuming that something bad will happen—that it's inevitable and nothing can be done to prevent it. Oftentimes those of us with artistic temperaments assume from the outset that something is going to be horrible. That's what the Israelites did. They had a giant problem on their hands, and they were convinced they were going to die (Numbers 14:1–3). I've done that too. I've actually heard myself say, "These Christmas services are going to kill me." Or "This Easter program is never going to come together." Exaggerations like that felt real at the time, but they turned out to be negative overreactions. If you see only the opportunities, that would be reckless. If you see only the obstacles, that would be faithless. Don't latch on to one and ignore the other.

Many decisions in my life have been made difficult by obstacles, even though there were great opportunities at stake. When my son, Joel, was very young, he started to take an interest in fishing. The problem was, I didn't grow up with an interest or experience in that activity. The only thing I knew about fishing was that a lot of fathers and sons did it together, so I realized it might provide a great relationship-building opportunity for Joel and me.

But the obstacle was equally huge; I didn't know the first thing about fishing. I couldn't turn to any of my artsy friends because none of them were outdoors people either. Fortunately, I found a man at church who was willing to teach me. I took pages of notes every time we talked. The first few times Joel and I went fishing, I actually spread little note cards all over the pier, each containing instructions on how to tie the hook onto the line, what size split shots to use, or where to attach the slip float. I must have looked like I was putting together a swing set! I have many Stupid Dad stories from my attempts at fishing, but more important, I have a lot of fond memories of Joel and me together.

Not long after we started fishing, Joel decided he wanted to take up hunting. I remember praying, "Lord, help! I was able to fake my way through fishing, but I can't fake my way through hunting." It was yet another wonderful

opportunity with serious obstacles. To make a long story short, we took a hunter's safety course, and with the help of a few outdoorsmen we met along the way, we managed to learn how to shoot and hunt. Joel then took the hobby further and became an award-winning target shooter. He earned the Marine's Rifle Expert medal in boot camp—not bad for being the son of an artist. Every great opportunity comes with obstacles, and behind every obstacle there are great opportunities.

FAITHFULNESS AND RELIABLITY

An artist friend of mine from Southern California, Hyatt Moore, showed me some sketches he had made during his recent visit to Nigeria. One of them caught my eye because it succinctly captures the noble beauty of a can-do attitude. It's called *Church Drummer between Sets* (plate 4). In the sketch, a female percussionist takes a break between sets during a service or rehearsal. She may even be taking a "cat nap." When she's playing, her hands are a blur of busyness, but now they are quiet. While one hand supports her weary head, the other rests gently in her lap. Her drum sits quietly in the center foreground, also taking a break.

Though resting, she has not left her post. She'll be ready when needed. She's somebody you can depend on. She's a picture of faithfulness and reliability. That is what defines a can-do attitude, and instrumentalists understand that very well. Many of them come early and leave late because they have equipment to set up. They're usually highly trained and often the best musicians in the church, yet they're most commonly in the background, visibly and audibly, behind the vocalists.

There's a lot of waiting involved in being an instrumentalist—waiting to play, waiting while the vocalists woodshed their parts, waiting for the sound crew to get levels set. The waiting is necessary, but it still requires grace and patience. It's part of their calling. Hyatt Moore has given us a window into the soul of a serious church artist. After studying this sketch, it is obvious that a can-do attitude is not perky bursts of enthusiasm interspersed with covert grumbling and complaining. It is a steady and serene commitment of one's time and talent, given to the local church for the glory of God and the advancement of his kingdom.

Follow-up Questions for Group Discussion

1. Do you think having a negative attitude is a sin we need to take seriously or just a minor infraction not worth getting worked up about? Why?

2. What are some of the long-term effects of a negative attitude on someone's marriage, job performance, and walk with the Lord?

3. Why do you think artists struggle with negativity?

4. How can you tell whether or not a can-do attitude is genuine?

5. What sort of behavior or attitudes could undermine the unity among the artists at your church?

6. What could your team do to promote a greater sense of unity among artists?

7. Have you ever minimized the value of something you were asked to do for the ministry? In doing so, how did that affect the way you went about performing that particular task?

8. What are some attitude adjusters that work well for you? How might you incorporate them into your life more often?

9. What happens when those of us in church work see only the opportunities in an endeavor? What happens when we see only the obstacles?

10. Is there anything God is asking you to do but you're hesitant because of the obstacles involved? What can you do to overcome those obstacles?

Personal Action Steps

1. Are you aware of anyone who has been wounded by your critical spirit? Make an appointment to meet with that person this week and seek his or her forgiveness.

2. Ask someone who knows you well to offer an opinion as to whether you are a positive, can-do person, a negative person, or somewhere in between.

3. Have you participated in any conversations this week in which you fueled someone else's negativity? Write down some ideas demonstrating how you could have avoided doing so.

4. Have you participated in any conversations this week in which you were pulled into someone else's negativity? Is there a better way you could have responded?

5. Select your favorite attitude-adjusting Scripture verse or choose one from the following list. Write the verse on a card and put it someplace where you'll see it often throughout your day.

- James 5:9

- 1 Peter 4:8–9

- 1 Corinthians 13:7

- Philippians 2:14

chapter six:

Cultivating Confidence

She skipped three grades, said her mother. She was the youngest girl ever to enter Mary Baldwin. She won the music prize her sophomore year and gave a concert her junior year, the only time it's ever been done.

Yeah, I was smart. I opened my mouth and nothing came out. I forgot the words. Forgot the Schubert, blew the Wolfe. I stood still and looked at them. Time passed. People looked away. They were embarrassed. Not only embarrassed but frightened and hateful. Who are you, you bitch, to do this to us when we didn't want to come here in the first place? What to do? Leave. Check out. Went off the stage, straight out the fire-escape door, into the street, and right on out of town.

Walker Percy, *The Second Coming*

Shana, Karen, and Alicia are rehearsing a special number for this Sunday. Shana and Karen have been singing together for years and are the best of friends. They used to sing with Pam, another friend, but last year Pam and her husband were transferred out of state. Alicia is Pam's replacement; maybe that's why she is not yet completely comfortable. She is often nervous but figures it's because she's still new to the group. Her primary concern, though, is that she doesn't pick up her part as easily as the other two women do.

Shana sings the bottom part, has great pitch, and can sight-read anything. She majored in voice in college and even sang professionally. Karen has the most beautiful voice in the church. She can make any song sound heavenly. Alicia sings the middle part and sometimes she has trouble hearing it. Although Shana and Karen have extended a great deal of grace and patience toward her, Alicia can't help but feel that she holds them back. That's how she's feeling at tonight's rehearsal. They've been working on the same section for over an hour, and Alicia is still struggling to find her part in the three-voice harmony.

Karen plays Alicia's part on the piano; her stiff index finger seems determined to will the notes into Alicia's ear. Alicia sits next to Karen at the piano, leaning toward the keys in an effort to shorten the distance between those elusive notes and her vocal cords. Shana stands opposite them, her face in her hands with her elbows resting on the top of the old upright piano. "How about if I sing your part with you, Alicia?" Shana suggests cheerfully. They try that, but Alicia overshoots the high note, gets off, and stops singing. She's discouraged but trying desperately not to show it. Her hands start to shake. "I'm sorry," she says. "Let's try it again."

At this point, Alicia's mind goes to split screen. Half of her is sitting through the unbearable rehearsal. The other half visits various scenes from her past. She remembers the times long ago when her older brother plugged his ears every time she went into her upper register. She recalls a former teacher who constantly criticized her lack of technique. Someone once told her she had "intonation problems" but couldn't tell her if she was sharp or flat.

Her mind is racing now. Negative labels come instantly to mind: slow learner, undisciplined, bad sight reader. She thinks back on all the things she tried out for and didn't make. One time her mother even asked, "What makes you think you're good enough to sing a solo at church?" She never forgot that.

As Alicia's mind races through those humiliations, Karen continues to pluck out her part louder and with more force. Shana is practically singing in her ear, but Alicia can't hear anything now. It's all white noise. She's fighting back tears. The voices in her head crescendo to a climax and she blurts out, "Who am I trying to kid? I'm just no good!"

Silence. It lasts for just a few seconds, but it feels like hours to Alicia. Although she's shaken, she tries to pull herself together. "I'm sorry. I'm just not feeling well tonight," she says. That's not really true, but it isn't entirely false either. She's frantically trying to save face. "It's okay," Karen empathizes. "We all have our bad days." "Yeah," Shana chimes in, "I'm sorry you're not feeling well. Why don't we knock off for tonight and pick it up again Saturday morning? My place at eight?"

They all nod in agreement. "I'll work on the music at home and promise I'll have it down by Saturday," Alicia assures them. "Sounds good. I know you can do it," Karen encourages. As Alicia gathers her things and heads for the door, Shana adds cheerfully, "Don't let this get you down, Alicia. It'll come. See you on Saturday."

On the drive home, Alicia can't help but wonder what Karen and Shana said about her after she left. Do they resent her being added to their group? Would they rather have Pam back? She's already feeling anxious about Saturday. What if she works on the part and still doesn't have it down by then? "I'm so ashamed," she sighs to herself as she walks through the back door into her kitchen. An hour later, she cries herself to sleep.

Questions for Group Discussion

1. What factors made Alicia's ability to learn her part more difficult?

2. Would you say Alicia's inability to learn her part is more likely due to a musical problem or a mental one?

3. What emotions did Alicia exhibit during this rehearsal?

4. How might Alicia have handled this challenging situation if she had had more confidence?

5. What advice would you have for Alicia as she prepares for Saturday's rehearsal?

6. If you were Shana or Karen, is there anything you would have done differently to help Alicia in this situation?

7. What should Shana and Karen do if Alicia still can't get her part after Saturday's rehearsal?

8. Have you ever been in a situation like Alicia's, where you felt embarrassed by your own inability?

9. How do you think a lack of confidence affects artists and their work?

10. Is it okay for a Christian to be confident?

THE INSECURE ARTIST

During years of church rehearsals and performances, I have watched the above scenario unfold hundreds of times. Talented artists are paralyzed by insecurity. A weakness, shortcoming, or past failure gets blown out of proportion and they can't get beyond it. They shrink back or they play it safe, and their lack of confidence prevents them from taking artistic risks or venturing into new territory.

plate **1**

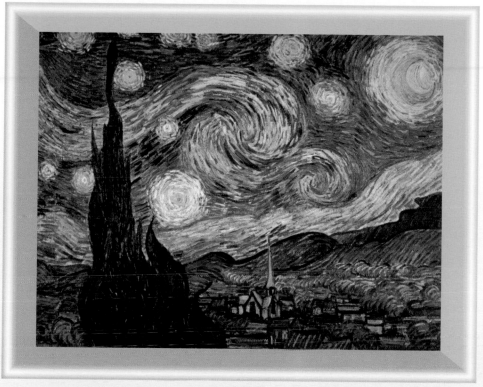

Vincent van Gogh
Starry Night

plate **2**

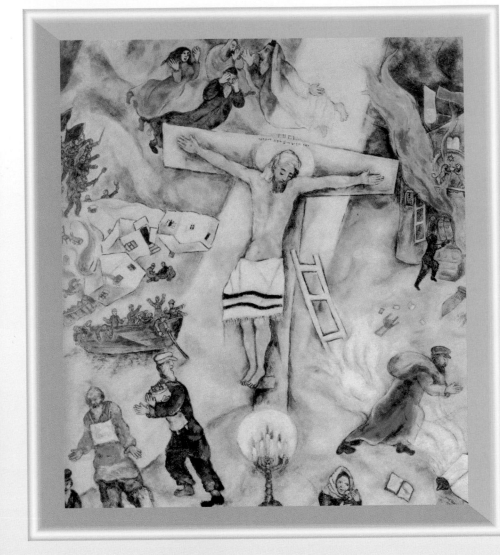

Marc Chagall

White Crucifixion

plate **3**

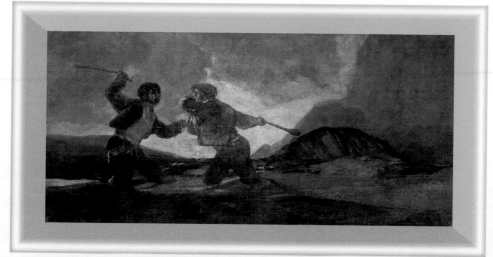

Francisco Goya

Fight with Clubs

plate **4**

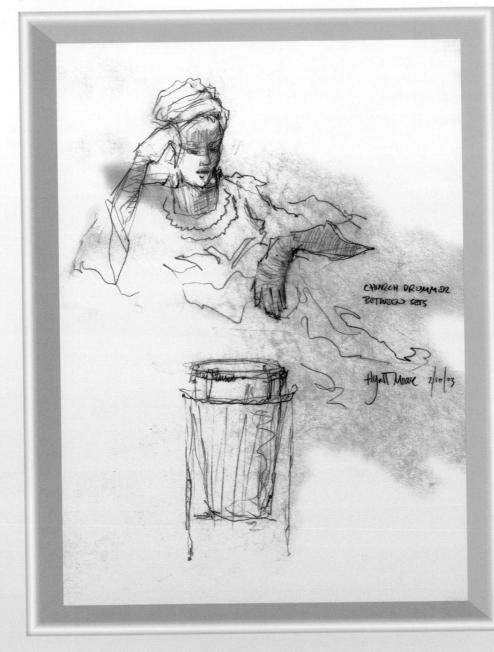

CHURCH DRUMMER
BETWEEN SETS

Hyatt Moore 2/10/03

Hyatt Moore
Church Drummer between Sets

plate 5

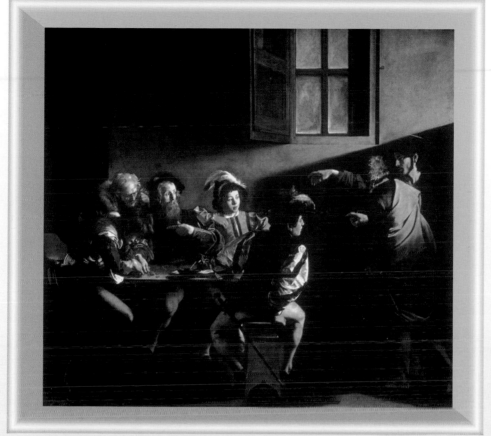

Caravaggio

The Calling of Saint Matthew

plate **6**

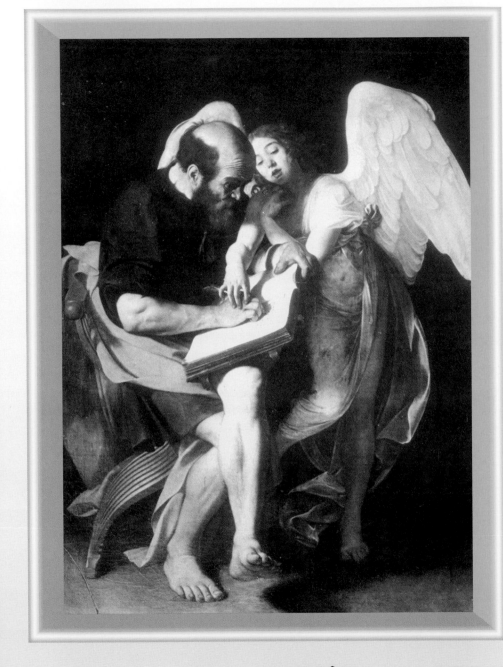

Caravaggio

Saint Matthew and the Angel

plate **7**

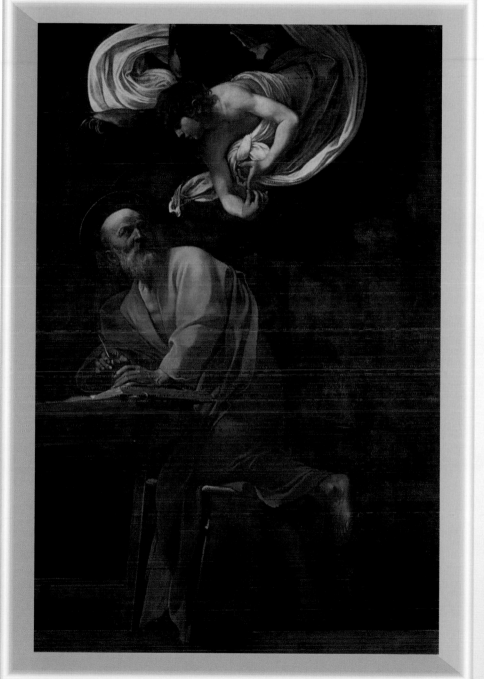

Church of San Luigi dei Francesi, Rome. Used by permission.

Caravaggio

The Inspiration of Saint Matthew

plate **8**

Georges Rouault

Christ in the Outskirts

Professional athletes talk about respecting their sport because it can humble them at a moment's notice. One day they appear to be on top of their game; the next day they're totally inept. We artists also know what it's like to be humbled by our craft. The virtuoso may be able to flirt with perfection, but the majority of us have to cope with limitations in our technique, training, or experience every time we perform or create. There are also things beyond our control that can ruin a performance. You catch a cold the day you're supposed to sing. A drumstick breaks right before your solo. The piano is so out of tune it sounds like you're wearing mittens. The French author Gustave Flaubert poignantly describes how writer's block can shake one's confidence:

> Sometimes, when I am empty, when words don't come, when I find I haven't written a single sentence after scribbling whole pages, I collapse on my couch and lie there dazed, bogged in a swamp of despair, hating myself and blaming myself for the demented pride which makes me pant after a chimera.[23]

Like Alicia, many of us carry insecurities we picked up during childhood into our adult world. When you were growing up, someone may have told you you'd never make it as a writer, or you didn't have a "good look for the stage," or you had two left feet. Even if you heard those things only once, if they were said by someone you respected, the experience may well have been a crushing blow. In fact, you probably remember the exact words that were said, and perhaps those comments have been debilitating.

You may also feel insecure because you didn't get the training you would have liked to receive. I have a close friend who grew up with an alcoholic father. Because of the chaos and instability at home, she was forced to forfeit a music scholarship to one of the best schools in the country. She eventually came to peace with her past, but for a long time she lived with a deep sadness about what might have been.

People cope with insecurity differently. Ironically, there are some who become overbearing braggarts. They may appear to be sure of themselves, but appearances are deceiving. Their manufactured confidence is a facade masking deep-seated insecurity. They get defensive quite easily because they don't want to be seen as incompetent. They drop names of important people they know or artists they've worked with because they're driven to prove themselves.

Another type of insecurity, the one we're probably most familiar with, is the kind that breeds weak, unassertive, and timid wallflowers. These individuals are so unsure of their abilities that they withdraw, tense up, or freeze when they have to perform or create. They're quick to point out their own faults and cut themselves down. They figure criticism is not only inevitable, it's deserved, so why not beat everybody to the punch? While most of us probably land somewhere between the overbearing braggart and the timid wallflower, one thing is always true: when we succumb to insecurity, it is impossible to do our best work.

IS IT OKAY TO BE CONFIDENT?

Many Christians feel conflicted about confidence. Those who lack it want it. Those who have it worry it may be un-Christian. One time, while auditioning a trumpet player, I asked the usual questions to discern his level of talent. "Can you improvise?" I asked. "Well, if it's okay to say this," he began, "I've had a lot of experience with improvisation." "Do you have a solid high C?" I asked hopefully. "Well, if it's okay to say this, I can go a few notes higher than that," he answered. I asked a few more questions, and each time he apologetically prefaced each answer with "Well, if it's okay to say this . . ." Finally, out of curiosity, I asked, "Why wouldn't it be okay for you to tell me about your musical strengths?" He looked down, hemmed and hawed for a while, and then said, "Well, you know, we're Christians. We're supposed to be humble. We're not supposed to brag about ourselves."

Confidence can be a thorny issue for Christian artists. It takes a certain amount of self-assurance—even assertiveness—to stand up and perform in front of a group of people. How do you reconcile that with what Jesus said about meekness and self-denial (Matthew 5:5; Luke 9:23)? Is it permissible for a Christian to be confident? Is it all right to be certain of one's abilities? If put in a position to perform or create, is it okay to believe you can do it well?

The Bible calls us to a higher level of godly confidence than most people realize. Through Christ we can approach God with confidence (Ephesians 3:12; 1 John 3:21; 5:14). We can be confident God will complete the work he started in us (Philippians 1:6). We are instructed to share the Word of God boldly (2 Corinthians 3:12; Ephesians 6:19). Isaiah 32:17 points out that when we are

living in submission to the Holy Spirit, "the effect of righteousness will be quietness and confidence forever." God never intended for us to live in constant fear and trepidation. Jesus said, "Let not your heart be troubled, nor let it be fearful" (John 14:27). While it's normal for an artist to be nervous before a performance, God does not want us to be controlled by insecurity. We were created to have dominion, to master, to rule (Genesis 1:26–28). The weak-kneed, wimpy approach isn't what the Lord has in mind.

Of course, the kind of confidence that comes from God is not arrogant or conceited (Philippians 2:3–4). It is not loud or boisterous (2 Corinthians 11:17). It is quiet and humble (Isaiah 32:17). It's an undaunted assurance that with God's help we are up to the task at hand (Psalm 27:3). It draws strength from the fact that our heavenly Father is the one who has gifted us in the first place. I wouldn't even call it "self" confidence. It's a "God" confidence that enhances our poise during performance and our courage when given the chance to be creative.

Some might object to my use of the word *performance* in conjunction with the church; they feel the word makes arts ministry sound like arts entertainment. I certainly don't believe church services should be relegated to the role of entertainment, and I would never condone a self centered, prima donna performance mentality in ministry. I define the word *performance* as the act of presenting one's art. The truth is, many of us are performers in the most literal sense of the word. Musicians play and sing, actors act, dancers dance. Some art has to be *performed* in order to communicate its message. My goal in this chapter is to free up artists to communicate that message so they won't be sabotaged by insecurity.

MOVING TOWARD A MORE CONFIDENT YOU

We know our confidence is not in the flesh (Philippians 3:3); it is in God. But for too many of us, the confidence that is in God never gets in *us*. Somehow it gets blocked out by our own fear and insecurity. It's like having a lot of money in the bank but living as if we are destitute.

Now, while it's always helpful to delve into the past to examine the sources of our insecurity and fear, that's not enough. Like most people, I can trace my dysfunctional behavior back to my childhood. But while doing so may help to

explain why I am the way I am, I can't let the process stop there. My dysfunctional behavior may be understandable, but it is not acceptable. So I must deal with it. Some of us have been fighting a losing battle with insecurity for so long we automatically see ourselves as underdogs, victims, or losers. Sadly, we no longer have any idea what a confident version of ourselves even looks like. We can't imagine ourselves performing or creating as confident artists.

It's never in our best interest to be insecure, especially if we're artists. God loves us too much to let us remain stuck in our dysfunctional behavior. We are like the marred vessel that the master potter is working to reshape and restore (Jeremiah 18:3–4). Overcoming dysfunctional behavior is a process, and God often asks us to participate in our own healing. He asks us to *do* something. Naaman was instructed to wash in the Jordan seven times in order to be healed of his leprosy as well as his pride (2 Kings 5:9–19). Jesus told the paralytic to get up, pick up his stretcher, and go home (Luke 5:18–26). At the very least, most of the people Jesus healed sought him out and asked for a miracle. We could never heal ourselves, but the Lord might ask us to invest the tiniest bit of effort to which he adds his infinite power. Besides, God has good reason to ask us to participate in the healing of our own insecurity and fear. Our participation is a constant reminder that we are intrinsically worth the effort.

Whether your battle for confidence is ongoing or you only have occasional bouts of self-doubt, it is possible to overcome your insecurity. I'm still growing in this area, but I'd like to share with you what the Lord has shown me (so far) about cultivating confidence.

Practice, Practice, Practice

I'll start with what I consider the most important thing you can do to bolster your confidence as an artist: make sure you're as prepared as you can possibly be every time you perform or create. In 1 Corinthians 9:24–25 Paul reminds us that hard work is what makes our greatest achievements possible: "Do you not know that in a race all the runners run, but only one gets the prize? Run in such a way as to get the prize. Everyone who competes in the games goes into strict training."

Always remember that your preparation is your personal responsibility. No one can do it for you. A lack of preparation not only affects your confidence,

but also hinders your ability to communicate freely and effectively. Take, for example, vocalists who are so anxious to make it through a song that they lose the focus of what they're singing about. There is no way they can communicate in a meaningful way. Well-rehearsed vocalists, on the other hand, are freed up to communicate convincingly. They don't become obsessed about their nervousness. They think less of themselves and more about the music. They are unfettered by insecurity. Contrary to the old adage, we don't practice to make perfect. We practice to enable artistic expression on the deepest levels.

If you think of practice as boring and unpleasant, I encourage you to change the way you go about it. Many teachers urge students to treat each practice session as an actual performance. Instead of mindlessly plodding through your repertoire, pretend you're in front of an audience. Be expressive. Create artistic moments in your practice room. Have fun.

I like the way jazz pianist and composer Danílo Perez describes his approach to practicing: "I go into my room and give thanks to God for this opportunity . . . I always ask God to help me to celebrate life when that moment of practicing comes."[24]

Even though preparation is vital, don't let it lead to paranoia. I remember times when I started to panic because I wasn't able to perform a section perfectly during warm-up before a performance. *Oh no! I didn't practice enough. I'm not ready!* Even though I had practiced conscientiously and done everything I possibly could to prepare, I was being done in by my own perfectionism. Artistic perfection, though, is not a reasonable objective for most of us. Doing the best you can under the circumstances you've been dealt is a much more reasonable goal.

In some cases, however, you can take charge of those circumstances. I remember, for instance, trying to help a singer who had lost his confidence. He was an extreme perfectionist and his own harshest critic. At one point in our conversation, he revealed, "The bottom line here is that I don't like the way I sound." In addition, he confessed that issues with his weight made him feel self-conscious. No wonder he lacked confidence—he didn't like the way he looked or the way he sounded.

His eyes lit up with hope when I told him his problems were fixable. "If you're unhappy with your sound," I said, "find a teacher or coach who can help

you improve your vocal tone. If you don't like your physical appearance, work with a trainer or dietician to help you shed a few pounds. And learn to dress in a way that de-emphasizes your problem areas."

Likewise, if the only thing standing between you and confidence is your physical appearance, put forth the effort it takes to look your best. If training is available to help improve what you consider your artistic weaknesses, sign up!

Replace Negative Voices with the Voice of the Good Shepherd

Like many artists, I was not born a confident person. I too battle insecurity and fear. When I was young, I often prayed, "Lord, help me to be more confident." One of the first things I sensed the Lord asking me to do was to stop listening to the negative voices in my head.

In the parable of the sheepfold, Jesus points out that there are destructive voices constantly vying for the attention of the sheep (John 10:1). However, the sheep listen only to the shepherd and ignore all other voices. They can tell which voice is his and they follow only his voice (John 10:4, 27). In the same way, we need to stop listening to those derogatory voices in our heads—the ones that say, "You can't do this. You're not good enough. You're going to fail." Those voices are not from God. God doesn't speak that way to his beloved. Instead, we need to listen to the voice of the Good Shepherd—the one who cares about us and extends to us unconditional grace, mercy, and love.

I first began to realize this just a few months after I accepted Christ. As a freshman on my high school baseball team, my mind was flooded with all sorts of negative voices as I stepped up to the plate to bat. The voices said, "You're going to let the team down. You're not strong enough. You can't hit a fastball."

Because I was a new believer, just crawling in the Spirit, the only prayer I could think of was, "Lord, help me." I hope this doesn't sound overly dramatic, but at that moment, I sensed him saying, "I'm here even on the baseball diamond . . . and by the way, keep your eye on the ball." He replaced the negative thoughts with encouraging ones and threw in some practical advice that allowed me to focus on the task at hand.

Ever since that day, whenever I'm hit with self-doubt, I look for those loving words mixed with some pertinent advice. I've come to recognize that voice as belonging to the Good Shepherd in my life. "I'm here for you . . . don't rush measure 49 and you'll be fine." "I'm here for you . . . play every note deliberately in that fast run and it'll sound clean." "I'm here for you . . . play legato with smooth bowing."

When I cry, "Lord, help me," and I sense God saying, "I'm here," it gives me peace. Then when he reminds me of some basic principles of performing, I am able to concentrate on what I'm doing instead of obsessing about how nervous I am. I start feeling the confidence David must have felt when he said, "With your help I can advance against a troop; with my God I can scale a wall" (Psalm 18:29).

Release Tension Before You Perform

To perform well, artists need to release tension and anxiety. I know professional musicians who have their own preconcert rituals to help them relax before going onstage. I'd like to share an easy exercise that has greatly benefited me, and it's one I've used with musical groups before difficult performances. It takes only a couple of minutes and it combines breathing and relaxation exercises, with a little positive visualization thrown in as well. You can do this sitting in the pew before you get up to sing or if you're standing backstage before a concert.

Step 1: Take one long deep breath. Inhale slowly through your nose and exhale slowly through your mouth.

Step 2: Relax your body. With your eyes closed, locate and relax any part of your body that feels tight. When I'm under stress the back of my neck gets stiff, so I always have to loosen my shoulders. Vocalists and actors might need to relax their throats. Instrumentalists might need to shake out their hands. Dancers might need to relax their leg muscles.

Step 3: Take another deep breath. Inhale slowly through your nose; exhale slowly through your mouth.

Step 4: Imagine the toughest part of your performance going well. Every piece has its challenges—that high note, that fast run, that intricate rhythm, that complicated dance move, that tricky line of dialogue. The toughest part is

any section of the piece that produces anxiety. Now close your eyes and imagine how you want that section to sound or look. If you're a musician, move your fingers or the muscles in your throat as you mentally play or sing that section. If you're an actor, listen to those difficult lines as if you were sitting in the congregation and hearing them for the first time. If you're a ballet dancer, visualize that fouetté en tournant and feel what it's like to execute it. Instead of obsessing over the toughest part of your performance, enjoy it being done well in your imagination.

Step 5: One last deep breath. Again, slowly in through your nose, slowly out through your mouth. Make this last breath count. Just because it's the last step, don't rush it.

Adapt this preperformance exercise to your needs. You can go through it in its entirety or just do parts of it. The important thing is to relax and gather your composure before you perform.

Perform Through Your Stage Fright

A voice teacher came to talk to me once about the paralyzing stage fright she experienced whenever she performed. She realized that a certain amount of adrenaline-producing nervousness was natural but said her anxiety was so traumatic that she missed notes, missed entrances, blanked on lyrics, and just stopped singing. She'd be trying to communicate a song about having God's peace and joy in her heart while feeling absolutely petrified. She tried to focus less on herself in an effort to "let go and let God," but then her lack of concentration caused her to lose her place in the music. She lost all confidence. She was like one of those ice-skaters you see every once in a while who falls during a competition and can't get up.

I told her what she, as a teacher, already knew: the best cure for stage fright is to keep getting up onstage and performing. The more experience one has in front of an audience, the less frightening it is. After our discussion, this voice teacher decided to invite some friends over on a regular basis and give small recitals. Whenever people or students stopped by, she asked if she could sing for them. Singing in a safer, smaller, more informal environment gradually increased her comfort level. Eventually she started to see herself as a competent performer instead of a spineless failure.

I used to experience a great deal of stage fright until I started asking, "What am I afraid of?" The answer always had something to do with me messing up and looking bad. This often prompted me to pray, "Lord, I certainly don't want to fall flat on my face, but if that happens I know you'll still love me and my friends and family will still love me. If that's what it would take for your name to be glorified, for your strength to be made manifest in my weakness, then so be it." I have yet to experience my worst nightmare come true onstage, but if I ever do, at least I know it won't be the end of me.

Draw Confidence from Your Calling

It's actually funny that I do a lot of public speaking, because back in the seventh grade, I had a problem with stuttering. Unfortunately, that was also the ill-fated year I contracted acute nearsightedness and buckteeth—the only cures for which were glasses and braces. I became Super Nerd overnight. On top of all that, my voice was changing. In the same breath, I could go from sounding like a three-hundred-pound defensive lineman to sounding like a pubescent female gymnast. As a result, I became deathly afraid of oral school reports, and suddenly my classmates and I seemed to be asked to give those at least once every week.

Hard consonants pose a problem for anyone who stutters, so on those occasions when I couldn't fake an illness, I'd go through my report and take out as many words as I could that started with a hard consonant. I remember one report I had to do was on the Bolshevik revolution. I was so worried about stuttering over the word "Bolshevik" that I couldn't sleep for days. The only way I was able to get through that little speech was to refer to the Bolshevik revolution as the "Russian revolution," a strategy that clearly irritated my teacher. But I didn't care. I was desperate.

Several years later as a youth pastor—with still no aspirations to do any public speaking—I found myself teaching God's Word in front of five hundred high school students every week. Now by God's grace (coupled with God's ironic sense of humor) I do a modest amount of public speaking all over the world. I can't help but wonder whether God first called others who were more gifted than I am to do this public speaking thing and they said, "No." So he had to settle for someone as unlikely as me.

I certainly recommend all that's at our disposal these days to help us deal with insecurities and fears. We can find real help as we read books about self-confidence, talk with a trained counselor, engage in worship, and memorize Scripture. Be patient with yourself, because growth in this area is a process. It takes time—and therein lies the challenge for an artist: while we're growing in self-esteem, how do we prevent insecurity and fear from interfering with our work? As we learned in this chapter's opening scenario, a rehearsal isn't the best time for us to work through our self-esteem issues. Yet the demands and the tension of a rehearsal setting can trigger fear and insecurity. So how do we stay attentive to this problem without being incapacitated by it?

Lose Yourself to Your Calling

According to Proverbs 3:26, "The Lord will be your confidence and will keep your foot from being snared." God can be our source of confidence because our adequacy is from him. Second Corinthians 3:4–6 says, "Such confidence as this is ours through Christ before God. Not that we are competent in ourselves to claim anything for ourselves, but our competence comes from God. He has made us competent as ministers of a new covenant." If I'm in rehearsal, about to perform, or about to speak and start to feel insecure, I can still choose not to respond that way. I often pray a quick prayer that goes something like this: "Lord, I'm feeling inadequate right now, but for some reason, you have called me to do this. You could have called someone else to play (or write, or speak), but for some reason known only to you, you have called me to do this particular task right now. So help me to do the best I can."

This prayer is not meant to suppress my feelings of inadequacy. I can deal with those feelings later. In the meantime, I have a job to do, a calling to obey, and that prayer helps me to shift the focus off myself and onto the task at hand. At that point the words of Paul often come to mind: "I thank Christ Jesus our Lord, who has given me strength, that he considered me faithful, appointing me to his service" (1 Timothy 1:12).

Singer-songwriter Michael Card offers the following account of his personal experience in this area:

> I have a concert looming in the near future. I go to the hall full of myself, thinking only of what people will think of me. I have everything to lose since

all that I am is riding on the success of the upcoming and as yet unrealized moment. As I begin to perform, the songs flow at first, but then as I play along, my mind starts to wander. "What are they thinking about me," I say to myself. Just then I learn the painful equation: thinking of yourself equals messing up.

Now let's look at the same example from another perspective. As I go into my concert I have a pretty good feel for my ability—that is, I know the truth of who I am in the whole scheme of things. I may not be the best musician in the world, but neither am I the worst. What does it matter anyway, since whatever gifts I have were given to me in the first place and are really not mine. So I can't lose. As I begin to play, my energy is not wasted on thinking of myself. The point of my playing is to present the message of the song, to "wash the feet" of the people or even God by faithfully playing my best with the ability I've been given. Now I become the beneficiary of another equation: to forget yourself equals the best possible performance.[25]

Go Forth in the Power of Your Calling

There is a painting I love that captures the power of God's call on our lives. The painting is titled *The Calling of Saint Matthew* by the Italian painter Caravaggio (plate 5). In this scene, Jesus calls Matthew, the tax collector, to follow him. The hand of Jesus reaches out to Matthew in the same way the hand of God reaches out to Adam in Michaelangelo's *Creation* painting from the Sistine Chapel. Jesus longs to connect with Matthew. The responses around the table are revealing. The man in the foreground reaches for his sword as if threatened. This prompts a rebuke from Peter, who stands next to Jesus. The young boy leaning on Matthew is in awe of the powerful presence of Christ. The two at the far end of the table are oblivious to the call; they're too busy counting their money to notice. My favorite response is Matthew's. The light of truth bursts into his life and he's humbled by the call. He gestures awkwardly, as if saying, "Who? Me?" He can't get over the fact that someone like Jesus is calling someone like him.

Notice that the calling occurs as Matthew and his friends go about their everyday lives. That's how it is for us too. We all have a purpose in life, a mission that we could call our primary calling. After that we are called to be Christ-followers in the everyday things God asks us to do. These secondary callings are just as important as our primary calling. As a husband, I am called

to love my wife as Christ loved the church (Ephesians 5:25). As a parent, I am called to provide and care for my children (Ephesians 6:4; 1 Timothy 5:8). We are called to be holy (1 Peter 1:16). We are called to always be ready to witness (1 Peter 3:15).

Romans 11:29 says, "God's gifts and his call are irrevocable." It's clear that our gifts and talents are part of our calling. For some of us, being an artist is our primary calling. For others, it's one of our secondary callings. Either way, always remember that you may be on the platform or in the spotlight because God put you there. That "special music" you're doing at next week's service really *is* special. It's part of your calling as an artist, so let that calling empower you to rise above your performance anxiety. Let it enable you to detach from those negative voices and to concentrate on the task at hand. Even if your art is created behind the scenes instead of performed publicly, like a writer or a painter, you too can draw strength from your calling.

Being faithful to the call means that when God asks us to do something, we "show up" in spite of how we feel about ourselves at the time. Whenever you use your talents, go forth boldly in the confidence of your calling. You really can do all things through Christ who gives you strength (Philippians 4:13). First Thessalonians 5:24 says, "The one who calls you is faithful and he will do it." That promise comes to mind whenever I sense the Lord calling me to do something for which I feel totally inadequate. "Who? Me, Lord? You want *me* to do that?" "Yes," God replies. "I'm calling you to do this and I will help you. Follow me."

Follow-up Questions for Group Discussion

1. In your opinion, what is the leading cause of insecurity among artists?

2. What's the nicest thing anyone ever said about your talent?

3. What was the most difficult thing you ever heard someone say about your talent?

4. How can your community of artists help each other deal with insecurity?

5. Do you ever sense insecurity holding you back as an artist? If so, when?

6. Does fear ever hold you back? If so, how?

7. What steps can you take to force you to stop listening to any negative voices that may be undermining your confidence?

8. What are some constructive words, pertinent to creating or performing, that you could use to replace those negative voices?

9. If you were to view your next opportunity to perform or create as a calling from God, how might that affect your confidence?

10. What are you doing to address any of the personal issues currently undermining your confidence?

Personal Action Steps

1. Schedule a thirty-minute practice session this week and treat that time as if it were a performance before a live audience.

2. Perform for your friends or family this week and write down what you learned from the experience that you can incorporate into your other performance opportunities.

3. Practice the preperformance exercise described in this chapter so you can use it the next time you perform.

4. Describe in detail, from preparation to execution, how a confident person would approach your next opportunity to perform or create.

5. Memorize Philippians 4:13 and record some ideas in your journal about how this truth can enhance your confidence.

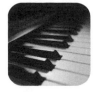
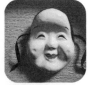

chapter seven:

Dealing with Your "Stuff"

Mattie noticed how many secrets she kept from William, so that he wouldn't see her as someone with a lot of problems. She wanted him to see her as someone with just a few pieces of colorful carry-on luggage, instead of multiple body bags requiring special cargo fees and handling.

Anne Lamott, *Blue Shoe*

For the past three years, a handful of faithful volunteers have met every Saturday night at Maple Street Bible Church to set up the sound and lighting equipment for Sunday morning services. Steven is their team leader. He recruited and built this Saturday night setup team, and he's proud of their camaraderie. Lately, though, he has noticed some problems brewing among team members.

During one recent evening, Steven had a church *Twilight Zone* experience. It began when he accidentally tripped on the stairs leading backstage. He hit his head on the railing, and although it was nothing serious—just a small bump— it seemed like from that moment on, he could hear not only people's words but also their thoughts and motives. Weird!

He first encountered Matt and Kristen who were in the middle of a heated argument about which microphone to use for the guitar amp.

"The SM57 sounds a ton better, a lot more natural. I don't know why you won't even let me try it. I'm mixing tomorrow and I think I should be able to use whatever I want." Steven not only heard Matt say these words to Kristen, but then he also heard Matt's thoughts: *Who does she think she is? I know what I'm doing, which is more than I can say for her. She has no idea what she's talking about. And why does she have to be so rigid all the time? She freaks out just because I don't do everything her way.*

"No, we need to stick to the sheet," Kristen argued. "Otherwise I'm gonna have to change everything, and it took me four hours to figure out our stage lay-out."

Steven quietly interrupted, "Kristen, how could it take four hours when this is the same layout we use every week?"

Kristen backpedaled. "Well, uh, I couldn't get my computer to draw the lay-out to scale, and then my hard drive kept freezing up on me." Steven then heard Kristen's thoughts: *Why is he questioning me? Doesn't he trust me? My computer did break down last month, and if I added up all the time I spent fixing it, I'm sure it comes to at least four hours. Besides, I'm the one who should be at the sound console, but instead I always get stuck doing these stupid stage layouts.*

Trying to ignore the thoughts he was hearing, Steven offered a solution. "Why don't we let Matt try the SM57s. We can use the AKG 414s for the extra percussion instruments. By the way, how do you guys like our new percussionist? I think he's fantastic."

"Yeah, I think so too," Matt said, trying to sound enthusiastic. "He's the best percussion player I've ever heard."

Kristen looked at Matt incredulously. *No, you don't,* she thought. *You told me last week how much you hate the guy's playing. You said he was too "busy" on the congas and he played the tambourine like he had the hiccups.*

"Oh, I see," Steven answered curiously. "So what did you think about his playing, Kristen?"

"I think he's pretty cool," Kristen eagerly offered. "He reminds me of some of the players I used to work with in the studio. They all loved working with me. They used to tell me I was the best sound engineer in the city."

"Yeah," Steven said, eager to move on, "this new guy has done a lot of studio work. He was telling me how complicated it is to lug his equipment from one session to the next. That reminds me, Matt, did you bring back the boom stands you borrowed for your band last week? We're going to need them today."

"Uh, yeah," Matt replied unconvincingly. *Oh man, I left them at home, and he told me if I did that again I couldn't borrow any of the church's equipment anymore.*

"Where did you put them?" Steven asked.

"Somewhere around here. They must be somewhere," said Matt.

"Matt, when you brought the stands from your car into the building, where did you set them down?" Steven asked.

"I don't know," Matt replied.

Steven pressed him further. "You mean you don't know where you set them down or you don't know if you brought them into the building?"

"Um, yes. No. Uh, I don't know," Matt stammered.

"Well, why don't you go get those boom stands from wherever they are and the rest of us will finish setting up," Steven said firmly.

"Okay," Matt said as he hurried out. Steven couldn't hear his parting words, but he did hear his parting thoughts. *"Someday when my band makes it big, I'll be famous and I won't have to set up equipment for anyone else. They'll be setting up for me. . . .*

As Steven and Kristen sorted microphone cables, Steven heard Kristen's thoughts loud and clear. *"Why do we all put up with Matt? He's so immature. I swear he does things just to get back at me. If I were in charge around here . . ."*

That night, Steven checked into a local hospital desperately hoping they could cure his "hearing" problem. He no longer wanted to know what those around him were thinking.

Questions for Group Discussion

1. What lies did Matt and Kristen tell?

2. What reasons might Kristen have for exaggerating how much time she put into the stage layout plan?

3. What motives might Matt have for telling Steven he loved the new percussionist's playing after telling Kristen the exact opposite?

4. Why did Kristen interject, seemingly out of the blue, how much the percussion players she worked with in the studio raved about her work?

5. Why would Matt cover up the fact that he left the boom stands at home?

6. What are some of Matt's and Kristen's personal issues that surfaced during this exchange?

7. What problems do you see unfolding for Matt and Kristen if they don't address those personal issues?

8. How would you propose they get started on that process?

9. Do you have any suggestions for Steven as to how he should deal with Matt and Kristen?

10. Do you believe our thoughts and motives stay completely hidden? Why or why not?

THE PURGING PROCESS

If we're intent on growing in character, at some point we have to deal with our "stuff." By stuff I mean the flaws and unhealthy tendencies we acquire while growing up that we carry into adulthood—what some refer to as "baggage." This baggage generates ulterior motives, alienates us from others, and eventually sabotages our work and our relationships. Without God's help, we are all on a collision course with our own baggage. I know a cellist who had worked up the musical ladder and was in the process of auditioning for one of the top orchestras in the world. Like many of us, this man battled insecurity, but instead of dealing with it, he turned to alcohol. He showed up drunk for his once-in-a-lifetime audition and, predictably, was turned down. His career never recovered.

Theologians use the word *sanctification* for the process by which we become more Christlike. Others call it discipleship, spiritual growth, or spiritual formation. Whatever we call it, it is quite clear that when we come to faith, we are not meant to remain stuck in immaturity. We're supposed to grow into the image of Christ (Colossians 3:10). Our character growth should never be an afterthought but rather something we should be diligent about (2 Timothy 2:15). Ephesians 4:15 encourages us to grow up "in all things."

Here's a question I think gets to the heart of the matter: What is different about you now that you're a Christian? One time I asked that question of someone who, with all sincerity, replied, "I no longer see R-rated movies." How sad that the only noticeable change this Christian brother could verify in his life was that he now avoided a certain type of movie. If our Christianity is defined by what we do (or don't do) instead of what God has done in our hearts, we will never be transformed people. So I ask you, what change in you can only be attributable to the work of God in your life?

The reason I'm asking is that some of us have been Christians for a long time, but we're not changed people. We may be more involved in church than we've ever been. We may be going to more Christian events and listening to more worship music than ever before. We may have been leading ministries for years. Yet we're still the same angry, discontented, unhappy, unfulfilled, unloving, lustful, selfish people we've always been.

Dealing with our stuff requires graduate-level character growth. That can be difficult because it deals with deeply ingrained tendencies we might even be

blind to. Some people know what I'm describing as the pruning process that Jesus refers to in John 15:2: "Every branch that does bear fruit he prunes so that it will be even more fruitful." Because it goes against the grain of who we've let ourselves become, the pruning process is often a catalyst for monumental change. For example, if you're an angry and bitter person, the Lord will strive to make you more loving and gracious. If you're a controller, the Lord might work in your heart to make you more trusting. If you are painfully shy and reserved, life may call for you to take initiative and be more assertive. The Lord might want to grow you up in these or any number of other areas.

Sometimes God uses his Word, among other things, like a divine scalpel. "For the word of God is living and active. Sharper than any double-edged sword, it penetrates even to dividing soul and spirit, joint and marrow; it judges the thoughts and attitudes of the heart" (Hebrews 4:12). Character growth this profound is going to feel like we're being purged. Indeed, God is working to purge us of our junk. It's like some diseased organ is being surgically removed. That's why this is the most difficult kind of personal growth—because a very unhealthy part of us is actually dying.

The passage that best describes this process comes from John 12:24. Jesus says, "I tell you the truth, unless a kernel of wheat falls to the ground and dies, it remains only a single seed. But if it dies, it produces many seeds." Jesus meant for us to die to self in such a way that we find true life in him. That's why he said, "But if you give up your life for me, you will find true life" (Matthew 16:25 NLT). Dying to self means God is purging us of our selfish and self-centered ways.

DYING TO THE RIGHT THINGS THAT ARE WRONG ABOUT YOU

A vocalist I know once announced she was giving up her singing ministry because God told her it was something she needed to die to. "Why would God do that?" I carefully asked her. "Why would God give you a talent and then tell you never to use it? Doesn't that contradict what Jesus teaches in Matthew 25, the parable that challenges us to steward our God-given talents?" She didn't answer, but she did confess she was a "hideously prideful person" and she blamed that on her singing. She scolded herself for her lack of humility and concluded the only way to deal with her spiritual immaturity was to give up her

vocal ministry. Surely that would prove to God she was serious about following him.

I suggested she might be running from a problem instead of facing it and that the Lord might want her to die to something other than her singing. It could be pride or her tendency to live for the approval of others. If she stopped singing, she might lose the best laboratory she had in which to examine and make changes in her life. I suggested that instead of singing solos, she sing backup for a while—or better yet, she sing in a large choir for a time. There, instead of being in the spotlight, her voice would be one of many. If she followed through with quitting, she might never resolve the deeper issues of her life. The lesson here is this: make sure you die to the right things that are wrong about you.

It's important that we understand what Jesus really meant when he talked about "dying to self." I've seen talented artists conclude that "dying to self" meant they should completely give up their art. Every one of them has ended up verifiably unhappy. The Lord may ask us to take a break from being on the front lines, or we may have to redefine ourselves as artists from time to time, but I've never believed God would ask someone to completely give up using a talent he gave them.

As we see in Philippians 2:5–7, Jesus is the supreme example of the self-emptied life. "Have this attitude in ourselves which was also in Christ Jesus, who, although He existed in the form of God, did not regard equality with God a thing to be grasped, but emptied Himself, taking the form of a bond-servant, and being made in the likeness of men" (NASB). Can you imagine what it would be like to be as unaffected by self-interest as Jesus was? Not to be preoccupied with self? To be at the point where you're no longer controlled by your own hidden agenda? To be unconcerned by self-preservation when making decisions? In other words, to be at the point where your stuff would not interfere with your life? Wouldn't that be nice?

Before we go any further, let's touch on a few things we should never allow ourselves to die to. There are some legitimate desires we should never stop hoping for or even fighting for. First, we should never die to our need for loving relationships. We were meant to live in community. We all prize that friend who "sticks closer than a brother" (Proverbs 18:24). In this day and age, when so

many people, even Christians, feel alone and alienated, we should never stop searching for meaningful friendships. Also, we should never forfeit our hope for a purpose-filled life. That's exactly the kind of life Jesus wants to give us, one that has meaning and purpose. He wants to give us something important to do so when we follow through, we can hear the Lord say, "Well done, good and faithful servant!" (Matthew 25:21). Lastly, we should never abandon our hope for the future. No matter how trying life might become, God assures us that there is always hope (Jeremiah 31:17).

THINGS TO LEAVE AT THE BAGGAGE CLAIM

At the root of a lot of our stuff are such issues as insecurity, fear, bitterness, anger, pride, and resentment. Let's look at ways these issues become the baggage we carry around until it interferes with (and sometimes ruins) our marriages, our friendships, our jobs, and our work in the church. This is hardly an exhaustive list, but these are examples of the baggage we artists in the church are most likely to exhibit—and that we most often need to be purged of.

Manipulating Attention (or "Someone, Please Notice Me")

Nobody likes to be ignored, but if we crave attention to the point where we manipulate others to get it, we become woefully self-absorbed. On the surface, it all may seem rather innocent. We just steer the conversation in a certain direction when, all of a sudden, we get stroked for some personal strength or achievement. I've done that knowing full well what I was doing—and I ended up hating myself for doing it. I was playing ego-satisfying mind games. I was setting myself up to be noticed. I was fishing for a compliment.

Acts 8 tells the story of Simon the Sorcerer. He was a man who craved attention. The Bible says, "He boasted that he was someone great, and all the people, both high and low, gave him their attention" (Acts 8:9–10). When he witnessed the breathtaking manifestations of the Holy Spirit, Simon wanted that kind of power so he too could wow the people and be the center of attention (vv. 9–10). He even offered to pay Peter and John for their spiritual power, but they rebuked him sternly and told him to repent (vv. 20–23).

When we manipulate attention, it's as if we're crying out, "Someone, please notice me!" This cry may take the form of name-dropping or exaggerating the

truth in order to impress others. Either way, the agenda is always the same— to upstage and redirect the attention to ourselves. It reeks of self-centeredness and exploitation. You don't have to be outgoing and gregarious to fall prey to the temptation to grandstand. The shy and reserved can be equally guilty; we're just more covert about it.

Grabbing attention is a misguided attempt to cure our loneliness and avoid feelings of alienation. You can tell how badly you hunger for attention by the way you react when you don't get any. That's why the Lord might continue to put us in situations in which we feel ignored and insignificant until we're forced to deal with this unhealthy tendency. If you sense the Lord trying to free you, let him have his way. Repent of your hidden selfish agenda to be noticed. "Each of you should look not only to your own interests, but also to the interests of others" (Philippians 2:4). Most often when we think we need attention from others, that's not what we need at all. We need to give attention *to* others.

Maneuvering for Approval (or "Someone, Please Like Me")

We all want to be loved and appreciated, but those who maneuver for the approval of others end up sacrificing their identities in the process. I've had a person or two in my life whose approval meant more to me than it should have. They became my Overly Significant Other. I overworked to impress them, altered my personality to please them, edited my words so as not to offend them, and reshaped my opinions to match their own. As a result, I could never really be myself around them, and the thought of letting them down paralyzed me.

Maneuvering for the approval of others always comes at a high price. Ananias and his wife, Sapphira, tried to impress Peter and everyone else by appearing to give a large donation to the church. They sold a piece of property and secretly kept a portion of the proceeds for themselves, but to gain others' approval, they claimed they were giving everything from the sale to the ministry. God was not pleased with their deception and struck them down dead (Acts 5:1–11). If that punishment seems harsh, keep in mind that the person who is constantly dying for the approval of others is never fully alive anyway.

It may be a strong temptation to misrepresent ourselves to curry someone else's favor. But when we pander for approval, we become "people pleasers."

Frequently that takes the form of committing to do something at church because we're afraid to say no. We can't bear the thought of disappointing our leader. People pleasers may avoid confrontation for fear of offending someone. They may withhold opinions because they don't want to rock the boat. When individuals aching for approval are in leadership positions, they are incapable of making wise decisions. They appear wishy-washy, and people soon lose confidence in their ability to lead.

Artists are especially susceptible to becoming people pleasers because we perform or create for an audience. The poet Samuel Johnson's words to those in theater apply to us all:

> The drama's laws, the drama's patrons give,
> For we that live to please, must please to live.[26]

Your self-worth will fluctuate constantly if it's dependent on the approval of others, but lasting self-esteem comes only from the one who made you. That's why Paul exhorts us to be God pleasers instead of people pleasers. "Obviously, I'm not trying to be a people pleaser! No, I am trying to please God. If I were still trying to please people, I would not be Christ's servant" (Galatians 1:10 NLT). Ephesians 6:7 (NLT) expresses that thought even more clearly: "Work with enthusiasm, as though you were working for the Lord rather than for people."

Holding Out for Validation (or "Someone, Please Tell Me I'm Important")

Often we artists desperately hunger for someone important to validate us— a certain leader, teacher, professor, colleague, critic, patron, or industry executive. We yearn for someone whose opinion we trust to tell us what we're good at so we can go about doing it. For too long I yearned for a noteworthy person to legitimize my manhood, my musicianship, or my leadership. *If they say I'm a good leader,* I thought, *then I will finally* be *one.* Until the "right" person waved a magic wand of validation over me, my feelings of inadequacy remained intact. Because I did not receive the validation I craved, I didn't lead well at all, even though I was serving in a leadership position. We all want to impact others and feel like we're playing a significant role. However, if we

withhold our time, talent, and energy until someone empowers us to play that role, we may miss it altogether.

As we discussed in chapter 6, those who constantly brag about themselves typically have an unhealthy need to feel important, and their grandiosity is usually a facade masking deep insecurity. On the other hand, most artists with validation issues go toward the other extreme. We withdraw and let people walk all over us. Ironically, often the people with validation issues already have the titles, the positions, the assignments, or the jobs, but they shrink back because they feel inferior. Like Moses, God calls them to do something, and they reply, "But, Lord, I'm a nobody. I'm not an eloquent speaker. I'm not qualified." They have all the ability needed to do a task, but they hesitate to act. If they're in leadership roles, they may be assertive one minute and shrink back the next.

Artists who have validation issues usually feel like they've missed their calling in life, like they settled for "second best" and there is something else they should be doing. They've lost sight of who they are, so they look for others to tell them. They are also apt to go into an emotional tailspin any time someone with greater talent is added to the team. They feel threatened. They're afraid of losing their place in the ministry because they're so deeply insecure.

Paul went out of his way to empower and validate Timothy. In his second letter to the young leader, he addresses Timothy as "my dear son" (1:2). He reminisces about Timothy's rich spiritual heritage, that his mother and grandmother were early converts of the first-century church as was Timothy (1:5). Paul then goes on to remind his favored disciple that Paul himself is the one who laid hands on him and commissioned him for ministry (1:6). It appears that Timothy lacked confidence (1 Corinthians 16:10–11), so Paul exhorts him to be bold: "For God did not give us a spirit of timidity, but a spirit of power, of love and of self-discipline" (2 Timothy 1:7).

If you have a mentor like Paul who gives you wings, you're fortunate. If you don't, you need not despair. Paul leads up to an even greater truth in this passage: the fact that our validation comes straight from God. After heaping large amounts of encouragement on Timothy, he writes that God has "saved us and called us to a holy life—not because of anything we have done but because of his own purpose and grace" (2 Timothy 1:9). God is the one who calls us to a life of purpose and meaning. Our validation, our empowerment, comes from

him. So keep seeking first his kingdom and he will provide your sense of purpose and accomplishment (Matthew 6:33). Meanwhile, don't hold back. Don't stand still. Move forward on whatever path the Lord puts you.

Controlling (or "Someone, Please Make Me Happy")

Controlling takes on various forms, but the end result is always the same. We coerce and manipulate to get our way instead of doing what the Lord wants us to do in his way. We mistakenly think we'll be better off, happier, doing things our way instead of God's. You can tell you're experiencing control issues by how you respond when things don't go as you wish. In Genesis 16, Sarah took matters into her own hands in an effort to acquire the child God had promised to her and Abraham. Trying to compensate for her old age, she coerced Abraham into sleeping with her young Egyptian maid, Hagar. Her scheme backfired miserably. When Hagar became pregnant and gave birth, Sarah became jealous, hated her, and treated her cruelly.

Jacob, Sarah's grandson, was a contentious, conniving controller. His name actually means "one who clutches or supplants." Jacob coveted the wealth and prestige his brother, Esau, was due to inherit because he was the firstborn. So Jacob conned Esau into trading him his birthright for a pot of stew (Genesis 25:27–34). Then little brother tricked their father, Isaac, into giving him the special blessing that should have gone to Esau (Genesis 27). On his deathbed, Isaac unknowingly assured Jacob abundant land and power. Unfortunately for Esau, the blessing was irrevocable. He had been trumped by Jacob once again. Throughout most of his life, Jacob attempted to finagle his own way, always looking out for himself above all else.

Since there are entire books written about this topic of controlling, I'll limit our discussion to the most common control issues experienced by artists involved in church work. Many of us encounter these issues when it comes to our work because we've invested a lot of time and energy into it. There's nothing wrong with having a high degree of ownership, but if it causes us to become defensive or close-minded, we're holding on to our talents too tightly. I'm referring to the bass player who insists on playing his own style even though it doesn't complement what the rest of the band is playing. Or the singer who rejects reliable advice about stage presence from her vocal coach because she's

convinced she knows better. Or the songwriter who responds to suggestions with, "How dare you criticize my work. I prayed about it, so this song is from God. How can I change something that was inspired by almighty God?" A response like that is a very heavy-handed attempt to control by shutting out the opinions of others.

A great deal of controlling is motivated by fear. We experienced something embarrassing or painful in our past, so we take matters into our own hands in an attempt to make sure we never again experience that kind of adversity.

Passive Resistance

Passive resistance is another common yet subtle form of controlling. This happens when people disagree with something they're asked to do, so they perform the task poorly. Or maybe they don't like the individual who made a request, so after they agree to do it, they do it only halfway, incorrectly, or not at all. This feeds their need to feel in control.

Jesus denounced this kind of deception in the parable of the two sons. "There was a man who had two sons. He went to the first and said, 'Son, go and work today in the vineyard.' 'I will not,' he answered, but later he changed his mind and went. Then the father went to the other son and said the same thing. He answered, 'I will, sir,' but he did not go. Which of the two did what his father wanted?" (Matthew 21:28–31). The second son clearly exhibits passive resistance behavior.

One time I watched a music director ask his piano player to play a specific riff at a certain point in a song. The pianist obviously didn't like being told what to play, so he purposely played the riff poorly. When somebody else in the band asked him why he was playing "that awful riff," he innocently stated that he was merely playing what the music director asked him to play.

Playing the Victim

That brings us to another example of controlling—playing the role of victim. Instead of taking responsibility for our actions, we blame someone else. If we make it sound like we had no other choice in the matter, how can anyone fault us? After all, we're just victims of somebody else's bad decisions or

actions. Sometimes, for instance, volunteers don't show up for something they knew was on the schedule because they "inadvertently" missed the call time. They might say something like, "I didn't know what time to come because no one called me." Of course, they themselves could just as easily have called to learn the start time, but they prefer to play the role of the neglected volunteer.

If you think of yourself as a victim, you will act like one. In our opening scenario, it's obvious that Kristen sees herself as a victim of the church's decision not to let her run sound. She harbors jealousy toward Matt because he is at the soundboard and she feels "stuck" carrying out her designated responsibilities.

The servant from Jesus' parable who was given only one talent tried to claim he had been victimized by his master. He said, "Master, . . . I knew you to be a hard man, so I became afraid and buried my talent in the ground." By making his boss out to be an intimidating, difficult man, the servant would have us feel sorry for him and even condone his irresponsibility with the talent he was graciously given. I've known some people who fell into serious sin and were quick to blame others for their bad decisions. Their spouse didn't meet their needs. Their friends didn't keep them fully accountable. Or the church overworked them. An experience of mistreatment is a poor excuse to mistreat others and a lame excuse for sin. Every one of us encounters difficult circumstances from time to time; life is tough. But that doesn't justify casting ourselves as victims.

THE GOODNESS OF THE LORD WILL PREVAIL

It's difficult to break free from our baggage because it's been with us for so long, we actually think we need it. We're afraid we can't live without the attention, the approval, the validation, and the control we crave. So when the pruning process challenges the validity of these cravings, we feel threatened. When purging is at its worst, we may wonder, *Where is God in all this?* But God never abandons us. Jesus said, "I am with you always" (Matthew 28:20). So instead of asking, "Where is God?" it might prove more helpful to ask, "Who is God?" That's because our concept of God determines how well we navigate the turbulent waters of the purging process.

A friend had several instances when he lost his temper at work, and it eventually cost him his job. Because he figured God was punishing him, this man went into penance mode, getting more involved in church and trying to talk and act more "spiritual." Meanwhile, the depression causing his anger raged on unattended. His arduous efforts to get back into the good graces of God stemmed from his jaded concept of God. If there was trouble in his life, he thought God must be mad at him. Therefore, he figured, God must somehow be appeased.

That's not at all how the God of the Bible operates. He may allow us to experience the consequences of our baggage in order to get us to deal with it, but the pruning process is not God's way of punishing us. If we think God is against us or out to get us, we are less likely to cooperate with his work in our lives. If we see God as *for* us and on our side, we are able to view the purging process as an opportunity for personal growth. That's why it's crucial that our concept of God be biblically accurate.

Our God is first and foremost loving and merciful. Isaiah 42:3 says, "A bruised reed he will not break, and a smoldering wick he will not snuff out." Whenever you are hurting, God is there for you. Whenever you feel emotionally raw, he cares about what you're going through. Be assured that every effort God makes to conform us into the image of Christ is done out of love. Proverbs 3:11–12 (NLT) says, "My child, don't ignore it when the LORD disciplines you, and don't be discouraged when he corrects you. For the LORD corrects those he loves, just as a father corrects a child in whom he delights." The Lord disciplines us for our own good (Hebrews 12:10). He is also a gracious God who can bring good out of the worst of circumstances (Romans 8:28) to accomplish something significant (Genesis 50:20). He can be trusted. The psalmist wrote, "I would have despaired unless I had believed that I would see the goodness of the LORD in the land of the living" (Psalm 27:13 NASB). No matter how stressful the purging process gets, know that the goodness of the Lord will always prevail.

HOW TO COOPERATE WITH THE WORK OF GOD IN YOUR LIFE

Early in my ministry, I was rudely awakened to the fact that I carried a lot of baggage. It affected my leadership, my decisions, and my relationships.

Ministry is already full of adversity, and my stuff made it worse. It threatened to demolish the very ministry I worked so hard to build. After barely surviving my first few ministry hardships, I realized I couldn't control what circumstances would make of my life, but I could control what they would make of me. Although I still have not jettisoned all my baggage, now I realize God is not only trying to do ministry *through* me, but trying to do ministry *in* me as well. Ephesians 2:10 (NLT) says we are "God's masterpiece." We are his *masterpiece*. My fellow artists, let's make sure we don't get so caught up in creating works of art that we neglect the work of art God is making of us.

The way you and I respond to adversity determines whether we grow from it or are defeated by it. The best way to respond to the purging process is to give the Lord your full cooperation. God is in control. He can be trusted and he cares about you, but he does his best work in those whose hearts are willing and yielded. The French mystic Jeanne Guyon wrote, "The purest love you can ever know is that love which comes to you when the Lord is working on your soul. So let *him* work."[27] The older I get, the more I realize transformation is not something I do; it's something God does in me when I get out of his way.

At any given moment—whether or not we realize it—nearly every one of us is going through some kind of purging. So let's briefly analyze the various stages of that process and draw some conclusions about how we can cooperate with our heavenly Father's efforts to mold us into the people he wants us to be.

The Painful Beginning

The purging process starts with an intense period of introspection and self-examination that's often prompted by some sort of conflict. Romans 5:3–4 says, "Suffering produces perseverance; perseverance, character; and character, hope." The process ends with proven character, but it starts with some kind of trial, frustration, failure, or pain.

In my early twenties I was discipled by an older man who was very wise. One time, in my youthful exuberance, I said to this seasoned man of God that more than anything else in the world, I wanted to be transformed into the image of Christ. His reply took me back. He said, "Good, I'll be praying that the Lord allows a lot of difficulty in your life, because that's the only way you're going to

grow in godly character." That didn't deter me, but it did wake me up to the reality that spiritual growth can be painful.

What's distinctive about the purging process is that it brings some sort of personal flaw to the surface. You may have a run-in with someone, heated words are exchanged, and you're left wondering if any of the negative things he or she said about you are true. Or you get passed over for some promotion or opportunity because some people find working with you to be unpleasant or difficult. Perhaps conflicts at church are causing deep-seated insecurities and anger to emerge. Or maybe you can't even put a finger on why these things are happening. You sense, though, that you need to take a long, hard look at yourself. Even more important, you sense God's hand may be in this, trying to shape your character.

Don't Harden Your Heart against the Lord

If you deny you have a problem when all the evidence proves otherwise, you will short-circuit the purging process. If somebody points out a personal foible, be open-minded. Believe me, I know that's easier said than done. I can be just as defensive as the next person, but being defensive always impedes growth. The Lord says, "I will instruct you and teach you in the way you should go; I will counsel you and watch over you. Do not be like the horse or the mule, which have no understanding but must be controlled by bit and bridle or they will not come to you" (Psalm 32:8–9). If the Lord is working on your character and you act like a stubborn mule, you end up fighting God. Isaiah says, "Destruction is certain for those who argue with their Creator. . . . Does the clay dispute with the one who shapes it, saying, 'Stop, you are doing it wrong!'" (Isaiah 45:9 NLT). When someone detects a possible flaw in you, embrace the possibility that God might be using this revelation to help you deal with your stuff.

Instead of getting defensive, consider if there is any truth—no matter how small—to what has been said. Ask yourself, "Is there anything about me that needs to change? What am I doing or saying that is contributing to negative opinions about me?" Invite the Holy Spirit to take a character inventory like David did in Psalm 139:23: "Search me, O God, and know my heart; test me and know my anxious thoughts. See if there is any offensive way in me, and lead

159

me in the way everlasting." If the Lord convicts you of any sin, be sure to turn away from it. In Revelation 3:19 God says, "Those whom I love I rebuke and discipline. So be earnest, and repent." Repentance is one of the best ways you and I can cooperate with God's plan to grow us up.

Sometimes we're offended by how someone approaches us and we accuse them of "bad process." "If only they had approached me this way instead of that way, I would have listened," we reason. This is clearly a defensive maneuver. Instead of facing our shortcomings, we change the subject and shift the blame to someone else. If we dismiss criticism unless it's delivered in a certain way, we will end up dismissing all criticism. That's because life does not come with a "good process" guarantee. It is unrealistic to expect people to word something in exactly the way we'd like to hear it.

There is a fellow in the Bible named Shimei who accosted King David as he fled from the murderous intentions of his son Absalom. Shimei threw stones at David, cursed him, and insulted him. One of David's men wanted to go after Shimei, but David restrained him. He said, "Leave him alone; let him curse, for the LORD has told him to. It may be that the LORD will see my distress and repay me with good for the cursing I am receiving today" (2 Samuel 16:11–12). David's response is a galvanizing example of nondefensive humility. Shimei's accusations were all false, but David didn't retaliate. He listened just in case God was trying to say something to him through those accusations. If he wasn't, David figured the Lord would vindicate and reward him for at least being open to God's work in his life.

A fellow leader once told me I can sometimes be too intense and that my intensity makes those I work with uncomfortable. When he mentioned that there were several others who also felt I had a problem, in this area, I was embarrassed. I was tempted to blurt out, "If this is such a problem why didn't all these other people do a Matthew 18 and come and talk to me about this?" In a rare moment of clearheaded thinking, however, I restrained myself. I'm glad I did. Perhaps others should have come to me, but this was not easily definable as a Matthew 18 type of offense. No one felt sinned against, yet my intensity was still having a negative impact on those around me. Besides, the very problem people experienced with me made it difficult for them to approach me. After all, who would look forward to confronting an overly

intense person or a hypersensitive person or someone who's angry or controlling? If I had taken issue with the process, I would have missed the *real* issue, which was my inappropriate intensity.

Be Teachable, Not Defensive

One time I had to confront a ministry leader about his tendency to control people and situations. His controlling leadership style hurt his ministry and alienated him from his people. I agonize over these types of conversations, so I prayed long and hard during the days leading up to our talk. But my friend amazed me with his openness. After hearing me out, he said, "Thank you. It must have been hard for you to tell me this. I'll certainly take what you're saying to heart and give it serious consideration. I probably have a blind spot in this area. Can you tell me some of the things I'm doing or saying that come off as controlling?"

My friend's response is a great example for all of us to follow. It reminds me of the words of Jeremiah, "I know, LORD, that a person's life is not his own. No one is able to plan his own course. So correct me, LORD, but please be gentle. Do not correct me in anger, for I would die" (Jeremiah 10:23–24 NLT). Try to be open-minded when someone confronts you about a flaw.

Recently a worship leader friend took a position with a new church. Eager to get off on the right foot—and knowing he had made some mistakes with his previous congregation—he asked me, "Is there anything I need to change about myself as I start this new ministry?" With a humble attitude like that, I know God is going to use that young man in a mighty way. Second Chronicles 34:27 reminds us that when we are tender before God, he hears us. "Because your heart was responsive and you humbled yourself before God when you heard what he spoke . . . I have heard you, declares the Lord."

The Wrestling Period

After the initial self-awareness comes the wrestling period. This is the hardest part, and sometimes things get worse before they get better. You may encounter more conflict instead of less. Remember, this is long-term character growth that involves deep-seated life issues. It is a journey, a process. Being delivered from our stuff takes time. One issue may come up so often that you

start feeling you'll never escape it. This is sometimes God's way of keeping the issue on the front burner so we can't run from it. You may also feel needy at this point. You are, and if that feels uncomfortable, the purging process will cure you of your pride and self-sufficiency.

During this phase we may pray about the issue, search Scripture, seek out counseling, talk to a close friend, or all of the above. Anything and everything we do at this point is helpful, but our sanctification is more in God's hands than in our own. The purging process is not a self-help approach to transformation. In fact, you don't control it. You don't even initiate it. God does. So rest assured that "he who began a good work in you will carry it on to completion" (Philippians 1:6).

Keep Checking Your Motives

Once when speaking to a small group of sharp, artistically minded young people, I asked whether they had ever dealt with issues like stage fright, self-doubt, or trusting God. They clammed up. The more we talked, the more I realized they didn't know how they felt about these things. Yet when I asked how we should resolve some of these issues, they were quick to offer a Bible verse or a pat answer. It was clear they knew all the right Christian answers but had never asked themselves the right questions.

Scripture encourages us to keep checking our motives (James 2:4; 4:3). During the wrestling stage, it is crucial to ask questions that bring to light any ulterior motives. These include questions like: Am I behaving a certain way because I'm trying to be noticed? If you're aching for approval, keep asking yourself why the approval of others is so important to you. If you seek validation and empowerment, ask yourself: Is there any part of God's will I'm not accepting or obeying? Ask yourself if any of your most recent words and actions were meant to control people or circumstances. Avoid getting stuck in endless rounds of introspection, but keep probing your thoughts and motives.

Don't Give Up or Run Away from Your Problems

At this point you'll be tempted to give up. That's the worst thing you could do. We need to hang in there and wrestle with our character issues. Second Corinthians 4:16 says, "Therefore we do not lose heart. Though outwardly we

are wasting away, yet inwardly we are being renewed day by day." Never give up too soon on the purging process. We need to have the persistence of Jacob. He didn't stop wrestling with God until he had the blessing he sought (Genesis 32:24–32). Likewise, Paul encouraged young Timothy to persevere when things got difficult. "Timothy, my son, I give you this instruction in keeping with the prophecies once made about you, so that by following them you may fight the good fight" (1 Timothy 1:18).

I once heard a pastor misuse this verse as his personal battle cry during a dispute with his elder board. To him, "Fight the good fight" meant he could intimidate, bully, and antagonize anybody who disagreed with him. Because he had a blind spot in this area, he couldn't see that his stuff was ruining his church. Later, in Paul's letter to Timothy, Paul repeats the admonition to fight the good fight, but this time it follows a passage that urges Timothy—and us— toward deeper character transformation. "But you, Timothy, belong to God; so run from all these evil things, and follow what is right and good. Pursue a godly life, along with faith, love, perseverance, and gentleness. Fight the good fight for what we believe. Hold tightly to the eternal life that God has given you, which you have confessed so well before many witnesses" (1 Timothy 6:11– 12 NLT). You can't acquire the godly traits that are listed in this passage without wrestling with your issues. So when it comes to building your character, fight the good fight.

It is at this point that sinful pleasures can become most appealing. You might be tempted to overeat, abuse alcohol or drugs, or engage in illicit sex. You might be tempted to change churches or to purchase something you think will make you feel better. When you're so close to a breakthrough, this is no time to run away from your problems. Your brokenness is stirring up a hunger for God. Don't substitute escapist behavior for the real thing. It only numbs you to the pain God is using to transform your soul.

A New You Emerges

The tricky thing about the purging process is that there is no clear finish line. Instead of an end point, there is noteworthy progress along the way. Instead of one big triumph, there are small victories that shift the momentum of the battle your way. But it's clear that a "new you" is emerging. God is putting a

new heart and a new spirit within you (Ezekiel 36:26). Your identity is becoming more focused as you gain greater clarity about who you are and why God put you here. It's the ultimate "lose your life to find it" miracle. As illustrated so often in Scripture, death brings life. Proverbs 6:23 points out that the disciplines of God are not only part of life, but "the way to life."

You will also begin to see blessings emerge from your perseverance (James 1:12). One day you find yourself in a conversation and when you are tempted to manipulate the discussion to highlight yourself, you don't do it. Or you realize you can express disagreement with someone whose approval is important to you without worrying whether or not that person will still accept you.

You may come to the point someday where all the validation you need is in a Bible verse. Instead of controlling others, you notice yourself trusting God more. You become strengthened in your inner being (Ephesians 3:16). Your baggage may still be there, but it doesn't have as tight a grip on you as it used to. While you agonized through all the painful growth you were forced to endure, another layer of maturity was quietly woven into the fabric of your character. You will undoubtedly agree with the psalmist who wrote, "It was good for me to be afflicted so that I might learn your decrees" (Psalms 119:71).

Truly Humble

One result of the purging process is that you are humbled. You realize your talent, your ministry, and your life aren't all about you anymore. Gratifying your ego won't be the blind ambition it once was. During his wrestling match with God, Jacob was struck on the thigh. From that day on he walked with a limp. He was humbled. He looked at life differently. He looked at people differently. The same little brat of a kid brother who cheated, lied, and manipulated to get what he wanted had now experienced genuine life change. After his wrestling match with God, Jacob met up with his old nemesis of a big brother, Esau, and said to him, "To see your face is like seeing the face of God" (Genesis 33:10). How's that for a change in attitude? Jacob was finally purged of his need to control and supplant.

Humility challenges us to be less dominated by self, which enables our stuff to become less of a distraction. Kathleen Norris uses the word "detachment" to describe this emptying of self:

The word "detachment," valued by early monks as a virtue, has almost lost its positive connotation. Nowadays it is most often used in a negative sense, to mean the opposite of a healthy engagement with the world, and with other people. It conveys a sense of aloofness, a studied remoteness that signifies a lack of concern for others. The monastic interpretation of "detachment" could not be more different: in this tradition it means not allowing either worldly values or self-centeredness to distract us from what is most essential in our relationship with God, and with each other. One sixth-century monk, Dorotheus of Gaza, describes detachment as "being free from [wanting] certain things to happen," and remaining so trusting of God that "what is happening will be the thing you want and you will be at peace with all."[28]

The purging process detaches us from our stuff so we finally can be at peace with ourselves and with those around us.

Celebrate the Work of God in Your Life

After Jacob wrestled with God, he was given a new name, a new identity; one that embodied the assurance that the promise God had made to Abraham and Isaac was also extended to Jacob (Genesis 32:28). The promise was that God was going to make a great nation of this family and that the world would be blessed through them. Jacob's new name was Israel, which is the name by which that nation is known even to this day.

As in the case of Jacob, there are numerous instances recorded in the Bible in which someone was given a new name, a new identity as a result of God's movement in their life. Abram became Abraham, Sarai became Sarah, Simon became Peter, and Saul became Paul. Jesus nicknamed two of his disciples, James and his brother John, the "Sons of Thunder." Isaiah confirms that when the Lord does a great work in one's life, "you will be called by a new name that the mouth of the Lord will bestow" (Isaiah 62:2). I'd like to suggest that we give each other edifying nicknames whenever we observe significant changes or growth in our lives. A nickname that captures the essence of what God has done in our lives serves as a constant reminder of how the Lord sees us. It can also prevent us from reverting to our old self.

I met a woman at a worship conference who shared a significant breakthrough she had recently experienced. Growing up, she had been told she was

stupid and was constantly made to feel that way. As an adult, she decided to wage war against the lifelong self-esteem battles she'd endured by enrolling in a nursing class. She worked hard, overcame her lack of confidence, and earned an A-minus. She discovered she wasn't stupid after all. In fact, a totally new identity emerged. She became increasingly more confident and capable. A bunch of us were so moved by her story that we gathered around her, prayed for her, and sealed her new identity by giving her a new name. We gave her the nickname "Bright Flower." The word "bright" was meant to convey the double meaning of "intelligent" as well as "radiant," and the word "flower" emphasized our confidence that she would bloom wherever God planted her.

James 1:2–4 (NLT) says, "Dear brothers and sisters, whenever trouble comes your way, let it be an opportunity for joy. For when your faith is tested, your endurance has a chance to grow. So let it grow, for when your endurance is fully developed, you will be strong in character and ready for anything." I used to think that the first part of that passage was too hard to swallow. How can anyone be expected to be joyful in the midst of trials? Now I see that James's focus is on the end result. Our joy and our hope are in the confidence that the Lord uses the trials we face for our own good. He uses them to complete his work in us. He brings us to fuller spiritual maturity and we become people of character because we persevered through the pruning process.

Follow-Up Questions for Group Discussion

1. What is different about you now that you're a Christian? Or, putting it another way, what change in you can only be attributable to the work of God in your life?

2. Is there anything you've done recently to intentionally set yourself up to be noticed?

3. Can you identify anyone whose approval meant so much to you it proved to be unhealthy?

4. Is there any area of your life in which you have been waiting to be validated? Describe how waiting has affected your assertiveness and your confidence.

5. Can you think of areas in your life where it's especially difficult when things are not done your way?

6. What are some Scripture verses that one might find comforting on the journey through the purging process?

7. Have there been any negative things said about you lately? Did you discern any truth, no matter how small, in that negative feedback?

8. Do you see any tendencies in yourself that would make working with you or getting along with you a challenge?

9. What is it about you that needs to change in order for you to be all that God wants you to be? (For starters, check out the list of the fruits of the Spirit in Galatians 5:22–23).

10. What insights jump out at you from the scene in which Jesus gave Peter a new name and identity? (See John 1:40–42 and Matthew 16:18.)

Personal Action Steps

1. Isaiah 28:23–29 contains an analogy that compares the work of a farmer to the work God does in our lives. Meditate on this passage and write down insights about building character and the role God plays in our spiritual growth.

2. Consider whether the Lord might be asking you to die to something that is inhibiting your spiritual growth. Pray a prayer of submission, asking the Lord to purge you of whatever stands in the way of becoming the person he wants you to be.

3. Discuss with a trusted friend what you sense the Lord is doing in your life. Ask this friend to pray for you and keep you accountable to your commitment to personal growth.

4. Is there anyone in your life who has gone through a significant spiritual breakthrough? Think of a suitable nickname that captures the essence of the new identity emerging from this breakthrough.

5. Find a piece of art, or create one, that reflects your journey through the pruning process.

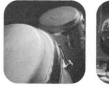

chapter eight:

How to Survive as a Leader in the Church

Afterwards, I stood at the door, shaking old
hands, acting the role of pastor as the elderly
filed out into oblivion, and I was certain God sat
on my shoulder, proud and impressed, though
of course now I know it was a different pres-
ence at my shoulder, and the only one proud
was me.

What impresses God, I wonder?

Probably not much.

Jeff Berryman, *Leaving Ruin*

Scene opens with Tom and Sharon in the kitchen on a Monday morning. Sharon is dressed for work and is eating a bagel over the kitchen sink. Tom is sitting at the table, in his sweats, reading the classifieds.

Tom	Honey, here's one. *(Reading)* "Drivers, OTR, Class A with two to five years' experience and clear MVR for expanding LTL carrier."
Sharon	Tom, that's driving a truck.
Tom	I know.
Sharon	And you need two to five years' experience.
Tom	I can drive, can't I?
Sharon	Yeah, you can drive a '95 Toyota Corolla. Besides, you don't have a license.
Tom	I could get one. *(Playfully)* Never underestimate a man who's driven to succeed, my dear. No pun intended.
Sharon	*(She smiles and nods.)* Why do people always say, "No pun intended," when they intend one?
Tom	*(Shrugging)* I dunno. What does OTR and MVR and LTL stand for anyway?
Sharon	Well, if you don't know the lingo, that's probably not a good sign.
Tom	Yeah, you're right. *(Reading)* What's a "collections" job? Is that anything like taking an offering?
Sharon	No.
Tom	*(Reading)* "Customer relations." *(Apprehensively)* That isn't working with people, is it?
Sharon	Yeah, a lot of angry people.
Tom	Rule that one out.
Sharon	Tom, how much longer are you going to do this?
Tom	Oh, just a few more minutes. I have a meeting with Pastor Bob—
Sharon	*(Interrupting)* No, how much *longer* are you going to do this? Every morning you scour the classifieds and you get all excited about one or two "possibilities," but you never follow up on any of them, do you?
Tom	Well, I'm busy all day. Besides, I don't want to call from my office when I'm supposed to be working on church stuff and have someone walk in on me. Here's one. *(Reading)* "Health care activities aide."
Sharon	Huh?

Tom	No, listen to this. "We have full-time opportunity for a spirited individual to lead social, recreation, and therapeutic activities (games, sing-alongs, and so on) for dementia unit residents." That's pretty close to what I do now.
Sharon	*(More serious)* Tom, I hate seeing you like this. You hate your job. You're not excited about the church any more. Saturday—your one day off—you mope around all day, and every Sunday you come home ready to quit.
Tom	Sundays are tough.
Sharon	I know. That's what I mean. I can't stand to see you like this, honey. Remember your first year? You used to jump out of bed and you couldn't wait to get to church.
Tom	Those days are long gone, aren't they?
Sharon	I found your letter.
Tom	What letter?
Sharon	I believe it's your resignation letter. I found it on the computer. It starts out, "Dear Pastor Bob and the Board of Elders, I hereby resign my position at the church. . . ."
Tom	*(Interrupting)* That was the second draft—the kinder, gentler version.
Sharon	Tom, are you really quitting this time?
Tom	I don't know. . . . I'm really confused. I don't know if the church is the problem or if I'm the problem. But if I get out of ministry, what else would I do? The economy isn't so great right now. It's not a great time to be job searching, ya know.
Sharon	*(She's moved closer to him. While holding a cup of coffee in one hand, she sympathetically puts her other arm around Tom's shoulders.)* Honey, whatever you want to do, let's do it. I just want you to be happy. If you need to make a change, we'll be okay. Even if it gets tough for a while, we can get by. We've been out on a limb before. *(Warmly and a bit playfully)* Remember, you always said that the term "starving artist" was redundant. *(He smiles, nods, and puts his hand on top of her hand.)*
Tom	You're right. I know. I can't keep doing this. I gotta do something or I'm gonna go crazy. *(He gets up abruptly.)*

Sharon	*(Sounding a bit worried)* Where are you going?
Tom	*(Picks up his cell phone and starts to dial)* You're right, it's about time I do something about this. I'm calling Pastor Bob.
Sharon	You're going to quit just like that over the phone?
Tom	*(Laughs)* No, I'm gonna call in sick.
Sharon	But you're not sick.
Tom	Doesn't being sick of your job count? I'm gonna stay home and fast and pray about our future.
Sharon	All day?
Tom	*(Joking)* Well, at least until lunch. *(More serious)* I don't know if I'll have an answer by the time you get home from work, but I promise not to be mopey.
Sharon	Good. *(While standing by the table, she's now looking at the classifieds.)* Hey, this one sounds good. How come you didn't circle it? *(Reading)* "Make $50,000 a year on your own time. Easy sales position. Product sells itself. No experience necessary."
Tom	Oh, that's selling encyclopedias.
Sharon	No kidding. How do you know?
Tom	I called that one yesterday.

End

Questions for Group Discussion

1. How common is Tom's situation?

2. What makes leading a ministry difficult?

3. Whether or not you're a leader, in what ways do you identify with Tom's story?

4. What advice would you give Tom?

5. How is this affecting Sharon? What do you think life is like for the spouse of a leader in the type of crisis Tom is in?

6. What advice would you give Sharon?

7. What, if anything, makes being a leader in the church different from being a leader in other arenas, such as the business world?

8. In your opinion, what does it take to be a successful leader in the church today?

9. What leaders, inside or outside the church, have impacted you most? What was it about them that affected you so deeply?

10. Do you know any ministry leaders who are going through a difficult time? What can you do to help?

THE PERILS OF LEADERSHIP

A music director in his early twenties sat despondent in my office. After three years in church work, he'd had enough. He was frustrated and angry and he wanted to quit. I listened and gave what little advice I could think of, then we prayed together and agreed to stay in touch. Fortunately, this young man overcame his discouragement and is still going strong in ministry. But we nearly lost him. The point is not that this kind of thing happens but how frequently it happens. Judging from the phone calls, letters, and emails I get, there is a crisis among arts ministry leaders today. Many are discouraged and beaten down. Some are on the verge of burnout or breakdown.

I suspect that Satan's main strategy to defeat leaders is to get us to quit. Years ago I attempted to start a network of church music directors. I selected eight sharp and successful leaders, and we resolved to touch base on a regular basis

to encourage each other. Less than a year later, all but one had left the ministry. The two most prominent reasons for their departures were the difficulty of the job and the adversity that accompanies church work.

Overworked and Understaffed

Leading an arts ministry, or any segment of it, is one of the hardest jobs in the church. Whether you do it full-time or part-time, as a paid staff member or as a volunteer, it is an extremely demanding and stressful position. If it were easy, anybody could do it. But it is far from easy. Many of us are overworked, routinely putting in sixty to seventy hours every week. Marriages suffer. There is little or no time for families, friendships, solitude, or replenishing diversions or hobbies. And because ministries are usually short on everything—staff, finances, volunteers—ministry leaders are often spread way too thin.

In addition, working with people can be extremely demanding. As leaders, we're heavily involved in the lives of our volunteers—shepherding, counseling, and discipling. When they have a need, we're always on call—even if it's in the middle of the night. In addition to our primary responsibilities, it's not uncommon for churches to ask arts ministry leaders to also lead areas outside the arts. I know one music director whose job description includes doing research for the pastor's sermons, and another who serves on the church's elder board.

Under Pressure

Crafting weekly services puts leaders under constant pressure to be fresh and creative every seven days—that's a prescription for burnout right there. I recently spoke with a music director who was about to retire after thirty-four years of faithful ministry. He sounded weary from the week-to-week grind we're all on. "Take Christmas, for example," he said. "After doing thirty-four pageants, I'm completely out of ideas. It's time to move on."

Not only that, but the more successful you are, the higher the expectations become. Achieving excellence is always hard work. After knocking yourself out for a special Easter service, someone invariably says, "I don't know how you're going to top that next year." You want to strangle them, don't you? *Next year? Who can even think about next year after we've just completely exhausted ourselves doing this year?*

Opposition

Another ministry difficulty is that every great work of God faces opposition. When Ezra set out to rebuild the temple in Jerusalem, the surrounding neighbors tried to discourage him and frighten his workers. They even hired consultants to thwart the building plans and took legal action against Ezra (Ezra 4:4–6). When you're doing something great for God, expect obstacles.

Artists in the church also face their share of opposition. Because people's response to the arts is subjective, not everyone in the congregation appreciates what the artists do. On occasion, the arts can even be controversial, prompting open antagonism from volunteers, church members, the elders, or even your pastor. Music styles alone have been known to split congregations. All these factors can affect the leader's approval rating. And you're in good company when that happens. Johann Sebastian Bach, whom many regard as the quintessential church composer, if not the father of church music, faced his share of disapproval. When Bach's church in Leipzig first performed his masterpiece, *The St. Matthew Passion*, a rich baroness hated the music so much she filed an official complaint with church leaders and threatened to withdraw her financial support. Church leaders scolded Bach and told him to "tone down the dramatic quality" of his music. Then they banned *The St. Matthew Passion* from their church.

LEADERSHIP PRINCIPLES FOR ARTISTS

The apostle Paul understood how trying ministry can be. His words in Galatians 6:9 are an encouragement not to lose heart: "Let us not become weary in doing good, for at the proper time we will reap a harvest if we do not give up." I once tried to console a disheartened young worship leader who was facing ministry problems. When I shared similar incidents I had faced, he felt less alone. Toward the end of our visit, he said, "Just knowing you're still in ministry after all these years, and after all you've been through, gives me hope that maybe I can make it through this." I found it interesting that far from anything I may have accomplished as a leader, he was more impressed that I was still standing after all these years of toiling in the trenches of church work. And they haven't been easy years. Maybe that's why I resonate so deeply with Paul's fighting words in 2 Corinthians:

Therefore, since through God's mercy we have this ministry, we do not lose heart. . . . We are hard pressed on every side, but not crushed; perplexed, but not in despair; persecuted, but not abandoned; struck down, but not destroyed. (2 Corinthians 4:1, 8–9)

This chapter is written for leaders, and that includes everyone who fulfills a leadership function on a ministry team, whether or not you are a paid staff member or have an official title. Perhaps people look to you as a leader because you're knowledgeable, capable, or have long ministry experience. You may even be a leader by default because no one else is stepping forward to take charge! Whatever the case, always be on the lookout for ways to grow your leadership skills. You owe it to the people who follow and look up to you.

All leaders are role models. We are example-setters. So we need to live the kind of lives we ask our followers to live—lives they would want to emulate. Paul said, "Join with others in following my example. . . . Whatever you have learned or received or heard from me, or seen in me—put it into practice" (Philippians 3:17; 4:9). That doesn't mean we must be perfect or hide our struggles from those we lead. On the contrary, people need to see us living authentic Christian lives, and that includes dealing with the ups and the downs. The writer of Hebrews tells us to remember our leaders and to "consider the outcome of their way of life and imitate their faith" (13:7). With that in mind, I'd like to share a few suggestions I hope will help you not only survive as a leader but flourish as the kind of role model others desire to emulate and follow.

Work a Reasonable Number of Hours

On occasion I hear leaders complain that the pace of ministry at their church is too fast; if they burn out, they reason it's the church's fault. So they start demanding a slower pace. Be careful what you ask for. A church that moves along at a slow pace can be dull. Whenever I read the book of Acts, I get a picture of the church that's anything but boring. In fact, the first-century church was a place where exciting Holy Spirit activity was the norm. People came to Christ by the thousands, signs and wonders were commonplace, miracles happened every day, prayers were answered, and people were healed. Those early Christians even did missions work and gave to the poor. When a church is

healthy, the pace picks up. At that point, leaders need to manage their lives in ways that make fruitful ministry sustainable over the long haul.

The first step to surviving as a leader in the church is to work a reasonable number of hours. Whenever I hire a new employee, one of the first things I have them do is write out a forty-hour-a-week schedule. This basically comprises their office hours. However many hours you're expected to work, draw up a schedule and then stick to it. We all have busy seasons like Christmas and Easter, but beyond these, I encourage you to maintain a consistently reasonable workweek.

When church leaders tell me they routinely work sixty to seventy hours a week, I often unearth three reasons. The first is that there is so much work to do they have to work overtime to complete it. I used this excuse myself until I realized that putting in inordinate amounts of time never made the work go away. I had a few less things on my to-do list, but there was always more work to be done than I had time for. The psalmist echoes this frustration: "In vain you rise early and stay up late, toiling for food to eat" (Psalm 127:2). Between the people demands, the administrative challenges, and one's specific ministry tasks, there is always more than enough church work to keep a leader overly busy.

The second reason leaders overwork is because they're workaholics. I've had to battle this tendency myself when, driven by deep-seated insecurity, I used to overwork because it made me feel important. With a youthful cockiness masking my insecurity, I thought the church couldn't get along without me. That is, until I remembered that the church had been doing quite well without me for nearly two thousand years. I realized then that my value as a human being has nothing to do with how busy I am at church.

The third reason for overworking comes from leaders who put in an inordinate number of hours every week because their pastor does. In these cases there is an unspoken expectation that everyone in leadership should be following the pastor's lead. If that's the case at your church, find out whether this is indeed an expectation or if it's a figment of somebody's overactive imagination. Ask your pastor or elders how many hours leaders are expected to work. Get it in writing if you want to and then abide by it. If you or another leader wants to work more, that's an individual choice. If not, don't feel guilty about putting in an honest day's work and then going home.

Working a reasonable number of hours also includes scheduling a day of rest—a weekly Sabbath. It's not just a good idea—it's one of the Ten Commandments. "Remember the Sabbath day by keeping it holy. Six days you shall labor and do all your work, but the seventh day is a Sabbath to the LORD your God. On it you shall not do any work" (Exodus 20:8–10). Most people take the weekend off from work. But since church leaders typically work on weekends, we need to schedule our Sabbath for another day. Many leaders don't take a day off, or if they do, they fill it with enough work that it becomes a scaled-back workday instead of a true Sabbath. Take a day off and treat it as a Sabbath. Use it as a day to rest, recreate, and recalibrate.

Manage Your Ministry More Efficiently

After you decide to work a reasonable number of hours, the next step may seem daunting. You must figure out how to be more productive in less time. You need to learn how to manage your ministry more efficiently.

Moses was a great leader, yet he faced the same challenge. His father-in-law, Jethro, pointed out that Moses needed to make more efficient use of his time. Jethro observed the way Moses led the people of Israel, and he asked Moses, "What is this you are doing for the people? Why do you alone sit as judge?" (Exodus 18:14). Jethro asked two insightful questions every leader needs to ask.

What Does It Take to Run Your Ministry?

Jethro's first question couldn't be more to the point: "Moses, what are you doing?" My fellow leader, have you ever stopped to ask yourself that question? What *are* you doing? What exactly does it take to do your job, run your ministry, or lead your team? I'd like to walk you through an exercise I've used frequently and that has proved immensely valuable in helping me manage my ministry. Use a blank sheet of paper or the Ministry Management Exercise on page 195. (You are welcome to photocopy this page for future exercises.) If you're not currently leading a ministry or a team, feel free to skip this exercise for now, but keep it in mind for future use should the need arise.

To begin, choose your ministry as a whole or a subministry such as the worship team, the band, the drama team, the choir, or the technical team. Write the

name of that ministry at the top of the page. I've completed the same exercise as an example on page 196, where "Willow Creek Church Orchestra" is the subministry I'll focus on. I've done this exercise for our music ministry—and for the orchestra in particular—dozens of times over the years.

Step 1: Analyze tasks. Using the left column of the sheet, list all the tasks needed to carry out the ministry you've selected. To help start the process, ask yourself this question: If someone wanted to replicate this ministry, what tasks would they have to complete? In other words, what does it take to run your ministry? Since you're the leader, you know better than anyone else what your ministry entails. Making this list will probably only take a few minutes, and it needn't be in any particular order. It's up to you how detailed you want to be, but the more comprehensive you are, the better. In the example on page 196, you'll find the tasks necessary to run the Willow Creek Orchestra.

Step 2: Prioritize tasks. Next, in the right column, write your name across from the tasks only you, the leader, can do. Don't let your mind get ahead of you and worry about how the other items will get done. That's the next step. For now, put your name only by those responsibilities you alone should fulfill. This is not the time to be overly modest. You might be better able to do a task because you think about your ministry more deeply and more often than anyone else does. Assuming you're the best person to lead your team, the items you claim for yourself probably reflect your unique giftedness and passion. In addition, they undoubtedly are the most important tasks needed to run the ministry—and it's vitally important that you as the leader make sure you're putting your time and energy into these key areas. (The greatest value any of us can offer to our organizations is not to do the largest number of tasks but to do the most important ones.)

This step toward prioritizing your responsibilities will help you become a better manager of your time. The tyranny of the urgent always competes with what's actually most important, and as the leader, you must be disciplined enough to stay focused on those things that matter most. As you can see in the example, I put my name by the writing/arranging task as well as the overall leadership role. As I look over the list, those are the two tasks that only I can do. It's entirely up to you how many tasks you assign to yourself. Because I have many responsibilities other than the orchestra, it is wiser for me to do

fewer tasks and do them well than to take on too much of the ministry by myself.

Who Can Help You Run the Ministry?

Jethro's second question is equally brilliant: "Why are you doing this all by yourself, Moses?" Jethro saw that Moses needed to share the workload. Delegating is not a matter of foisting off the things you don't want to do. It's about spreading out the ministry responsibilities so they can get done more effectively. It's sharing the burden of responsibility and the leadership load. Assuming you don't have unlimited resources to hire all the help you need, it is of paramount importance that you recruit volunteers to assist in the work of the ministry.

Step 3: Delegate tasks. After writing your name across from a few items, your sheet should still have a number of tasks with no names beside them. It's time to strategize how to raise up more leaders and volunteers to help you. No one can do ministry alone, and our longevity as leaders depends in large part on whether or not we find teams of volunteers who will help carry the workload.

Take a moment to ask the Lord for wisdom, then for each of the remaining tasks, write down the name of someone who has the ability to complete them. In some areas, someone may come to mind who already has a bent toward that particular activity. Be discerning, but be open-minded. Don't assume a candidate is too busy. That individual might be dying for you to ask for help. Don't avoid someone who's more talented or smarter than you are. And don't pass over someone who's capable but inexperienced. You may have to train that person, but in the long run, doing so can be well worth the effort.

Once you have a few names written down, set up an appointment with each individual and invite each one to play the role you're considering for them. Envision and empower these volunteers. Paint a picture for them of what their roles will look like by clearly describing what they will be doing. Don't be shy about asking for help, but don't twist arms either. Ask potential volunteers to pray about their decisions and get back to you. If they are unsure, suggest they give it a try and see how they like it. Make sure you clearly communicate the work and your expectations. If they accept your invitation, stay in touch with them, especially at the beginning. In the example, I filled in the

names of musicians who are currently responsible for each task listed. Notice the blank spot with the question mark. I'm currently in need of someone to lead our brass section. In some years I've had more blank spots; in other years I've had none.

Let me say a brief word about blank spots. Those items on your list for which you have no names represent people the Lord will eventually bring to your ministry. So keep praying that God would reveal those individuals to you. Jesus said, "The harvest is plentiful but the workers are few. Ask the Lord of the harvest, therefore, to send out workers into his harvest field" (Matthew 9:37–38). Don't be shy about asking the Lord to send more workers for your ministry. Keep your blank spots at the top of your prayer list. The Lord may already be working to bring you the helpers you need.

Seeing volunteers get plugged into meaningful ministry opportunities is the best part of my job. I can think of many examples, but let me share a favorite.

Before the advent of computer music notation, we wrote all our music out by hand. This was especially time consuming when writing for band or orchestra because every instrument needed its own individual part. Once after doing the Ministry Management Exercise, I concluded that copying parts was important but that if I could find someone else to do it, I'd be freed up to tackle other things. However, I didn't know anyone else who could copy parts, so I had a blank space by that task. At our next rehearsal, I asked if anyone would be interested in learning to copy music.

A college student and flute player named Lisa Mertens took me up on it. She learned how to take a score and write out all the parts. She did such great work and became such a valuable asset to our ministry that we eventually hired her as our first administrative assistant. Before she retired from the position to raise her family, she organized our ministry in ways I never could have and impacted our church as a high-capacity leader. She also helped start our Arts Center and became its first director. This all happened when I realized I couldn't do ministry by myself and asked for help. I'm sure glad I did.

Protect Your Prime Directive

In the early eighties, I bought a synthesizer, the renowned Yamaha DX7. After a few months I knew that instrument inside and out. I learned how to use

the breath controller and the modulation wheel, but when I started to customize my patches, I faced a dilemma. I realized I could spend all of my waking hours programming synth patches. In fact, some professional keyboard players I admired were making a living by mastering the DX7 and programming their own custom algorithms. The question was not whether this was a good use of someone's time, but whether it was the best use of *my* time.

It wasn't. I fell behind in my work, and even worse, I neglected my *prime directive*. By that I mean my job or position in a nutshell, as determined by my primary responsibilities. As a church music director, my prime directive is to build a music ministry. In this case, I needed to cut back on the hours I spent programming synthesizers and put that time back into ministry.

Jesus had no confusion about his prime directive. When word got out that he was in Capernaum, scores of people flocked to his doorstep. The next day, Jesus got up early and found a secluded spot to pray. Meanwhile, the crowd was searching frantically for him. Peter caught up to Jesus and tried to get him to return to the crowds in Capernaum, but Jesus had other plans. He said, "Let us go somewhere else—to the nearby villages—so I can preach there also. That is why I have come" (Mark 1:38).

Jesus knew what his mission was. He wasn't turning his back on the needs of people. After all, he had spent most of the previous night healing those who were sick, and we read that he healed a leper just a few verses later (Mark 1:40–42). Jesus knew healing people was an important facet of his ministry, but his main mission was to preach about the kingdom of God and to redeem lost souls. He couldn't neglect his prime directive.

What is *your* prime directive? Do you know the essence of your leadership responsibilities? Keep in mind that your prime directive will have at least one verb in it. For example: I will build, manage, shepherd, lead, write, teach, and so on. It will also involve a specific team or group of people you've been called to lead. My prime directive is to build a church music ministry featuring music that is relevant, powerful, and excellent; and to take care of the musicians God sends our way. Write your prime directive in your journal or your Bible so it's close at hand, and memorize it so you can articulate it quickly and concisely to anyone who asks.

First Chronicles 9:33 informs us that the musicians in the temple "were exempt from other duties because they were responsible for the work day and

night." They didn't gig on the side all the time. They knew what their main responsibilities were and they focused on carrying those out. Today, more than ever, it is easy for artists in ministry to get sidetracked. The arts offer many perks and fun opportunities. And it's okay to do some of these things. But if they pull you away from your prime directive, you will not last long as a leader.

I know a worship leader who started writing praise songs for his church. It was quite a buzz for him to hear several hundred people singing his music, so he decided to put more time into songwriting. The church eventually funded and produced a worship CD that included a few of his songs. Doing the project caused him to become enamored with recording, so he began to spend a couple of days every week in the studio working on the next CD. He started to fantasize about becoming a well-known worship leader who wrote and recorded his own songs. But although his songs were good, they weren't good enough to be published or recorded by a big record company. Meanwhile, this leader spent less time at church and even less time shepherding his musicians. The worship times he led were hastily thrown together and featured only his songs. Because he lost sight of his prime directive—to lead his church in worship—the church suffered.

So know your prime directive and protect it from distractions that could cause you to lose your focus. And beware of taking too many outside jobs or gigs, especially if your church is already paying you a full-time salary. The extra income isn't always worth the time away from your family or your ministry.

If you are unsure about your prime directive, talk to your supervisor. Ask his or her opinion about the most essential part of your job, and together, come up with clear, succinct answers to the following questions:

- What is my job description in a nutshell?
- What have I been placed in leadership to do?
- What is the most important task the congregation needs me to do?

When you're clear about your prime directive, it is much easier to decline requests that are outside your main responsibilities. If you say yes to every request that comes along, you're probably a nice person, but you need to set clear boundaries. In my case, I need to honor any request that comes straight from my leaders. They are my bosses. In addition, it is my responsibility to oversee anything having to do with music in a service or anything that calls for

leadership within the music ministry. However, a request from a congregation member to put music to a poem or to play at a cousin's out-of-state wedding is clearly not within my job description. I would love to serve people in that way and I would if I could. But I can't. To do so would take valuable time and energy away from my real focus. For the greater good, I politely decline.

If you have a hard time saying no, at least delay saying yes until you've had time to carefully consider the request. Check your schedule and make sure you have the time to give to something before you make a commitment. Or consider first running all requests by a friend or colleague who is familiar with your ministry and family obligations. If you burn out because you've said yes too often, you have only yourself to blame.

Take Responsibility for Your Own Health

To survive the heavy demands of ministry, you must do whatever you can to stay healthy—physically, emotionally, and spiritually. On the most basic level, that means exercising, eating healthful foods, getting enough rest, and having a regular quiet time with the Lord. Don't subscribe to the notion that your health is of little concern to God. The prophet Elijah once became so exhausted from doing ministry he wanted to die. In response, God led him into the wilderness to restore him. God first made sure Elijah got some much-needed sleep and then sent an angel to feed the bedraggled prophet (1 Kings 19:5–8). God knows we are but flesh and that there is a vital connection between our well-being and our ability to do sustainable ministry.

For some reason, though, we artists are not known for taking care of ourselves. Most of us are allergic to exercise, addicted to fast food, sleep deprived, and too busy to pray. (Other than that, we're just fine.) Meanwhile, as leaders we need to be able to make wise decisions under stress, interact with people without getting irritable, and tirelessly lead the charge in the face of adversity. You can't do those things well if you're not at your best, so your every effort toward staying healthy is an investment in the success of your own leadership.

There are many options for exercise, and you needn't be athletic to work out. Some people exercise at home; others join a health club. Some prefer to bike or jog; others walk or swim. You don't have to have an aggressive workout regimen, but it's critical to your energy level and well-being to engage in

some kind of physical activity on a regular basis. Most people have greater success when they schedule their exercise like any other appointment. Pencil it into your schedule at the same time every week, and it will become part of your regular routine.

It is also up to you to develop healthy eating habits and to get enough rest. Sensible eating habits are better than eating indiscriminately. Giving up a late-night TV show to get a good night's sleep is a small price to pay for being at your best the next day. Ecclesiastes 4:6 says, "One hand full of rest is better than two fists full of labor and striving after wind" (NASB). Remember that your body is a temple for the Holy Spirit (1 Corinthians 6:19). Like your talent, your body is on loan to you from God, so take good care of it.

For some, getting healthy might also mean seeing a Christian counselor and working through self-esteem or anger issues. For others, it might include taking medication for a lingering depression that interferes with their ability to function optimally.

I have discovered that in my case, the key to doing ministry in a healthy way is to balance my intensity. In fact, I attribute my longevity in ministry to learning to utilize two basic gears: slow and fast. I'm an early riser. When I get up I have several hours at home before I head for work. In those hours I have a quiet time, read, go for a walk, eat breakfast—all at a slow and leisurely pace. My wife says I mosey around the house every morning. But when I get to church I shift gears. There are phone calls, emails, meetings, rehearsals, appointments, and deadlines that force me to work fast and hard. When I leave church at the end of the day, I downshift back into slow gear.

If I tried to go through my entire day at an all-out speed, I'd burn out quickly. There would be no room in my life for solitude, introspection, creativity, or even laughter. On the other hand, if I tried to mosey my way through work, I'd get fired. When I was starting out in ministry, someone gave me some advice in the form of a catchy slogan: "Work hard; play hard." It turned out to be bad advice. I love working hard, but if I played hard too, I could no longer live from a serene centeredness. When at work, work hard. When not at work, relax and enjoy life.

Lastly, being healthy means having a life outside of church. That includes engaging in rejuvenating hobbies, interests, and recreational activities. I used to

tend a rather large vegetable plot. And in fact, I fancied myself quite the sub-urban farmer. Planting, watering, and hoeing offered me a welcome departure from the rigors of ministry. A fellow staff member at the time heard about my hobby and sarcastically said, "It must be nice to have time for that sort of thing." His remark made me feel guilty. Instead of reinforcing an all-church-and-no-play mentality, we should encourage each other to have diversions that allow us a break from the intensity of ministry.

If Something Is Broken, Fix It

Leaders can't afford to look at their ministries through rose-colored glasses. If any part of a ministry is broken or not working well, leaders need to see the reality of the situation and define the problem. Then they need to fix it. The tendency for many of us is to ignore problems and hope they go away. Or hope someone else jumps into the fray to fix it. But the reality is that if we leaders don't address the problems within our ministry, the ministry will fall apart and take us down with it. When all others look at a problem and say, "I wouldn't touch that with a ten-foot pole," a leader pulls out an eleven-foot pole specifi-cally designed for just such difficult situations.

David's words to young Solomon come to mind. "Be strong and courageous, and *act*; do not fear nor be dismayed, for the LORD God, my God, is with you. He will not fail you nor forsake you" (1 Chronicles 28:20 NASB, emphasis mine). It is as if David is saying, "Hey, Solomon, if there's a problem, you're the leader; do something about it." Leadership is all about taking initiative. And fixing whatever is wrong.

I recently had to face morale problems within our ministry. Some volunteers were disheartened and losing motivation. I talked with a few musicians individually to learn what was going on, and a couple of them said, "Volunteers aren't valued around here anymore." At first I took that to mean that our volunteers were feeling unappreciated and overburdened, but when I pressed for details, I learned they felt disconnected from the ministry because of poor communication. Receiving last-minute information often threw their lives into upheaval. They wanted more timely details about upcoming events, including more information about when and how they'd be needed and earlier notice about call times. That sounded reasonable to me, so instead of waiting until

rehearsal to communicate vital information, we started to send out emails a few days ahead of time so our volunteers could be in the know sooner.

Sometimes special events and projects expose a weakness within a ministry. There have been times when we tackled a big project and it nearly ended in disaster because of process problems we were previously unaware of. For instance, after a particularly difficult Christmas run, we vowed to start planning Christmas Eve services earlier in the year; rushed planning had been way too taxing on our teams. A wise leader identifies problems and tries to solve them so the ministry doesn't repeat the same mistakes. I know a church with only two technical team volunteers that decided to host an arts conference, a major outreach event at a rented facility, and their regular weekend services—all in the span of three days. By the end of that weekend, those two volunteers felt abused. To the church's credit, organizers vowed never again to hold events of that magnitude without first building teams that could handle them. When a weakness in your ministry is exposed, do everything you can to fix it. You'll set yourself and your teams up for success the next time around.

One of the harsh realities of leadership in a volunteer-based organization is that you're in constant recruiting mode. I can't think of even one time in all my years of ministry in which I've leaned back in my office chair and thought, *Ah, now I can rest easy because we finally have enough musicians.* We've always needed more vocalists or certain instrumentalists. This used to discourage me because I assumed it was a poor reflection on my leadership. But I eventually realized there's no such thing as too much depth on a team of volunteers. The unexpected always occurs at the most inopportune times. A key volunteer gets an out-of-state job transfer or needs to take maternity leave. Sometimes volunteers go through busy work seasons and can't be as active as they'd like to be. Or the pastor announces that, due to staggering attendance growth, the church will add a service every Saturday night. Talk about sending you scrambling for more volunteers! Stay in proactive mode: When you meet artists who are not going to a church, invite them to yours. Challenge talented people in the ministry to reach out to their talented friends. Make a list of all the non-Christian artists your team knows and pray that those precious seekers find Christ and start using their talents for him.

Give Volunteers More Than an Artistic Experience

When artists begin serving, they always start out with a lot of enthusiasm. Everything's new and exciting. They're using their talents for the Lord. They're meeting other Christians. Rehearsals are fun. They don't think twice about getting out of bed early Sunday morning to serve at church. After about a year, though, the thrill often begins to wear off and complacency starts to set in. Rehearsals become a chore. Getting out of bed early becomes more difficult. Ministry begins to feel like plain old hard work.

I used to get dismayed when volunteers began to act like the honeymoon was over; then I realized that is just human nature. Paul saw this happening to the Christians at Galatia, prompting him to ask, "What has happened to all your joy?" (Galatians 4:15). The *New American Standard* translation reads, "Where then is that sense of blessing you had?" Revelation 2:4 states the church at Ephesus had lost its first love. Their interest in spiritual things had waned.

If your ministry is only about the art, your artists will eventually get bored and leave. Church artists need and expect more than just an artistic experience. They won't stay engaged unless they're pulled in relationally and spiritually, through some kind of relational connections with a leader and with other artists in the church. They're also hungry for some kind of spiritual input. Leaders must try to provide these things.

A Personal Connection with You

I once had a musician who constantly complained he wasn't being challenged musically. He assessed his talent a little higher than I did, and the truth is, he wouldn't have been able to handle anything more challenging. Then a crisis surfaced in his life and he started coming to me regularly for Bible study and prayer. Eventually the complaining stopped because he was getting something more valuable than just playing in the band. He was getting my personal attention. He was getting some of his relational and spiritual needs met in a way that only the church can provide.

In his letter to the church at Philippi, Paul sounds rather frustrated that he can't find enough leaders who really care about people. "I hope to send Timothy to you soon. . . . I have no one else like Timothy, who genuinely cares about your welfare. All the others care only for themselves and not for what matters

to Jesus Christ" (Philippians 2:19–21 NLT). Servant leadership means giving ourselves away, opening our hearts to those we lead. Paul told the church at Corinth, "We have spoken freely to you, Corinthians, and opened wide our hearts to you" (2 Corinthians 6:11).

I am reminded of a youth pastor who spent forty hours every week preparing Bible studies. He never got out of his office to meet and mingle with the kids. He was a great teacher, but students drifted away from the youth group because none had any personal connection to the leader. He claimed to love the students, but he never spent time with them. Ironically, he was too busy doing church work to do the work of the church, which is ministering to people.

Peter advises all leaders to shepherd the flocks God puts under their care (1 Peter 5:2). You needn't have the spiritual gift of shepherding to care for your artists; you just have to be willing to spend time with them. And doing so is not only beneficial for your artists. When your ministry is about people as well as art, you will find ministry far more satisfying.

If you're an extrovert and like large gatherings, throw parties, schedule retreats, and have get-togethers as often as you can. If you're more introverted, lead a small group, initiate one-on-one appointments, make phone calls, or have small get-togethers. Don't be intimidated if you don't consider yourself highly relational. An introvert can be just as effective, if not more so. An introvert may not walk into a room and be the life of the party, but when someone needs to talk, he or she is usually the person others feel most comfortable opening up to. Shepherd your volunteers in ways that fit your individual relational capacity.

I know a music director who could never imagine teaching a Bible study. Yet he loves to head to a nearby restaurant after rehearsal and hang out with those in his band. That's an excellent way for him to spend time with them. Some of my fondest memories of my early church experience took place when our youth leader met with us after our meetings or when I was invited to attend breakfast planning meetings with him. In the same way, volunteers value personal interaction with you.

If investing personal time in the lives of your volunteers is new territory, start with small amounts of time. If you have only one lunch a week with a volunteer, for example, that gives you about fifty opportunities a year to minister on a personal level. If you have a large ministry, don't worry about getting

around to every single person. Give what you can reasonably give to as many as you can. That's what Jesus did. He spoke publicly to thousands but gave personal time to a smaller group, which included friends and his twelve disciples.

A Personal Connection with Each Other

Be sure to also offer your volunteers a sense of community with one another. Everybody wants to feel they belong, and virtually all Christian artists long to be with other people who love the arts and love the Lord. Small groups, retreats, and parties are all great opportunities for building community. The orchestra at my church meets every Tuesday night, and we try to save the last twenty minutes of those rehearsals for prayer. We divide into the same groups each week, and during that time, tremendous community building takes place. There are a couple of professional musicians in the group who really don't need to attend rehearsal for musical reasons. They could sight-read the material during the service if they had to, but they come because of the community time. They know that life can be burdensome and that when hardships come they'll need a small group of friends who can pray for them and help them through. In the meantime, they stand ready to help others who are going through tough times. That's the beauty of the body of Christ, where we can know and be known; where we can help and be helped.

Spiritual Input

God's Word instructs us to build our ministries on strong spiritual foundations. "Because of God's special favor to me, I have laid the foundation like an expert builder. Now others are building on it. But whoever is building on this foundation must be very careful. . . . Now anyone who builds on that foundation may use gold, silver, jewels, wood, hay, or straw. But there is going to come a time of testing at the judgment day to see what kind of work each builder has done. Everyone's work will be put through the fire to see whether or not it keeps its value. If the work survives the fire, that builder will receive a reward" (1 Corinthians 3:10, 12–14 NLT).

To build ministries that withstand the test of time, we leaders need to provide basic spiritual nourishment to our volunteers. This doesn't require giving long sermons or leading extensive Bible studies. It may mean providing a short

devotional or worship time at the end of rehearsal. You might share a verse of Scripture and explain why it has become especially meaningful for you. Those who follow you need to see your spiritual side and they need to know you spend time with the Lord. In my opinion, the ideal music rehearsal contains its share of spiritual moments. But rehearsals aren't the only opportunity you have. For instance, you could share a brief spiritual thought or a meaningful prayer before the service starts.

As the leader, always be mindful of opportunities to point your volunteers to something higher than themselves and their art. Ministry is more than singing notes on a page or reciting lines from a drama sketch. It is the Lord's work, and it impacts people for all eternity. Proverbs 27:23 says, "Be sure you know the condition of your flocks, give careful attention to your herds."

1. How many hours do you put in at church every week? Do friends or your spouse ever voice the opinion that you spend too much time there?

2. What is your prime directive as a leader or as an artist in the church?

3. How healthy are you . . .

 • Physically?

 • Emotionally?

 • Relationally?

 • Spiritually?

 • Artistically?

 Rate yourself in each area using the table below.

	Healthy Enough for Now (You're satisfied with where you're at.)	Need Some Attention (You're close, but not where you want to be.)	Very Unhealthy (You're far from where you want to be.)
Physically			
Emotionally			
Relationally			
Spiritually			
Artistically			

4. What steps can you take to be healthier in the areas you rated as needing attention or very unhealthy?

5. Do you have a life outside of church? Do you have any hobbies or diversions you enjoy on a regular basis?

6. Were there any ministry events this past year that exposed a weakness or a problem within your ministry? What can you do to avoid the same predicament in the future?

7. What specifically are you doing to invest in the lives of your volunteers?

8. Are you satisfied with the amount of personal time you give to volunteers? If not, what's a reasonable amount of time you can offer them, and how might that time be spent?

9. What sorts of activities have successfully built community on your team?

10. What are you doing to meet the spiritual needs of your volunteers?

11. What can you do to make rehearsals a spiritual experience as well as an artistic one?

Personal Action Steps

1. List three activities you enjoy doing just for fun. How often are you able to do those things? If it's not often enough, how might you fit more of those healthy diversions into your schedule?

2. Evaluate your ministry by giving a letter grade, A to F, for each of the following areas:

 _____ Depth of your team (do you have enough volunteers?)

 _____ Morale of your team (are people excited about the ministry?)

 _____ Spiritual condition of your team

 _____ Unity of your team

 _____ Overall effectiveness of your ministry

 _____ Overall effectiveness of your leadership

3. What can you do to improve any of the areas that you graded low?

4. List five people in your ministry in whom you'd like to invest more time. Call each of them and set up a time to get together this week.

5. Rewrite 2 Corinthians 4:8–9 in your own words.

Ministry Management Exercise

Ministry:

Tasks Needed to Run the Ministry	Who Can Do the Task?

Ministry Management Exercise Example

Ministry: Willow Creek Orchestra

Tasks Needed to Run the Ministry	Who Can Do the Task?
Overall leadership (vision, direction)	Rory
Writing / arranging music	Rory
Photocopying parts, stuffing folders	Jamie, Jake
Phone calls	Jamie
String section leaders	Gina, Wendy
Woodwind section leaders	Floyd, Dan
Brass section leaders	?
Auditions	Rory, section leaders
Leading prayer groups	Section leaders
Planning / organizing social activities	Diana
Overseeing extension activities (i.e., helping the poor)	Bob
Point person for church membership	Gina
Emergency Care (i.e. prayer, meals for the sick)	Carrie
Assistant conductors	Tom, Floyd
Selecting music for spring and fall concerts	Section leaders, Tom
Small groups	Sandy, Gina

chapter nine:

Rising Above Our Artistic Differences

Proud of what he had done to change the company . . . he now mainly supervised and okayed artwork to which he could not particularly relate, his blue-penciled initials and corrections appearing in the margins of work produced by the newer, younger artists, who were in touch with the latest fashions. . . . While his own style of illustration went by the wayside, a new kind of "free-form" creativity started to show up in advertising art—a style that Ives could not, nor wanted to, adopt.

Oscar Hijuelos, *Mr. Ives' Christmas*

Curt looks around his living room full of people, eager to begin the meeting. "Hey, everybody, let's get started before Mark falls asleep on us," he says, inter-rupting the clatter of conversation. Playing along, Mark starts to snore and "wakes up" with a jolt and a loud snort. Everybody laughs. Not a night person to begin with, Mark gets up every morning at 4:00 a.m. to commute into the city, so he has a reputation for zoning out by 9:00 every night.

As those who are standing find seats, Curt continues. "Emily and I want to thank you all for coming. I know it's eighty degrees outside, but Christmas will be here before we know it. In fact, if we follow our usual schedule, choir rehearsals start in six weeks."

As if on cue, everyone gasps, which then causes them to all laugh out loud.

"Do we have a theme yet?" Todd asks.

"No," Curt answers, "but we have something better. We have a writer," Curt motions to the pleasant-looking young man seated next to him on the couch. "I'd like to introduce you all to Nathan. He started at the plant just a few weeks ago, and during the interview I found out that he's a brother in Christ *and* he's a writer. He's even had a few articles published in *Sports Illustrated*."

The group audibly approves. "Just a series of human interest stories," Nathan clarifies. "I happened to be at the right place at the right time."

"He's being modest, folks," Curt asserts. "He's won awards, so that makes Nathan here closer to being a full-fledged professional than any of the rest of us."

They all clap. Feeling a bit self-conscious, Nathan quickly diverts attention to the matters at hand. "Curt said you all needed help with your Christmas pag-eant. I've never written for a church before, but I thought I'd come and see if there's anything I could do to help."

"Let me introduce everybody for Nathan," Curt chimes in. "You've already met my lovely wife." He points to Emily seated next to Nathan on the other side of the couch. "When Emily isn't chasing the Seven Dwarfs around, she's our accompanist—been playing the piano since she was five years old." Emily nods and smiles.

"You have seven kids?" Nathan asks somewhat incredulously.

"No, we have three," Curt laughs, "but they're small, and at any given time they can be whiney, noisy, crabby, bratty . . . all at once. You get the picture. Next are Todd and Kendra. They own the only movie theater in town, and

they've written and performed some great drama sketches for us. They're the best actors in the whole church." Todd and Kendra smile and wave.

"Next to them are Jason and Annie. Jason does construction. If you need any work done on your house, he's the world's best handyman—and a great tenor too."

"Pleased to meet you," Jason says. "Annie here is in real estate, and she sings alto in the choir."

"I'll be giving you a call," Nathan says to Jason. "I'm a complete moron when it comes to doing stuff around the house."

Curt continues, "Last but not least is Mark, computer consultant by day, choir and drama director by night—our fearless leader." Mark shakes Nathan's hand.

"You all volunteer," Nathan notes out loud. "No one here works for the church?"

"No, we're a pretty small church, but we do all right," Jason answers proudly. "The whole town comes out for this Christmas show every year."

"That's great," Nathan says, eager to get down to business. "Since I'm the new kid on the block, can you tell me what kinds of things you've done in the past?"

No one knows quite where to begin, so Mark speaks up. "We pretty much tell the Christmas story every year—wise men, shepherds, angels, Mary, Joseph, and the baby Jesus. We use whatever music we can find, and we take most of the readings and dialogue straight from Scripture."

"Would you be up for doing something different?" Nathan inquires.

"What do you mean?" Kendra asks apprehensively.

"Yeah," says Jason, sounding a bit worried, "I don't know if we should mess around with Christmas."

"That's a good point, Jase," Mark adds. "People prefer everything to be pretty traditional."

"Let's hear Nathan out," Curt suggests.

Nathan continues, "Well, I've always wondered what it would be like to set the Christmas story in modern times—the present day. If the story of Christmas is God coming down from heaven to become one of us and walk among us, why couldn't we show him being born right here in the suburbs in the

twenty-first century? People might relate better to a Jesus who dresses and talks more like they do."

"I don't know," Kendra says. "We take great pride in the authenticity of our biblical costumes, and the church has invested a lot of money in them over the years. Being a writer, you probably don't realize how expensive costumes get. Since we have them and they're still in good condition, I think we owe it to the church to use what we already have."

"Do you think our congregation would get it?" Jason asks.

"What do you mean?" Nathan responds.

"Get that the drama scenes are taking place today?" Jason explains.

"It's kinda like *Godspell*," Curt suggests. "I think everyone would get it. But if we needed to, we could put a notice in the bulletin indicating that the production takes place in a contemporary setting."

"I never liked *Godspell*," Jason quips. Everybody laughs.

"How would we work in the altar call?" Todd asks, turning serious.

"Are we expected to have one?" Nathan asks.

"Yeah, every year our pastor wants to have an altar call for the 'christers'—people who only come to church for Christmas and Easter," Todd explains. "We usually have Mary explain the plan of salvation and then have an altar call."

Nathan looks puzzled, but he senses a need to tread cautiously. "I don't think it's all that believable that Mary would fully understand the plan of salvation right then and there, do you? It wasn't fulfilled until Easter, and even the disciples didn't get it right away."

Annie, obviously troubled, finally speaks up. "I just have to say that this is the worst idea I've ever heard. If we did anything like what you're suggesting, I'd be disappointed. None of my friends would even come. It doesn't feel like Christmas unless Mary and Joseph are in a stable and the baby Jesus is in the manger."

There is an awkward pause. No one knows quite what to say, but it is obvious that Annie's comments have pretty much killed the idea of presenting the Christmas story with a contemporary twist. The group continues to brainstorm for another hour and ends up with a service similar to what they do every year.

Later, as the group chats around the punch bowl, Kendra asks Nathan if he'd be interested in helping her write the church's monthly newsletter.

"Let me think about that and get back to you," Nathan responds diplomatically.

Questions for Group Discussion

1. If you were Nathan, would you be looking forward to working with this church on their Christmas production? Why or why not?

2. What are some of the positive group dynamics the team exhibited during this meeting?

3. What do you think about the way the group responded to Nathan's suggestion for the production?

4. What are some indications this team didn't respect Nathan or his ideas?

5. Do you feel that the way they had been working the altar call into the production was the most effective way to do it? Why or why not?

6. If the team wanted to try to change the pastor's mind about presenting the plan of salvation through the actors, how would you recommend they go about doing that?

7. What was it about Annie's statement that brought the discussion to a standstill?

8. If you were in Nathan's shoes, would you take Kendra up on her offer to help write the church's newsletter? Why or why not?

9. Have you ever felt artistically restricted by the church? How did that feel?

10. Have you ever had artistic or philosophical differences with others at church? How were those differences resolved?

GUIDELINES FOR RESOLVING ARTISTIC DIFFERENCES

Of all the groups working within the church, artists may well have the most opportunities to disagree among themselves. That's because during our rehearsals and meetings we make scores of subjective decisions—decisions that are often simply matters of personal preference or taste. Whenever artists interact, it is inevitable that artistic and philosophical differences will arise. There are disagreements over what music to use and how it should sound. There are differing opinions about what the lighting should look like or about how the drama or video should end. There are countless decisions that go into any artistic endeavor, and it is unrealistic to think that we will always concur.

Such artistic and philosophical differences are, however, no reason for alarm; they are not a bad reflection on the unity or maturity of your team. In fact, such discussion is a good indication that artists feel a sense of ownership and care about your ministry.

The way those differences are expressed and resolved, though, is a reflection on everyone's character. Whether the controversies are large or small, every team of artists must learn how to quickly work through issues in ways that preserve unity while fostering a diversity of opinions and fresh ideas. Teams that don't learn to do this fall into dysfunctional behavior. Their sense of community is compromised, creativity is squelched, and the team eventually falls apart.

These days more volunteers (like the ones in our opening scenario) are involved in service planning as well as rehearsals—the two occasions that most often require artistic decisions. Even though the team leader sets the tone for the group's relational dynamics, the responsibility is on each team member to work through artistic differences with utmost integrity. Let's consider how to go about doing that.

Voice Your Opinion with Conviction

If you have a strong opinion about something, don't hesitate to express it. Your thoughts and feelings count, so don't apologize for having them. Your opinion more than likely represents the preferences of a certain percentage of your congregation; whether that percentage is high or low is up to the entire team to decide. So even if you're quiet by nature, speak up and present your point of view with confidence and conviction. If you mumble or let your voice trail off when you speak, others may not understand you or think you don't really believe in what you say—let alone be swayed to your point of view.

A piano player once told me he was going to keep his mouth shut and not make any suggestions in meetings. "Whatever I say, they always do just the opposite," he complained. I told him that the law of averages works that way for all of us. For every one idea I've had accepted, there are probably ten others that didn't win out. Or they became stepping-stones to someone else's idea. Just because the team doesn't do things your way doesn't mean you should stop offering your opinions—or that your input is not critical to the creative process.

Express Your Opinion in a Spirit of Deference

If you tend to be a "take charge" kind of person, be gentle and humble when voicing your point of view. We are to clothe ourselves with humility toward one another (1 Peter 5:5). The person who comes across as pushy, arrogant, or belligerent won't win anybody over; in fact, that person incites a spirit of competition instead of cooperation within the team. Remember that your artistic preference is just an opinion—nothing more, nothing less. So hold it loosely, offer it freely, and don't be adversarial about it. Don't block a decision just because it wasn't your idea. And if there is an idea that makes more sense than yours, get behind it and support it fully.

And by all means, don't take it personally if your artistic preference is not the one the team decides to go with. That doesn't mean you're a bad artist or that you have bad taste. This is not a matter of right and wrong. Your idea or your way of doing things might work better at another time or in a different setting. So don't be so married to your own ideas that you can't be open to new ones. And rather than give in to the temptation to sulk, withdraw, or shut down, always defer graciously to the collective wisdom of the team.

Show Consideration for the Opinions of Others

Whenever I travel these days, I get to see a lot of the great art coming out of our churches. I also get to see behind the scenes into a lot of arts ministries—and that's not always pleasant. Sadly, I've come to the conclusion that we artists quite often lack respect for the opinions of others, especially if those opinions come from a nonartist or even from someone outside our particular discipline.

On one occasion, I witnessed a preconcert rehearsal in which the programming director couldn't get anyone to listen to her. She was sharp, congenial, and had good programming instincts, but when she made suggestions to the music director, he rolled his eyes in a what-do-you-know-about-music sort of way. When she approached the drama director, he ignored her and walked away. The sound engineer pushed a fader up when she asked for more of something, but when she glanced across the board a few minutes later, that same fader was back at its original setting.

Unfortunately, it wasn't just the leaders who showed little courtesy toward each other, as volunteers got into the act as well. When a vocalist complained he couldn't hear himself in the monitor, a stage crew member moved the vocalist's music stand over a few inches so it wouldn't block the speaker. This infuriated the vocalist. He glared at the sound booth, curled his bottom lip, grabbed the music stand, and put it back in its earlier position. The artists on that platform all jealously guarded their own turfs—a sure recipe for failure, no matter what the artistic endeavor might be.

Scripture commands us to "show proper respect to everyone" (1 Peter 2:17). Whether we're in meetings, in rehearsals, or just together with friends, we need to listen to and honor the opinions of others. Be especially careful not to say anything that would discredit or disrespect somebody else's opinion. Next time you're driving to church for a meeting or rehearsal, pray, *Lord, when I get to church, help me to say only that which I have permission from you to say.*

Be Open to Opinions from Outside Your Artistic Discipline

I once attended a brainstorming meeting to which I brought a song to suggest for an upcoming service. That particular day, everyone around the table happened to be a musician except Nancy Beach, our longtime programming

director. She has great artistic instincts, but she is not a musician. All the musicians in the room absolutely loved the song. They raved about the sophisticated production of the recording, the high caliber of its musicians, and the creativity of the songwriting. But when Nancy's turn came to weigh in with an opinion, she said, "I'm sorry. I know you all love this song, but it's not doing anything for me."

In spite of Nancy's misgivings—and convinced she was just having a bad day—we went ahead and scheduled the song. It was a complete flop. Then, thinking that we just needed to perform it better, we repeated the song a few months later. It was an even bigger flop. The congregation endured it stoically like airline passengers sitting through another pre-takeoff safety presentation. Then they politely applauded—no doubt because the song was finally over.

Nancy was right, and what we learned from this experience is that there are some songs that only musicians can love. Such a song may have all the bells and whistles that excite musicians but still leave everyone else bored and unaffected. Musicians must never ignore the opinions of others simply because they're not musicians. Sometimes the nonmusician knows better than the musician what music will or won't be well received. The same holds true for other art forms as well.

Be Open to the Opinions of Nonartists

Artists should also respect and value the opinions of nonartists. Always remember that they usually represent the largest proportion of your audience. My wife is not a musician, but she has good taste in music. At least, that's what I concluded every time she liked something I had written! When she didn't like something I had done, however, I would get irritated and act hurt. Then I would pester her for an explanation and get impatient with her inability to articulate her feedback in succinct musical terms, which, of course, was hardly a fair expectation. I've grown up since then (praise God), and I've learned a great deal from listening to my wife's opinions about music. Even if it's expressed in the clumsiest of layperson's terms, feedback from nonartists is extremely valuable and can greatly benefit our work.

That's why I strongly believe that a team of people—not one individual—should select the music, drama, and all other programming elements for a

service. And that team should include at least one nonartist who offers input that will help us keep touch with the average person in the congregation.

Communicate from Your Head, Not Just Your Heart

We artists can be deeply emotional people. That's how God made us, and we should never apologize for being in touch with our feelings. If we respond only from our hearts and not at all from our heads, however, we won't develop the necessary verbal and critical thinking skills needed to resolve artistic differences. In a rehearsal or a brainstorming meeting, the most logical ideas usually win out. When trying to solve a problem, most teams choose the alternative that seems to make the most sense. That's why it's important that we "artsy types" learn how to communicate the logic behind our artistic preferences.

Recently I overheard two artists trying to work through their artistic differences. Instead of listening to each other's points and debating their merits, the two kept repeating the same arguments. One of them stated his artistic preference, and then the other one stated his. They went back and forth like this for quite some time. You could tell neither of them was listening to the other, and to make things worse, they were getting increasingly angry. They were so caught up with emotion that they weren't thinking straight. What could have been a constructive debate turned into a heated argument.

I once spoke with a worship leader who struggled to convince those he worked with that he needed the drums set up in the middle of the band. His coworkers didn't want the drums to be so visible. He got very emotional, and here's what he said: "I really feel that the drums should be in the middle. It's the way other churches do it. If any of my musician friends come this week, they'll notice the drums are in the wrong place."

Notice that he didn't really communicate any compelling reasons to have the drums where he wanted them. He only stressed his artistic preference. Nonartists don't have the same aesthetics you do, but if you can give them good reasons for doing something, you stand a better chance of winning them over. For example, my worship leader friend could have said, "If the drums aren't set up in the center, it's hard for the musicians to lock in the same tempo and stay together. If we put the drums back in a corner, the worship time won't have

the energy it needs to have. And if the drummer is too far away, it makes it that much harder for me to communicate transitions and tempo changes." That would have communicated several logical reasons for putting the drummer in the middle.

The apostle Paul makes a strong appeal for clarity in 1 Corinthians 14:9– 10: "Unless you speak intelligible words with your tongue, how will anyone know what you are saying? You will just be speaking into the air." Even though this passage refers to spiritual gifts, the principle is true every time we communicate something important: be clear. If you have trouble being understood, it may not be your listener's fault. Stop and ask yourself, "What am I trying to say, and what's the simplest way to say it?" If you can feel all that a "feeler" feels and yet communicate like a "thinker" whenever you need to, you'll be doing yourself, your ministry team, and your art a great service.

Words are the most common communication tool we have. So if you want to learn to speak or write more clearly, feed on a steady diet of great literature. Besides being enjoyable, reading the works of exceptional writers, especially the classics, is an ideal way to learn to think clearly and express yourself articulately. It won't make you a Dickens or a Hemingway, but through osmosis, it will improve your communication skills. It's no accident that those who can communicate logically are also avid readers.

GUIDELINES FOR RESOLVING PHILOSOPHICAL DIFFERENCES

Along with the artistic differences that commonly occur, issues also arise that are more philosophical in nature. These philosophical differences most often revolve around how the arts are used in church, and they may become points of contention between artists and their ministry directors, between artists and pastors, or among the artists themselves. For artists in the church, this can become a huge frustration.

Because I am a musician as well as the one who manages the church music staff, I'm in a position to view most of these issues from both sides. In fact, I believe it is part of my job to bring opposing parties together whenever there are philosophical differences. Both sides must sit down and talk. If controversies are ignored, artists grow disenchanted and may even leave the church. We

won't agree on everything, but we must work at trying to listen and understand one another. Remember, there is no "good guy, bad guy" in this process. Each viewpoint includes valid points worth considering.

Over the years I've identified four common philosophical issues that often prompt disagreements. I'd like to take a look at these issues by posing the question that lies at the heart of each one. And while I'll offer general comments about how our ministry has dealt with each issue, you should consider this input simply as examples, not as absolutes. In fact, the Bible doesn't have a lot to say on these topics, and not every church is going to arrive at the same conclusions. My objective is to get both sides to talk through their differences and offer some ground rules for the discussion. It is up to you and your church to work toward resolution to the mutual satisfaction of all involved. When artists know their church is aware of these issues, and is in fact willing to discuss them, they feel more secure about their roles in the ministry.

What Is the Purpose of Art?

You might hear a Christian songwriter ask, "Does every song I write for church have to have an overtly religious message?" A drama writer might ask, "Does every drama sketch have to contain all the main points of the pastor's sermon and have a happy ending?" A visual artist might pose this question: "Am I only allowed to paint Bible scenes or characters?" A photographer might ask, "Does my art always have to evangelize?"

Artists aren't trying to be provocative or irreverent when they ask such questions. They need to know where their church stands on these issues, because that position greatly affects how they will serve. Behind every one of these questions is a broader issue—what is the purpose of art? This most basic question is far from innocuous. When there is contention concerning this question, artists often accuse the church of being utilitarian, and the church may accuse artists of being worldly. If both sides fail to come to some kind of resolution on this issue, they frequently part company in bitter dispute.

The purpose of the arts may vary from church to church, but each one must answer this question for its artists. To facilitate the discussion, let me first try to explain both the artist's and the church's perspective on this issue.

The Artist's Perspective

Artists contend that art is not good at preaching. A drama sketch that parrots the pastor's main points, for instance, is far less effective than the sermon itself. Great art tells a story, expresses emotion, or personalizes truth. Used in this manner, the arts effectively draw people in and prepare their hearts to listen more attentively to a message. Art that is relegated to being a mini-sermon comes off as preachy. For example, a song that incessantly says you must do this or that never persuades anybody to do anything. Believers may nod in agreement through the entire song, but the unconvinced remain unmoved. To their ears, it sounds more like Christian propaganda instead of heartfelt truth. Great art doesn't *tell* you to do something; it *moves* you to do it—and it should never hit you over the head with an agenda. In an essay entitled "Religion and Literature," T. S. Eliot wrote, "What I want is a literature which should be *un*consciously, rather than deliberately and defiantly, Christian."[29]

Art must always be believable. A song that portrays the Christian life as one that's carefree, without problems or setbacks, is unrealistic. To insist that every drama sketch or multimedia presentation tie up every loose end so all the characters live happily ever after is not true to life. Such art comes across as trite and inauthentic. Especially in church, we must never be afraid to address the serious and difficult issues of life, and we must be careful not to give pat answers that sound contrived or manipulative. That's why, in many cases, art is better at raising questions than it is at answering them.

When it comes to evangelism, art can give an effective witness to the faith if it's first allowed to be artistic instead of "evangelistic." If a church insists that a drama scene present the Four Spiritual Laws, the result is invariably shallow characters trapped in an implausible plot. Besides, it's unrealistic to expect anyone to come to Christ by mere exposure to "Christian art." That's just too lofty an expectation. Evangelism is the work of the Holy Spirit, and it often involves prayer and a personal witness of some kind. Art can play a role in someone's journey to faith, but it rarely holds redemptive powers in and of itself.

One thing many believers might have a difficult time understanding is that most Christian artists don't want to be confined to producing only "Christian art," especially if that means their work always has to be overtly religious. According to Francis Schaeffer:

Christian art is by no means always religious art, that is, art which deals with religious themes. Consider God the Creator. Is God's creation totally involved with religious subjects? What about the universe? The birds? The trees? The mountains? What about the bird's song? And the sound of the wind in the trees? When God created out of nothing by his spoken word, he did not just create "religious" objects.[30]

In some circles, a song is not "Christian" unless it makes direct references to God or Jesus and contains the right buzzwords like *worship* or *salvation*."But what if a musician wants to write a song that celebrates romantic love or speaks to loneliness, materialism, or racism from a Christian point of view? The mainstream culture needs to hear Christian perspectives on these topics. All truth is God's truth, and life doesn't fit neatly into sacred and secular compartments. I encourage all artists who are Christians to follow the muse even if it means producing work that may not be overtly religious. Who knows? If your church can't use it, maybe God has a purpose for it outside the confines of a Sunday morning service. As an artist you need to express the depths of your soul, even if it means working on something you might never do in church.

The Church's Perspective

Above all, an artist needs to realize that every church has a mission to spread the gospel, preach the Word, make disciples, care for the poor, and engage its members in worship. Therefore, the church is often more didactic in its approach because it sees the arts as an effective tool for carrying out its mission. That's not always a bad thing. In fact, most art produced in our culture, whether pop or serious, is utilitarian to some degree. It has a purpose. That purpose might be to entertain, make money, sell a product, express an opinion, communicate an idea, display an artist's talent, or fit into some kind of marketable mold. I'm a proponent of "art for art's sake" (unless it's used as an excuse for making bad art), but there is really very little pure art created in today's culture.

My fellow artist, your art can play a vital role in the church's mission, but the church is not a *platform* for your art. For that reason, it is unrealistic to demand that your church be the place where your full artistic potential is realized. Sometimes that happens; sometimes it doesn't. The church is not

responsible for making sure you are artistically gratified. Just as I advise churches against using art in ways that feel contrived or preachy, I encourage you to respect the mission of the church. It has a mandate from Jesus Christ to "go and make disciples of all nations, baptizing them in the name of the Father and of the Son and of the Holy Spirit" (Matthew 28:19). The purpose of the church is far more important than showcasing the talents of its artists.

The Story Behind *Jairus*

A few years ago our church produced an original musical called *Jairus*. It was based on the story from Luke 8 of the synagogue ruler who sought out Jesus to heal his dying daughter. If this had been the work of a group comprised solely of artists, we probably would have focused on the touching father-daughter relationship as the main theme of the show. The climax would have been her healing. In fact, that's the direction we took at the onset, but as we progressed, the fact that this would be a church-sponsored Holy Week event forced us to also consider our church leaders' input. In one song written early in the process, Jairus sings of his unconditional love for his daughter, prompting several leaders to point out the powerful parallel between Jairus's sacrificial love for his daughter and God's love for us. In fact, they wanted to make that the main theme of the show. Out of respect for the evangelistic mission of our church, we artists submitted to the wisdom of our leaders, and our little musical took on an evangelistic thrust of epic proportions.

In the months prior to opening night, our teaching pastors encouraged the congregation to pray, build relationships with seekers, to share the gospel with them, and invite them to the performance. The entire congregation mobilized its energies and resources around this musical. As the creators, we were buoyed by the congregation's support, but we were also concerned about the artistic integrity of our work. We respected the evangelistic designs our leaders had for the show, but we didn't want *Jairus* to come across as trite Christian propaganda. The tension this created prompted many discussions. We eventually worked it out, and in the end, over 40,000 people saw *Jairus*. Seed was sown and fruit was borne. It didn't turn out exactly the way we artists had originally envisioned, but we still ended up with a musical we were proud of, both artistically and spiritually.

Though every church and its artists need to settle on a purpose for the art they feature, I hope what I've shared helps artists and church leaders to understand each other better. As is often the case with differences between artists and the church, when both parties give and take amiably, they can form a powerful alliance.

How Much Freedom Do I Have as an Artist in the Church?

How much artistic license can an artist take in a church setting? A sound engineer may be asked to turn down the volume because some in the congregation complain the music is too loud. An actor may want to understate his or her closing lines while the pastor wants the lines overstated. A singer may be asked to move less or more or not at all depending on the church's style. At some point, every artist in the church asks, "How much artistic freedom do I have?" Because the church is not known as a bastion of artistic innovation, artists don't often trust church leaders to make tasteful aesthetic choices. In fact, some artists don't want anything to do with the church for fear of being put into an artistic straitjacket. On the other hand, if artists have no governor whatsoever, they might do things that are so artistically edgy the congregation would not understand what they are trying to say. So where's the happy medium?

A Word to Artists

I can't tell you how much artistic freedom is appropriate for your church and your artists. Every church needs to wrestle with this issue and decide for itself. What I can do is offer some advice to both parties. To artists I say: be patient. Artistic freedom is not something one demands. It is earned by working cooperatively within the limitations of the environment and patiently bringing everyone else around to your way of thinking. Also, the more trustworthy you prove yourself to be, the more freedom you'll be given. Understand that your leaders take the heat and field the complaints every time you go off and do your own thing. Don't make their jobs any harder than they already are by griping that they cramp your style. And if you've previously abused the artistic freedom you've been given, your leaders (and the congregation) are probably nervous every time you get up on the platform. You will have to work hard to regain their trust.

Unlike you, your church may not be up on the latest artistic trends, but that doesn't always make your opinion right. It's important to become a student of the congregation God has called you to serve and to learn what works and what doesn't work in your setting. The church is not the appropriate place for esoteric nuances that go over everybody else's heads. I'm not suggesting you dumb down things to the point that your revisions suck all the life out of your work, but that you strive to stay in touch with your target audience. I especially admire Isaac Watts, the great hymn writer, for his ability to create art that was both excellent and accessible to the average person in the pews. He said, "I would neither indulge any bold metaphors, nor admit of hard words, nor tempt the ignorant worshiper to sing without his understanding."[31]

It may help to remember that artists outside the church also struggle for artistic freedom. There are always concessions to be made—to the audience, the players, the critics, and those writing the checks. There are often time and budget constraints as well. A good friend of mine has a brother who writes movie scripts for a living. After he writes a script, a producer may demand huge changes. Then the director may want certain changes and may even hire other writers to rewrite parts or all of the script. Then the investors give their input. By the time the movie comes out, it may bear little resemblance to the original script. Successful artists learn to work around the limitations that stand in the way. You must always do the best you can with what you have.

A Word to the Church

To church leaders I say: be open to new ideas from your artists. If you give them a reasonable amount of freedom, they will serve you well. The arts can inspire people and communicate in ways that a sermon can't. Artists are by nature innovative and creative. They often have fresh ideas that can breathe life into a church service. Be open-minded. Hear them out. You won't get the best out of them if you try to control every aspect of what they do. Give artists as much freedom as you're comfortable giving, and then help them understand and stay in touch with your target audience.

I remember a period when I heard a number of our artists complain about feeling micromanaged. They felt we were being too rigid. Singers felt they had less freedom when they were on the platform, and music arrangers felt

smothered. I brought this concern to the attention of our leaders, and they, being artists themselves, were sympathetic. We started to give fewer details in our directions, and our artists felt they had regained some freedom. When working with artists, it's wise to be specific about what you want, but don't do their work for them. Instead of telling a musician every note you want in a piece of music, narrow your direction down to the most essential guidelines. If at any point you feel comfortable saying to artists, "Do whatever you think is best," that will make them feel trusted and believed in.

Artists tend to work hard and put in a lot of hours, so when they serve well, be sure to thank them. Be supportive. Encourage your artists to take chances— not recklessly, of course, but well-thought-out, calculated risks. When they fail, try not to overreact. If you give ultimatums or threaten to terminate their ministry over minor infractions, they'll become demoralized and insecure. If you have to curb their freedom, do so in firm but loving ways.

Steer Clear of the Christian Subculture

Here's a bit of advice for both artists and the church: don't use art to perpetuate a Christian subculture. In the United States at least, a segment of the Christian population has isolated itself from the rest of society to escape what it considers to be worldly influence. One result is the emergence of a Christian subculture that adopts and deems certain forms of art and entertainment more wholesome and edifying than others. Much of this is done in an attempt to protect children from unsavory influences in secular music, movies, and books, and while I'm all for protecting children from having their innocence shattered, this is taken to an extreme when we exchange immoral art for bad art. For example, the Christian music industry now offers a Christian version of every successful singing act currently on secular pop radio. Their lyrics may be less vulgar and their CD covers may show less skin, but unfortunately, they don't sound as good. Even if they did, doesn't it underscore our total lack of originality if the best we can do is to copy what the world is already doing?

When it comes to literature, many in this subculture read only Christian self-help books or biographies of godly people. Fiction is frowned upon unless it deals with Bible characters, but you can find Christian romance novels should you be so inclined. As with the music, many of these books are poorly written

substitutes for what's on the *New York Times* best-seller list. It's no wonder modern-day Christians have a reputation for producing bad art. It's also no surprise that artists are reluctant to use their talents within a Christian subculture. After all, what artist wouldn't feel hopelessly trapped in an environment that doesn't value excellence, fosters narrow-mindedness, and allows little or no artistic freedom?

According to Christ, we are not of this world, but we are still very much in it (John 17:11–14). We may be "aliens and strangers" here on earth (1 Peter 2:11), but we are commanded to let our light shine before the world in such a way that they see our good works and glorify our Father in heaven (Matthew 5:16). In other words, we're supposed to engage with the world around us and make a positive impact, not escape into a comfortable Christian enclave. To borrow a line from Rebecca Manley Pippert, we can't be the salt of the earth if we remain in the saltshaker. The challenge of living holy lives in an unholy world creates a tension we all need to face.

Churches that cater to the Christian subculture soon begin to function like exclusive country clubs. They use Christian jargon only the initiated understand, and they talk about things that seem irrelevant to most people's lives. They also sing music that sounds out-of-date. For obvious reasons, outsiders, and especially non-Christians, don't feel welcome.

On the other hand, when a church is serious about reaching lost people, the arts can help it communicate in ways that are imaginative, relevant, and timely. That's what Jesus did. He didn't speak only to the religious folks of his day. He went after the nonreligious, and he told them stories about a farmer sowing seed, about a sheep getting lost, and about a wayward son returning home. These were all things his audience could relate to. In the same way, a church and its artists can partner to effectively reach a wide variety of people, not just the Christian subculture.

Who Should Have the Final Say When It Comes to Artistic Decisions?

Because the making of art involves dozens of aesthetic choices, this question begs to be answered. Who has the final say? Should it be the artist? The team leader? The ministry director? The pastor? If the pastor is not an artist, will

artists respect his or her opinions? If an artist is not a seminary graduate, should he or she make decisions that affect the spiritual life of an entire congregation?

To discuss how we handle this issue at my church, I should begin by describing our decision-making process. At Willow Creek most decisions about the programming elements of a service are made as a team, and our planning meetings tend to be very lively. Typically, someone offers an idea or a suggestion. Someone else jumps in to support or expand on it. Another person might refute or challenge. After animated discussion, the best ideas emerge, and we eventually arrive at a consensus that represents the collective best efforts of the group. The wisdom of this approach comes from Proverbs 11:14, which says, "Many advisers make victory sure." When a group considers multiple opinions and arrives at a consensus, the decision is likely to be the best one possible.

The process I've just described produces the best results, but it's not infallible. There are still occasions when a leader with the proper authority needs to step in and, for good reason, reverse a team's decision. Whether working on a film project, a play, a ballet, or a church service, everyone needs to know who has the ultimate authority. Out of respect, every artist involved needs to defer to that individual. At Willow, weekend service director Corinne Ferguson has the final say on the programming elements for our seeker services. With anything pertaining to New Community, our midweek services, New Community director Pam Howell has the final say. Nancy Beach oversees the entire programming and production department, so she is next in the line of authority. But the person who ultimately has the final word on any decision we make is our senior pastor, Bill Hybels. If Bill, Nancy, Pam, or Corinne wants to make a change, the rest of us need to submit to their leadership. Hebrews 13:17 sums it up nicely: "Obey your leaders and submit to their authority."

When you disagree with a decision, I don't advocate suppressing your opinion and mimicking your leader's preferences. That's inauthentic submission. Instead, talk to your leader and share your ideas and concerns. Unless it's a serious issue, make the discussion brief, and be sure you hear out your leader. Follow his or her logic carefully, because if the decision stands, you're going to have to submit and then clearly articulate the leader's line of reasoning to others involved in the service, and you'll also need to do that without any trace of insubordination.

For example, suppose I am the music director and have been asked to cut a chorus from a worship song because it feels too long and redundant. If I go back to the worship team or the band and sarcastically joke that the "worship police" want us to omit the last chorus, I've misrepresented my superiors. I've made it sound like an ugly, top-down power play. Remember, it is the leader's prerogative to have the final say. If I further let on that I think my leader's decision is stupid and unfair, I injure the leader's reputation.

It would be better for me to say to my musicians, "Let's cut the last chorus. The song is starting to feel long." That way it doesn't come across like I'm reluctantly following orders. In fact, I make it sound like it was my decision—and rightfully so. If I've had the opportunity to discuss this with my leaders, either I concur with the decision or I come to understand some aspect of their logic that I can make my own. How you communicate the wishes of your leaders to others reveals your true character. Don't use them as scapegoats. Whenever you can, protect your leaders from becoming the brunt of resentment among the other artists in your church.

How Should Last-Minute Changes to the Service Be Handled?

Once after arriving early to speak at an arts conference, I decided to watch the musicians rehearse. Everything was going smoothly until they came to the song that would follow my presentation. After several start-stop attempts, people were starting to get a little uptight because the band and the singers couldn't stay together. One of the vocalists said, "I think we should do it this way," and proceeded to demonstrate. Another replied, "But that's not how we rehearsed it." The first vocalist asserted, "Yeah, I know. I want to change it."

The bewildered bandleader, who was the group's bass player, joined the vocalists with the music in his hand, and a rather frenetic discussion followed. I couldn't hear all of what was said, but I saw one person point to some spot in the chart, prompting another person to emphatically shake his head no and point to a different spot. Then two other individuals put in their two cents while the bandleader threw up his hands in disgust. "We can't be making all these changes at the last minute," I heard him say quite angrily. Finally, the

conference producer came over and informed everyone that the first session was about to begin.

The conference started with a wonderful time of worship, and then I got up to speak. At the end of my talk, I prayed and then sat down fully expecting to hear a closing song. A couple of the vocalists sheepishly meandered onto the platform, but the band was nowhere in sight. Apparently, the bandleader had decided to make a last-minute change of his own. He canceled the last song, but he didn't tell anyone except the band. The result was utter confusion.

Artists are always making improvements to their work. Rewrites and revisions are part of the creative process for any writer. Performers constantly make adjustments and alterations. Sometimes the changes are small and easy to do, like adjusting a tempo or a lighting cue. Sometimes, though, they're not. An author, for instance, may discard entire chapters before arriving at a final manuscript draft.

While church artists must always be open to changes that improve their work, it can be challenging when those changes are requested at the last minute. This is not uncommon in church work. A drama director may discern that entire sections of dialogue are not working and want to alter them right before the service. The pastor may want to add, change, or cut a song the day before. No matter how thoroughly we try to plan a service, no one knows how well the elements will work together until we've seen them for the first time.

So here's the question: is it ever too late to change something once it's been rehearsed? If so, at what point is it too late? I know a music director who refuses to make any changes between rehearsal and the service no matter how small, even when doing so would deepen the impact of the service. Sometimes the issue is a clash of opposite personality types. Someone who likes to follow an order of service previously planned down to the last detail is going to be vexed every time a spontaneous worship leader suggests all sorts of eleventh-hour changes.

I noticed this problem at my church when music directors sent up distress signals about some last-minute tweaks the producers were making between our three weekend services. Although they were mostly minor changes, they still involved some work. By now you've undoubtedly picked up that the main theme of this chapter is this: *Whenever artistic or philosophical differences arise,*

talk them out. So we got the music leaders and producers together to discuss the problems brought on by last-minute requests for changes.

We had a very honest discussion in which the music directors aired their frustrations. Sometimes they felt left out of the loop and didn't understand the reasons for the changes. Other times the changes were so last-minute, the directors barely had enough time to notify everyone before the next service started. Some of the last-minute requests were difficult to carry out if a key musician wasn't a quick study. The producers also gave their perspective. They weren't trying to be cavalier or careless about making changes. Their goal was to make services the best they could possibly be.

It didn't take long for everyone at the meeting to realize that we all have the same objective—for the arts to be done with excellence and used by God to bring people closer to him. (The more we work together, the closer we come to achieving that goal.) We then established some guidelines to follow the next time this issue comes up, so the discussion proved helpful. Also, everyone left that meeting with a greater appreciation for the role each team member plays and a deeper understanding of what it takes to perform that role. Last-minute changes are a fact of life for the artist in the church. It is important to navigate those changes without frustrating your artists or jeopardizing the quality of the service.

CARAVAGGIO'S CONUNDRUM

To conclude this chapter, I'd like to draw from the annals of art history and share a story that contains, to some degree, all four of the philosophical issues we've just covered. In February 1602, church officials in Italy commissioned Caravaggio to paint an altarpiece for the Contarelli Chapel at the Church of San Luigi dei Francesi in Rome. *The Inspiration of Saint Matthew* was to be completed by Pentecost, which fell that year on May 23—less than three months hence. Although Caravaggio completed the painting ahead of schedule, church leaders were displeased and rejected it (plate 6). They were concerned that Matthew looked like a backwoods country peasant rather than a revered saint. The angel in the picture appeared to guide Matthew's hand so forcefully that one might have concluded the saint was stupid and illiterate. Church officials were also concerned about the prominence of Matthew's large, bony foot. Because the

painting would hang behind the altar, every time the priest raised the Host during the Eucharist, the body of Christ would be eye level with that bony foot— an unsavory distraction.

Caravaggio could have reacted belligerently to this criticism. After all, he was a famous artist, and the changes they were asking for weren't minor. To address their concerns, Caravaggio would have to start over—this time with a deadline breathing down his neck. He could have thought to himself, *What do those church people know about art? Why are they micromanaging me? Who are they to tell me what's good art and what isn't?* In response to church officials, a lesser person might have thrown up his hands and said, "This is my best work. Take it or leave it, because there is no way I'm going to finish a whole new painting by May 23."

Instead, Caravaggio went back to the studio and started over. The result was a painting art historians consider an even greater masterpiece (plate 7). It captures the gentle dignity of one who walked with Christ as a young man and who now, as an old man, is reflecting on his experiences and writing them all down. Notice the eager intensity with which Matthew writes. Instead of sitting, as he is in the first painting, he is standing, leaning over his desk. His eyes are trained on the angel in an intense effort to record exactly what God would have him write. One knee on the stool causes it to balance precariously in the foreground, making it appear as if inspiration struck suddenly and Matthew ran to his desk to capture it. The first painting is good, but the second is a stunning triumph.

When I struggle to navigate the artistic and philosophical differences I encounter in ministry and with others in the church, I draw great inspiration from the story behind this painting. I hope to handle my own controversies and tensions with as much grace and wisdom as did Caravaggio.

Follow-up Questions for Group Discussion

1. Do the artists at your church listen to and respect each other's opinions? What have you observed that causes you to answer yes or no?

2. What are some specific ways you can demonstrate respect for the opinions of the people you interact with at church?

3. How can you and the other artists on your team gather more feedback about your work from some of the nonartists in your church?

4. Would you describe yourself as a thinker or a feeler? (If you are both, what proportion of each would you say you are?)

5. What advantages does as a thinker have when it comes to expressing opinions? What are the disadvantages?

6. What advantages does a feeler have when it comes to expressing opinions? What are some disadvantages?

7. Is it clear to the artists at your church who has the final say on artistic decisions? If it's not clear, whom can you ask to help answer this question?

8. Do you experience many last-minute changes when you perform at church? Is that process handled well? Do you have any suggestions about how it could be handled better?

9. Of the following four questions, which has the greatest potential to be a problem at your church?

What is the purpose of art?

How much freedom does an artist have?

Who has the final say when it comes to artistic decisions?

How should last-minute changes to the service be handled?

10. Are there any other artistic or philosophical controversies between artists and the church that you would add to the list above?

Personal Action Steps

1. List some indications that the relationship between your church and its artists is a healthy one.

2. Write a letter of encouragement to the leader who is responsible for those healthy aspects of the relationship between your church and its artists.

3. What are some indications that the relationship between your church and its artists needs improvement?

4. Beside the ones already mentioned, are there artistic or philosophical differences between your church and its artists that have the potential to alienate those artists or jeopardize the quality of your services? What is the underlying issue or question?

5. Which leaders can you meet with to try to resolve any of the artistic or philosophical differences that exist between artists and your church? Who needs to be a part of those discussions? Is there anything else you can do to improve the relationship between your church and its artists?

chapter ten:

How to Fall in Love with Your Church ... and Stay There

Salvation

(after Jonathan Holden)

> Granted, the choir
>
> is an embarrassment. Those faces
>
> are too simple to be true. Take
>
> Mrs. Beamon, our soprano, whose
>
> perfect smile might warm some
>
> into admiration, if they can forget
>
> how she daily cows her skinny
>
> alto daughter into tears.
>
> The choir master himself
>
> is ridiculous; the way he stands
>
> tells everyone how short he thinks
>
> he is. That alone could help you
>
> like him, but when he takes every solo

like a general at war, you'll

probably change your mind.

Those two alone can make forgiveness

a nearly impossible thing. And each

of these singers has a similar story,

a sad quirk that tries each week to shape

those smiles into something lovely.

If you glance over this scene

too quickly, or without enough

real humor, you might write off every other scene

it touches, every kindness

that allows such comic abuse

to abound. You might see

those hilarious faces and believe

they are the whole show; you could miss

the real act. The comedy

is this: despite the annoyance

of grace, and this tired music

of salvation, it is what we all expect.

Scott Cairns

Sean is a youth pastor at Main Street Bible Church. That's where he met Megan Miller, the girl of his dreams. They met while attending the college-age group and have been dating for three months. Sean thinks this could be it—she might just be *the one*. A lot depends on the next couple of hours. Tonight is meet-the-parents night, and although Sean regularly speaks before large crowds at youth conferences and leads worship every week at the church's contemporary service, he's nervous about meeting Megan's family. She has assured him her parents will love him and that everything's going to be okay, but he still is eager to make a good first impression.

The introductions go well. Right away Sean sees that Megan is a spitting image of her mother. Her father shakes Sean's hand and says, "Glad to meet you, son. You can call me Frank." As they sit down to eat, Megan introduces her two brothers, identical twins who are both seniors in high school, and her baby sister who at sixteen isn't much of a baby anymore.

As Megan's mother asks Sean to say grace, Megan holds his hand under the table to encourage him. At the end, they all chime in with a hearty amen. Sean breathes a sigh of relief. So far, so good.

Amid the clanging of silverware and plates, Megan's mother says, "I hear you're quite the musician, Sean."

"Well, I play guitar and a little bit of piano, but what I'm probably best at is writing worship choruses," Sean replies.

"Did you know Frank plays the trumpet?" she interrupts, smiling at Megan's father.

"Is that right, sir?" Sean asks.

Frank laughs. "Well, no, not really. It's been twenty years since I've touched the trumpet."

"I know," Megan's mom concedes, "but he used to be very good back when we first met." Frank shakes his head as if to say, *I can't believe she's telling a real musician that I play the trumpet.*

"Well, if you ever want to start playing again, let me know," Sean offers. "We sure could use another trumpet player at church."

"Thanks, Sean," Frank answers, "but I don't get out to church all that much. I play in a racquetball league every Sunday morning. It's the only recreational outlet I have these days. Do you play racquetball?"

"No," Sean says as he scoops some mashed potatoes onto his plate, "but I play tennis. Is it anything like tennis?"

"No, you'll mess up your tennis swing if you start playing racquetball," Frank warns.

Sean suddenly realizes why he's never seen Megan's dad in church. "So . . . you don't go to church?" Sean asks delicately. He's more curious than accusatory.

"I don't mean to offend you in any way, son," Megan's father starts out matter-of-factly. "I think what you're doing over there at the church is a really nice thing, but I don't believe in organized religion. I'm a PK, a pastor's kid, and I think I've done my time in church—and then some. Besides," he continues without any hint of anger, "in my opinion, pastors are all power hungry and church people are all hypocrites. If it were up to me, I'd go to the beach every Sunday and watch the sunset. That's my idea of church."

There's an uncomfortable pause. Megan looks down at her food. Mrs. Miller senses the awkwardness and playfully scolds her husband. "Frank, you make it sound like we're backsliders." Then she tries to clarify. "We're churchgoers. In fact, we're members at your church, Sean, but I attend other churches too. I think it gives me a more rounded view. I go to First Christian when Pastor Johnson speaks. He's such a great teacher, very dynamic. I go to First Bible for the worship. They really know how to worship over there, and sometimes I go to Springfield Community. They have some of the best guest artists in town."

Sean doesn't know what to say. Megan had told him her folks were Christians with some pretty unorthodox views, but he wasn't expecting them to have such a low opinion of the church. He sticks a big forkful of mashed potatoes in his mouth to keep from saying something he might later regret. Meanwhile, Megan's sister and brothers, who have been quiet the whole time, finish their meals. They excuse themselves and run upstairs to their rooms. As they leave, Sean realizes he's never seen any of them at the church youth group. Megan recognizes a perplexed look in Sean's eyes. She squeezes his hand under the table and, in an effort to change the subject, cheerfully asks, "So, Dad, how are things going at work these days?"

Questions for Group Discussion

1. What are some of the drawbacks to hopping from one church to the next like Megan's mother is doing?

2. What are some of the benefits to having a church home and being committed to it?

3. Why might someone like Megan's father have such a low regard for pastors and church people?

4. What attitudes are Megan and her siblings learning from her parents about the church?

5. Do you see any conflicts ahead if Sean marries into this family and continues to work for a church?

6. What do you like most about your church?

7. How important do you think it is for Christians to be committed to a local church?

8. Have you had any bad church experiences that you feel comfortable sharing with the rest of the group?

9. In your opinion, what are some of the signs of a healthy church?

10. Why do you suppose some non-Christians have a low opinion of the church?

SURVIVING THE UPS AND DOWNS OF LIFE IN THE CHURCH

I grew up in the 1960s and '70s. Those were tumultuous times. Three key political figures were assassinated—President Kennedy, his brother Robert Kennedy, and Dr. Martin Luther King Jr. The US was sharply divided over the war in Vietnam, and antiwar protests were constant and often violent. The Ohio National Guard opened fire on a mob of student protesters at Kent State University, killing four. There was student unrest on every major campus in America and riots in every major city. The 1968 Democratic National Convention turned Chicago into a war zone. Our morals unraveled, as mind-altering drugs, though addictive and illegal, were popularized by our favorite rock stars and celebrities. Sexual indulgence of every kind was applauded, even flaunted. It seemed as though society was falling apart. A sign of the times was a pop song that posed the obvious question, "Don't you think we're on the eve of destruction?"[32]

In spite of all the unrest, my growing-up years were comparatively uneventful, enabling me to emerge from that era affected but unscathed. There were, however, two traumatic experiences that took place during my formative years, and interestingly, both of them occurred at church.

The first happened during my early teens, when I was involved in our church's youth group. A schism that had been brewing between our beloved youth pastor and the senior pastor developed into an all-out feud. I don't remember exactly how it started or even what the main issues were, but when the congregation started taking sides, it turned ugly. The older generation was pitted against the younger one, prompting emotional speeches at church meetings, loud arguments in the church lobby, and angry phone conversations in homes throughout the neighborhood. It even got physical. One night two men got into a shouting match in the parking lot. An altercation ensued, with pushing and shoving and even death threats. Both pastors eventually left, but it took that church several years to recover.

Fortunately, I had a respite from such conflict—and a view of what a healthy church could look like—over the next two years. I began to attend a youth group called Son City that was like nothing I had ever experienced. Son City had a band that played contemporary Christian music. They used drama and multimedia, and then this guy in his early twenties named Bill Hybels got up

and led a Bible study. It was the hottest thing going for high school students and, at its zenith, attracted two thousand students each week.

Son City was the highlight of our week, and every meeting was like a major event. It was loud, fun, and nonstop energy. That is, until Bill got up to speak. Then it was quiet. We students listened intently because we were all so hungry for spiritual truth, and Bill had a knack for making the Bible relevant to our lives. This was the first time many of us had ever heard that God wanted to have a personal relationship with us and that Jesus wanted to be our friend, forgiver, and the Lord of our lives.

We did not hesitate to invite all our friends to come to Son City, because we wanted them to experience what we were learning about God. In fact, reaching out to our friends who didn't yet know Christ was the driving force behind the ministry. No one had to tell us to build relationships with seekers—we all knew plenty of students who didn't know the Lord. And when we shared Christ with them or invited them to Son City, we never realized what we were doing was called "evangelism." It just seemed to be a natural next step to a bunch of young people who had been captivated by the love of Christ.

Bill and some of our leaders eventually started a church based on the same principles we learned in Son City. Willow Creek Community Church was born in October 1975 in a rented movie theater. It was a church for the unchurched, a place where our seeking parents and friends were welcomed with open arms. Relevant biblical teaching and the arts again played a prominent role at our weekly services. As a young church searching for a model after which to pattern itself, we drew a great deal of inspiration from another start-up church described in the second chapter of Acts:

> They devoted themselves to the apostles' teaching and to the fellowship, to the breaking of bread and to prayer. Everyone was filled with awe, and many wonders and miraculous signs were done by the apostles. All the believers were together and had everything in common. Selling their possessions and goods, they gave to anyone as he had need. Every day they continued to meet together in the temple courts. They broke bread in their homes and ate together with glad and sincere hearts, praising God and enjoying the favor of all the people. And the Lord added to their number daily those who were being saved. (Acts 2:42–47)

We were astounded that what the writer of Acts described was actually a church. Those people were serious about the Word of God. They were devout prayer warriors. They participated in the sacraments in a way that was meaningful instead of ritualistic. They worshiped. They witnessed. Their fellowship was genuine and their friendships ran deep. They shared meals together, and those who were financially well-off shared with brothers and sisters in need. We wanted to be that kind of church.

After a couple years, though, I had the opportunity to take this vision and apply it elsewhere. I moved to another state to do youth ministry—my first official job in professional church ministry. Unfortunately, it was also to be the scene of my second horrendous church ordeal.

The youth group I led was going along beautifully. Students were coming to Christ, our numbers were growing, and I was happily engaged, looking forward to my wedding day in a few months. Little did I know that storm clouds were gathering. A sharp disagreement arose between the pastor and another staff member. Again, the issues are fuzzy to me now, but I remember clearly that everyone took sides, and the conflict mushroomed into a churchwide tug-of-war. Dreadful things were said about the pastor, whom I admired and respected. His character was attacked, his leadership was criticized, and his methods were assailed. Some people threatened to leave the church; others threatened to stop contributing financially unless the pastor departed.

The youth group we had worked so hard to build suffered, as some parents withdrew their kids in a show of defiant solidarity against the pastor. One of the students I had asked to stand up with me in my wedding declined because it was perceived that I was on the pastor's side, that I was one of *them*.

During those turbulent days, church business meetings had a higher attendance than Sunday morning services. At one of those meetings, members voted on whether or not to retain the embattled pastor. He won this vote of confidence by a very narrow margin, but it was obvious that leading a congregation split practically down the middle would be a daunting task. The pastor resigned and started another church in the area. Other staff members quit the same week, claiming the church needed to start over with a clean slate. The elders called me in to ask whether I intended to stay or leave. I honestly didn't know how to

answer that question. I was disillusioned and wondered whether I really wanted anything to do with church ministry anymore.

After much prayer and deliberation, I decided not to give up. I had seen the darkest side of church life and was a little gun-shy, but I couldn't get the Acts 2 church out of my mind. That church turned the world upside down—why couldn't that happen again? Even though I wasn't sure if the church was up to the task, I was convinced that our world desperately needs all that the church—and only the church—can offer. This was my first inkling that God was calling me to give my life in service to the local church.

Many of my convictions about the church have rubbed off on me from my pastor, Bill Hybels. Those of us who have the privilege of sitting under Bill's leadership and teaching have heard him say hundreds of times that the church is the hope of the world. In his book *Courageous Leadership*, Bill asserts that the efforts of government, business, education, self-help programs, and psychology are important and beneficial, but they can only do so much. They're incapable of truly transforming the human heart. Bill contends that this is the mission of the church:

> I believe that only one power exists on this sorry planet that can [transform the human heart]. It's the power of the love of Jesus Christ, the love that conquers sin and wipes out shame and heals wounds and reconciles enemies and patches broken dreams and ultimately changes the world, one life at a time. And what grips my heart every day is the knowledge that the radical message of that transforming love has been given to the church. . . .
>
> There is nothing like the local church when it's working right. Its beauty is indescribable. Its power is breathtaking. Its potential is unlimited. It comforts the grieving and heals the broken in the context of community. It builds bridges to seekers and offers truth to the confused. It provides resources for those in need and opens its arms to the forgotten, the downtrodden, the disillusioned. It breaks the chains of addictions, frees the oppressed, and offers belonging to the marginalized of this world. Whatever the capacity for human suffering, the church has a greater capacity for healing and wholeness.
>
> Still to this day, the potential of the local church is almost more than I can grasp. No other organization on earth is like the church. Nothing even comes close.[33]

WHAT WONDROUS LOVE IS THIS ANYWAY?

Given the inconsistency of the church's reputation, you may be wondering, *What does Jesus see in the church? How can he love something that's so far from what it should be?* Or, to bring it closer to home, *How could Jesus love* my *church?*

Actually, Jesus sees more of the church's shortcomings than you and I do, but he has a totally different perspective. He sees the spiritual battle going on behind the scenes, but he knows the outcome has already been determined. Satan has targeted the church for annihilation. In fact, he's been trying to discredit, disrupt, and defeat the church for over two thousand years. Every day he launches deathblows in the form of persecution, scandal, and dissension. He knows he can't defeat God outright, so he ruthlessly goes after the little kingdom outposts God has planted all over the world. It's a struggle "not against flesh and blood, but against the rulers, against the authorities, against the powers of this dark world and against the spiritual forces of evil in the heavenly realms" (Ephesians 6:12).

The church therefore operates in a hostile environment. We are never without help from above, however. That's the message portrayed by the French artist Georges Rouault in his 1920 painting entitled *Christ in the Outskirts* (plate 8). Early in his career, Rouault created stained-glass windows, which accounts for the thick black outlines and intense colors that later characterized his paintings. In *Christ in the Outskirts*, the background is a cold, lonely, and desolate city at night; even the buildings seem to have facial expressions that cry out in horror over the depressing bleakness of this world. In the center foreground stands Christ, radiating a brilliant light that envelops the two children standing next to him. What a great picture of the church; we as his children—small and insignificant—gathered together in his name, trying to do his work in a world filled with hatred and cruelty. And our Lord and Savior, Jesus Christ, is always right beside us. He is our hope, our strength, and our ever-present help in time of trouble.

So even though the church fights for its life every day, be assured that it will prevail. In fact, the church has already won. Jesus said that the gates of hell will not overcome it (Matthew 16:18). The bride of Christ may stumble along the way and appear disheveled at times, but she is still poised for the ultimate

victory—to be united in intimacy with Christ forever. In spite of persecution, division, and scandal, the church is still very much alive.

Even in those countries where Christians are persecuted, pockets of Christ followers are on fire for Jesus, willing to be harassed, suffer abuse, and pay the ultimate price for their faith. Recently I spoke at a church in Cuba. Amid government persecution and harassment, this church, without a church building, baptizes almost two hundred new converts every year. For a Cuban church to accept you as a member, most will require the applicant to first renounce Communist Party membership, so a new member's commitment is not cavalier by any means. Indeed, I met dozens of Christians—many of them artists—who had accepted Christ within the past year and were eager to talk about it.

One of the highlights of my trip to Cuba was the Friday night I spoke at a home church in a rural area. People overflowed the small house, so at great risk we decided to meet outside under the stars. A group of men worked for about fifteen minutes to get the only lightbulb in the house to travel down a string that extended outside the door so I could read my notes in the dark. Toward the end of the service, I invited everyone to share examples of God's goodness in their lives. One man shared that the Lord had saved him from an alcohol addiction and restored his marriage. Another told us that God had miraculously healed him within the past month. Then a young girl recited from memory the first couple chapters of Philippians and exclaimed how happy she was that Jesus loves her. Obviously, the Lord had been moving mightily among them. These people were very poor economically but very rich spiritually. They were living victoriously for Christ in the most difficult of circumstances, and they were some of the most joy-filled people I had ever met.

Jesus' love for the church is characterized by two things—unwavering loyalty and undying commitment. Jesus died for the church, and when he christened it with its mission—to make disciples of all the nations—he assured us he would be with us always, "to the very end of the age" (Matthew 28:20). Loyalty and commitment—rare commodities in today's frivolous society—are the trademarks of a true love for the church.

Loyalty

I love baseball, and all my life I've been a fan of the Chicago White Sox. I grew up in the northwest suburbs of Chicago, which should have made me a Cubs fan like everyone else in my neighborhood. I don't know whether it's because my dad and older brother were Sox fans before me or if I just chose the lesser of two losers, but my loyalty endures to this day. In fact, every spring I optimistically predict the White Sox are bound for the World Series. Then by mid-July, when they're out of contention, I start rooting for whatever team is playing the Cubs.

The White Sox organization makes a lot of decisions I don't approve of, never consulting me about the batting order, trades, game strategy, or personnel moves. We haven't won the World Series since 1917, so I live with constant disappointment. But in spite of the frustration, I'm still the team's biggest fan. I would never leave or forsake my White Sox. They're my team.

My point is this: some of us exhibit more loyalty to our favorite sports team—or rock group or politician, and so on—than to our church. Some threaten to leave over the slightest disappointment or failure. Others change churches at the drop of a hat. I'm sure God finds our transient loyalty disconcerting. Hosea 6:4 says God becomes frustrated when our "love is like the morning mist, like the early dew that disappears." Loving the church like Christ loves the church first of all means being loyal to it. Acts 2:42 tells us that the first believers were devoted to this thing called church. So resist the temptation to take your church for granted or to hop from one church to the next. Find a body of believers you can call home, and be faithful to it.

Commitment

Being devoted to your church goes beyond mere affiliation. You need to get involved. Many artists volunteer at church out of sheer gratitude for what the Lord has done for them. They agree with David, an artist who wrote, "How can I repay the Lord for all his goodness to me?" (Psalm 116:12). How about you? Do you go to church only to get something, or do you give in return?

Whether professionals or amateurs, all artists need to give whatever they can of their time and talent to their home church. That doesn't mean being

there every time the doors are open or neglecting family obligations, but stepping up to serve in whatever ways are possible. Church work was never meant to be carried out by a few professional staff people. Ephesians 4:12 teaches that leaders are supposed to "prepare God's people for works of service." We are all called to do the work of the church.

If you're looking for a worthwhile cause to commit to, look no further than your own church. The church is in the business of saving souls, so what you do matters for all eternity. If you play guitar in the church band, you're doing so much more than merely strumming chords. You're helping to bring people closer to God. Everyone who sings, acts, dances, plays, writes, creates, mixes sound, or runs lighting in church is doing their part to reconcile lost people to Christ (2 Corinthians 5:18–20).

The church needs you and your gifts. When anointed artists humbly submit their gifts to the church, a very powerful alliance is forged for kingdom gain. In a booklet entitled *Letter to Artists*, Pope John Paul II writes:

> In order to communicate the message entrusted to us by Christ, the Church needs art. Art must make perceptible, and as far as possible attractive, the world of the spirit, of the invisible, of God. . . . Art has a unique capacity to take one or another facet of the message and translate it into colors, shapes and sounds that nourish the intuition of those who look or listen. It does so without emptying the message itself of its transcendent value and its aura of mystery.[34]

If it's a challenge to fit serving into your busy schedule, give whatever time you can reasonably give. Commitment is rarely convenient. You may have to give up a weeknight at home to be at rehearsal. You might have to give up part of your weekend to help out at services. But anything done in the name of Christ is well worth the effort. Your commitment is not only a sign of character but also a great witness to your unsaved friends. Those who are artists will probably be astounded that you would offer your talents at church without expecting pay. And think of what it says to your children to see your involvement. By faithfully stewarding your God-given talents through the ministry of your church, you're setting an indelible example of commitment to your family.

YOUR CHURCH: THE BRIDE OF CHRIST OR THE BRIDE OF FRANKENSTEIN?

In Psalm 122:1 David states, "I rejoiced with those who said to me, 'Let us go to the house of the Lord.'" You may wonder what church he could possibly be referring to, because you certainly don't get that excited about attending your church services. Loyalty and commitment are nice, but a lot of what-ifs can stand in the way, including the four that follow.

What If My Church Has Problems?

Perhaps you're thinking, *My church? The hope of the world? I don't think so. You should see what goes on at my church, especially behind the scenes! My church has got some major problems.*

Granted, your church may have shortcomings. All churches do. Just make sure you are part of the solution rather than part of the problem. If you hear gossip, squelch it. If negativity and apathy spread all around you, turn the tide with a genuine can-do attitude. Encourage those with differences to talk them out. If you're embarrassed by your church's feeble attempts at using the arts, work within the structure to help them out. As much as possible, try to get on the solution side of your church's problems.

Prayer should always be part of the solution. Pray that the ministries of your church would be fruitful. Pray that the Lord would preserve the unity of your church and protect you from the attacks of the Evil One. The apostle Paul prayed regularly for the churches under his care. To the church at Colossae he wrote, "For this reason, since the day we heard about you, we have not stopped praying for you and asking God to fill you with the knowledge of his will through all spiritual wisdom and understanding" (Colossians 1:9). Whatever problems your church is facing, they are not insurmountable. "With God all things are possible" (Matthew 19:26).

What If My Leader Is Difficult to Work With?

You may be disappointed by some leaders at your church. They may be frustrating to work under, controlling or overbearing, or even embarrassingly incompetent. There may even be a personality clash between your leader and

you. But if you're going to love your church, you're going to need to come to terms with any such conflicts.

First, always give your leaders respect, whether or not you think they deserve it. First Thessalonians 5:12–13 (NLT) says, "Dear brothers and sisters, honor those who are your leaders in the Lord's work. They work hard among you and warn you against all that is wrong. Think highly of them and give them your wholehearted love because of their work. And remember to live peaceably with each other." King Saul was an evil leader, yet David showed him proper respect. Even though David had been anointed as Saul's successor to the throne, he introduced himself to the king as "the son of your servant Jesse of Bethlehem" (1 Samuel 17:58). When Saul offered David his daughter's hand in marriage, David replied, "Who am I, and what is my family or my father's clan in Israel, that I should become the king's son-in-law?" (1 Samuel 18:18). In most of his interactions with Saul, David was a class act.

Second, just as you pray regularly for your church, pray for your leaders. Pray for their walks with Christ to be strong and full of vitality. Pray for their marriages and their families, that they make wise decisions that are in the best interests of the church and that they follow God's direction—even if that means making decisions with which you disagree. Paul was a great leader, but he never hesitated to ask for prayer. With all the leadership challenges he faced, he knew he needed that support. "Finally, dear brothers and sisters, I ask you to pray for us. Pray first that the Lord's message will spread rapidly and be honored wherever it goes, just as when it came to you" (2 Thessalonians 3:1 NLT).

If you pray for a leader with whom you're having problems, one of three things will happen. God will either change you, change the leader, or change the situation. Proverbs says, "The king's heart is in the hand of the Lord; he directs it like a watercourse wherever he pleases" (21:1). I assure you that if a leader is truly a terrible leader, he or she won't last long. Inevitably, the situation will get so bad the leader will be forced to leave. Sometimes difficult circumstances are the Lord's way of removing someone from leadership. Psalm 75:7 tells us God is the one who raises up and brings down leaders. God has a history of removing bad leaders, but it will be in his way and according to his timing.

Third, put real effort into your relationship with that leader. You may never be the best of friends, but you need to be able to work together effectively. If the two of you have a problem, always make the attempt to talk together about it. The more effort you put into this relationship, the easier it will be to hear each other out. As Paul suggests in 2 Corinthians 6:13, open your heart to your leader. Try to get to know him or her as a person. Periodically get together, or if appropriate, suggest lunch. Ask how you can pray for your leader. Don't run from this relationship just because it's difficult, but work to build as good a relationship as you possibly can. "Make every effort to do what leads to peace and to mutual edification" (Romans 14:19).

Fourth, be patient. Cut your leader some slack and give him or her time to grow. Leaders are not perfect; we all make mistakes. I'm so grateful to my church for being patient with my immaturity and my leadership blunders over the years. I'm thankful they gave me room to grow. David showed a great deal of patience with Saul even when the king was trying to kill him. On two occasions, David could have taken Saul's life but chose to spare him. Instead of taking matters into his own hands, David waited and trusted for God to work in his perfect timing.

Last, make sure you relate to difficult leaders with the utmost integrity. Don't badmouth them. Don't retaliate or be vindictive toward them. If your leader is behaving badly, don't behave badly in response. Dealing with a difficult leader can be a test of your character. Pass that test with flying colors.

What If My Church Doesn't Value the Arts Highly?

Recently a woman came to me for advice. She started a visual arts fellowship group at her church, and artists in the group were experiencing deep levels of community. They were discouraged, though, about their role at the church. Apparently their church didn't utilize the visual arts very much, so these artists were frustrated at not being able to contribute their talents. Many of them, including the woman who sought me out for advice, were contemplating leaving the church. She asked what I thought she should do.

Of course, no one can tell you whether or not to leave your church. That's a serious decision and should be considered only if you're absolutely convinced the Lord is leading you to do so. Always make sure you're not running away

from problems instead of dealing with them, and if you leave, leave well. When Moses left Midian to go back to Egypt, he was following a definite calling from God. He didn't use the occasion to take any parting shots at his father-in-law for making him do menial labor in the wilderness all those years. As Exodus 4:18 reveals, he departed on good terms: "Then Moses went back to Jethro his father-in-law and said to him, 'Let me go back to my own people in Egypt to see if any of them are still alive.' Jethro said, 'Go, and I wish you well.'" Likewise, if you leave, do so in a conciliatory way, and as much as it depends on you, leave without any broken relationships in your wake.

Also, make sure you don't leave too soon. Often I've seen people walk away from their church because "it just wasn't working out," and six months later the change they were dying to see happen took place. But they weren't around to enjoy it.

That's what happened to the woman who asked me about leaving her church. Within a few months of our discussion, her church hired an arts director, and it appears that everything is turning around for her and the other artists. Similarly, I know a group of people who left their church because the choir wasn't featured as often as they would have liked. They felt this devalued the choir's ministry. Actually, the choir was between leaders, but instead of being a stabilizing force during a difficult time, these folks were bitter, outspoken, and divisive. On one hand, the church was better off that this negative faction of the music ministry was no longer around. On the other hand, I wonder if they left too soon. Within a year, a new director had introduced an exciting new vision for the choir. Had these former choir members handled the situation with more humility and grace, they would have reaped the benefits.

Keep in mind that God may have placed you at your church so you can play a part in bringing more of the arts into your church. Remember Mordecai's words to Esther, "And who knows but that you have come to royal position for such a time as this?" (Esther 4:14). Who's to say whether the Lord doesn't have you at your church for the same reason?

What If the Church Has Hurt Me in the Past?

You may have had some bad experiences with church. If you were once part of a highly legalistic church, you may still struggle with a lot of serious

issues. If you've ever been caught at the vortex of an infamous church split, you might have the impression that church is nothing but a bunch of self-righteous people who constantly bicker and fight. Worst of all, if you've suffered sexual harassment or any kind of abuse from someone at church, especially a pastor, it would be understandable for you to have major trust issues with the church.

No one would fault you for leaving a church that has harmed you deeply, but resist the temptation to wash your hands of all church involvement. Find another church—a healthier church—and when you do, start off with minimal involvement. You need time to heal. Instead of serving right away, you need the church to serve you. You need to sit under the teaching of your church and let it minister to your soul. You need to be refreshed by corporate worship. You need to discover new Christian friends. It wasn't the church that hurt you; that happened at the hands of some misguided people. Unfortunately, there are individuals like that everywhere. We all need to learn to avoid those kinds of people instead of avoiding the church.

WHAT YOU CAN DO TO IMPROVE YOUR CHURCH

When the church is working right, it's a powerful force for the kingdom of God. It's like a city set on a hill, shining its light for all the world to see (Matthew 5:14). It's a taste of heaven on earth.

We all have a part to play in making sure our church works toward that ideal. Peter describes the church as a bunch of "living stones" that come together to form a "spiritual house" (1 Peter 2:5). Remember, the church is not a building. The church is us. I've already stressed the importance of praying for your church and its leaders, so let's look at two additional things we can do to help our churches run well.

Look beyond the Externals to What's Really Important

Recently a group of us were standing around and talking, and a young man named Brian hung around on the fringes of our little pocket of fellowship. Brian is a nice guy, but he's a bit of a loner—the kind of person some would describe as "socially awkward." Brian tried to participate in the conversation, but he was clumsy and self-conscious, often creating an uncomfortable silence after he

spoke. He didn't say anything inappropriate or distasteful—his statements were just incongruous, and I think we all felt a little embarrassed for him.

After Brian walked away, one of the older gentlemen among us said, "Oh, Brian. He matters so much to God." When he said that, I instantly realized how insensitive and coldhearted I had been to Brian. I hadn't thought anything derogatory about Brian, but I sure wasn't thinking, *Oh, Brian. He matters so much to God*. I wasn't being controlled by the love of Christ (2 Corinthians 5:14). While the rest of us didn't seem to see Brian at all, this man looked beyond the externals and saw something noble and good. That's how God sees us. The Bible says that "the LORD doesn't make decisions the way you do! People judge by outward appearance, but the LORD looks at a person's thoughts and intentions" (1 Samuel 16:7 NLT). If you want to improve your church, start by looking beyond the externals; work at seeing people as God sees them.

Accept Those Who Are Different from You

When you look beyond the externals, you will find that people's personalities, their backgrounds, and even their quirks will strike you as winsomely unique instead of irritating. I know two artists who are exact opposites. One is quiet and shy; the other is bold and assertive. One is very sensitive; the other is a bull in a china shop. It's no surprise that these two don't get along well. Each one seems to press all the wrong buttons in the other. I work with both of them and I often feel caught in the middle. I've tried, but so far I haven't been able to get them to see how much they could learn from each other. The shy one could stand to be more assertive. The bold one could benefit from additional sensitivity. If they could get beyond the externals, I think they would understand and appreciate each other more, and maybe even become good friends.

There's another problem. Mr. Shy N. Reserved wishes that Mr. B. Assertive would be more considerate and more encouraging. I happen to know that Mr. B. Assertive grew up with absolutely no encouragement. In fact, as a kid he had to practice his music when his parents weren't around because the "noise" bothered them. Then he married a woman who thinks his amateur music making is a waste of time. If Shy N. Reserved could see beyond the outward appearance, he'd see that his brother in Christ doesn't know how to encourage people

because he himself has rarely been encouraged. He became bold and assertive to survive.

In the Acts 2 church, believers spent a lot of time together. They never could have known such a depth of unity without a high degree of love and acceptance. Romans 15:7 reminds us to "accept one another, then, just as Christ accepted you, in order to bring praise to God." Just as God looks beyond our outward appearance and accepts us, so should we accept and appreciate others. Jesus said, "So now I am giving you a new commandment: Love each other. Just as I have loved you, you should love each other. Your love for one another will prove to the world that you are my disciples" (John 13:34–35 NLT). If believers did nothing else but practice this single teaching of Jesus, the church would be the most powerful force on the planet.

Get to the Heart of the Matter

Too often church people think they're standing up for their principles when they're really just disagreeing about methodology. If we can set methodology aside and get to the heart of the issue, we often find there is more about which we agree than disagree.

One example is the controversy surrounding evangelism these days. There are many different philosophies to choose from. There's worship evangelism, seeker-sensitive evangelism, seeker-driven evangelism, postmodern evangelism, street evangelism, door-to-door visitation evangelism, and more. Which one is right? Every method has its strengths and weaknesses, but wouldn't we agree that what matters most is that lost people find Christ? If that's truly happening, then every one of these methods can be right. An even bigger current dispute involves worship. Which worship style is right: contemporary, traditional, blended, or liturgical? Again, if God is truly being glorified, aren't they all right?

First Corinthians 12:5 reminds us that there are a variety of ministries but one Lord. There are many different methods but one Spirit. It's okay for your church to do things differently than mine. Instead of criticizing and even undermining each other, why don't we pray, support, and learn from one another?

When we fail to get to the heart of the matter, we can end up missing the whole point. We're like those who criticized Jesus for healing the blind man on

the Sabbath. They missed the main point: a man who had been blind from birth was miraculously healed! In fact, their only reason for not believing Jesus was the Messiah was that he didn't keep the Sabbath like they did (John 9:16). To them and to all of us, Jesus says, "Stop judging by mere appearances" (John 7:24). When we look beyond the externals of methodology, we arrive at the heart of the matter.

The biggest controversy in the church today may not be over missions or evangelism or social action—it may well be over the style of music used during our services! We all differ in our musical tastes, yet we complain or even refuse to worship if the style of music doesn't suit us. Churches should use a musical style that the majority of the congregation prefers, but styles change. And to complicate matters, there are so many different styles to choose from these days—soft rock, hard rock, alternative, pop, inspirational, easy-listening, gospel, rhythm-and-blues, country, jazz, hip-hop, classical, and others. The battle lines in this controversy are too often drawn between the generations. Over the years, I've heard older people complain bitterly that the music is too loud or the worship leader plays the piano too hard or that the worship leader's hairstyle is inappropriate. I've heard younger people complain that the music is boring or that they can't worship in the Spirit because the worship leader is too old. Actually, those are the milder things I've heard; unfortunately, I've also heard much worse.

My brothers and sisters in Christ, can we call a truce on the debate over musical style? When it comes to worship, musical style is not the main issue. The words are. If the lyrics extol Christ, don't let anything stop you from worshiping "in spirit and in truth" (John 4:23). The apostle John tells us to "test the spirits to see whether they are from God" (1 John 4:1). The first test of any worship song or hymn is whether or not the lyrics lift up the name of Jesus.

Several months ago I was invited to attend a conference in Indianapolis. I am middle-aged, so when I walked into the arena and noticed that the majority of the conference attendees were older and grayer than I am, I felt a little out of place. But when the worship started, I felt right at home. The music was not my favorite style—it was more traditional and most of it was southern gospel— but the lyrics were deeply moving. I had a great time worshiping the Lord. A short time after that, I attended Axis, Willow Creek's ministry to postmodern

twenty-somethings. The music was loud and there was a lot of youthful jumping around onstage. But I know the leaders in Axis. They love Jesus. The words up on the screen were just as worshipful as any I had ever heard. Again, I had a wonderful time worshiping the Lord.

Two different worship experiences, two completely diverse styles of music—why do I have this feeling that this is what heaven is going to be like? I'm not saying musical style is unimportant. After all, I am a musician. But the older I get, the more I realize that musical style is another one of those externals that doesn't matter as much as we think it does. As long as the lyrics are God-honoring and Jesus is at the heart of it, I'm learning that I can worship anywhere, anytime, and with any style of music.

Be an Example of What You Want Your Church to Be

In the book of Revelation, Jesus addresses seven first-century churches by name, and he begins with words of encouragement. He commends one church for their perseverance, another for being faithful, and another for being loving. Then Jesus points out to each church the specific areas they need to improve. In a similar way, I'd like you to think about some of the improvements you'd like to see take place at your church. This is not meant to give license to whine and complain. This should be all about constructive criticism. Here is an exercise to get you started. Complete any one of the following statements by filling in the blank:

- I wish my church were more _____

- I wish _____
 was more of a priority in our church.

- If I could change anything about my church, it would be

- One of the biggest weaknesses or shortcomings of my church is

- I wish the people at my church were

You might want your church to worship more. Perhaps you wish your church put greater emphasis on prayer, evangelism, missions, or the arts. You may want your church to do a better job of shepherding or discipling. Or you might wish your church would treat volunteers better or that the people in the church weren't so cliquey. These are all valid desires. My challenge is this: whatever it is you want your church to get better at, make sure *you* are getting better at the same thing. In other words, be an example of what you want your church to become. Paul wrote, "We put no stumbling block in anyone's path, so that our ministry will not be discredited" (2 Corinthians 6:3). If there is a cause within the church about which you feel passionate, live your life with a consistency of character and you will bring credibility to the cause you choose to stand for.

I know a man who was convinced his church should make prayer a higher priority. He wanted to see prayer appropriated on a deeper, more consistent level. What a wonderful aspiration to have for one's church. However, instead of fervently praying and thereby demonstrating the importance of prayer, he became self-righteous and constantly complained that his church "didn't pray enough." He alienated many people. Then he left the church for another that had weekly prayer vigils. Had he stayed and grown in his own prayer life, I wonder whether God could have used him to change the church's priorities about prayer. Had he been humbler about the situation and become a prayer warrior on his own, the rest of the church might have sat up and taken notice. I wonder whether he might have won them over by simply modeling how powerful prayer can be.

Hebrews 10:24 exhorts us to "consider how we may spur one another on toward love and good deeds." By striving to be an example of what you want your church to be, you stimulate others to change for the better. Be sure to do everything you can to be spiritually healthy and you'll be contributing greatly to the fruitfulness of your church. If everyone in our churches made obedience, love, and spiritual growth top priorities, our churches would be powerfully magnetic places.

SORRY, I STILL CAN'T GET THIS "CHURCH THING" OUT OF MY SYSTEM

To conclude, I'd like to return to the words of my college professor that I shared at the beginning of this book. If you recall, he was disappointed that I was "wasting" my talent at church and said, "I thought you would have gotten this church thing out of your system by now."

Well, as it turns out, I never have been able to get this "church thing" out of my system. Its mission—to reach a lost world for Christ and to care for those in need—has gripped my heart. I know of no higher calling in life than to serve God, and no better place to do that than in the church. Its potential for growth fascinates me. The possibilities it holds for the arts, and its potential to be a safe place for artists, compels me. Its people have enriched me and frustrated me, but they have never proved to be unworthy of my love and respect. They're not perfect, but then, neither am I.

The church's future excites me. A hundred years from now, entire nations will have come and gone and the latest philosophies will be old hat. But the church will still be here. Sorry, Professor, but I can't get this "church thing" out of my system. I hope I never do. Because I absolutely love this noble band of believers, this improbable horde of history-makers, this graced collection of Christ-followers that we call the church.

Follow-up Questions for Group Discussion

1. After reading Acts 2:42–47, what aspect of the first-century church impresses you most?

2. If all Christians believed that the church is the hope of the world, how would that change their view of the church and their involvement in it?

3. What are specific attitudes and behaviors that, if you saw them in others, would lead you to believe that they are loyal and committed to their church?

4. What is one challenge your church faces in the coming year, and what can you do to help meet that challenge?

5. Based on the material in this chapter, what advice would you offer someone who's having difficulty with a church leader?

6. What advice would you give someone who's contemplating leaving his or her church?

7. What are some of the different strategies for evangelism, and how do you perceive the strengths and weaknesses of each?

8. Why do you think musical style is such a touchy subject in churches today?

9. How can you be a positive influence in bringing about change in your church?

10. In what areas can you personally set a good example of what you want your church to be?

Personal Action Steps

1. Write down the names of two leaders at your church whom you will pray for regularly.

2. List two ministries in the church that you will pray for.

3. Show appreciation for one of your leaders at church by doing something special or writing a note of encouragement.

4. Is there anybody at church with whom you're at odds with over methodology? That is, you disagree with their methods of evangelism or worship? Are you handling the disagreement in a God-honoring and loving way?

5. Is there anything about your character, behavior, or lifestyle that is a bad reflection on your church? If so, what can you do to correct that?

appendix:

"Those Artsy Types": From the Introduction to The Heart of the Artist

Some time ago I spoke at a church conference in Ft. Lauderdale that was attended mostly by pastors and church leaders. I talked about the current state of church music and the future of the arts in the church. However, my deeper passion is for Christian artists to be living lives of integrity and godly character, so I sneaked in a few words about character and integrity. I hardly mentioned it, yet there was a flurry of questions afterward, all dealing with the issue of character and integrity in the lives of artists in the church. Character is fast becoming the hottest issue facing artists in the church today. In fact, the majority of the questions I get about church music ministry never have much to do with music. They revolve around character issues: How can I get my people to serve with a servant's heart? How can I cultivate unity on the team? How can I get my vocalists or my drama people to get along with each other? What should I do about the attitude problems of a few of my musicians? The music department and other arts-related ministries have become a hotbed for major character problems in the church. I've even seen more than a few music ministries blown apart because their leaders failed to address such character issues.

I've had pastors call me, frustrated over character issues they see in their music staff. "Our music director doesn't listen to suggestions," they'll say, or "He doesn't take criticism well. He's not a team player—he's more interested in doing his own thing."

I've also heard music directors express similar frustrations about their volunteers. "So-and-so is a great keyboard player, but they're just so difficult to work with," or "Our key vocalist throws a temper tantrum and threatens to quit once a month. We're scared because we can't afford to lose any of our best vocalists right now. What should we do?"

For too long churches have ignored the problem, letting character issues in the lives of artists slide. We've turned our heads, hoping the problem would go away by itself, but it never does. A pastor sat with me on the bus back to the hotel at this conference in Ft. Lauderdale, and he said something very revealing: "I just leave those artsy types alone. They're kinda off in their own little world anyway."

What did he mean by "those artsy types"? How do you know if you're one of those artsy types? If you love music, drama, art, film, photography, dance, sound, or lighting, if you love doing artistic things—singing, playing, performing, writing, creating, or expressing—chances are you have some kind of artistic streak, large or small or somewhere in between. You might be someone trying to pursue a career in the arts or someone who dabbles in the arts as a hobby. Maybe the extent of your artistic involvement is that you sing in the back row of the church choir. You might be an "amateur" or you might be a "professional." You might be a performer, a creative person, or both. Perhaps you work with artists or live with an artist and want to understand us artsy types a little better.

Unfortunately, there are certain negative stereotypes that are attached to people with artistic temperaments. Some people say that we are temperamental and eccentric. Some people think we're difficult and strange. Some might say we are moody and emotionally unstable. Others see us as free-spirited, quirky, and undisciplined. Excuses are often made for the shortcomings of the artistic temperament, more so than with any other temperament. The problem occurs when we artists buy into those excuses and use them to justify unacceptable behavior.

The negative stereotypes are unfair because not all people with artistic gifts fit the mold. My son informed me the other day that in school he was learning about how weird musicians are. He had been taking a music appreciation class, and what impressed him the most was that Beethoven had such a bad temper that he would cause a scene in a restaurant if his food wasn't right, that women would throw their room keys onstage at Franz Liszt, and that Wagner was a quirky man with strong anti-Semitic views. Since so many of the musicians he was learning about were very strange, it made me wonder what he thinks about me!

THE MELANCHOLY TEMPERAMENT

For centuries now scholars have been fascinated with the artistic temperament. It started with the ancient Greeks, who divided human personality into four main categories: choleric, sanguine, phlegmatic, and melancholy. Aristotle said that "all extraordinary men distinguished in philosophy, politics, poetry, and the arts are evidently melancholic."[35] As a result, people with an artistic bent were labeled as melancholy, which is somewhat misleading because not all artists are predominantly melancholy. I know quite a few who have only a few melancholy tendencies, and others who aren't melancholy at all.

During the Middle Ages melancholy was considered a physical disorder, and the church regarded it as a sin similar to slothfulness.[36] However, during the Renaissance melancholy made a comeback and was seen as a divine gift. Astrology played a large role in Renaissance thinking. A person's behavior was determined at birth by his or her planet's conjunction with other celestial bodies. Saturn was the planet for the melancholic. Someone born under Saturn would "be either sane and capable of rare accomplishment or sick and condemned to inertia and stupidity."[37] The capability for "rare accomplishment" obviously made the melancholy temperament quite fashionable during the Renaissance. In fact, it was written that "a veritable wave of 'melancholic behavior' swept across Europe" during the sixteenth century.[38] The more eccentric an artist was, the more he or she was considered a "genius."

In spite of this rather exalted view, which continued well into the Romantic period, the melancholy temperament has always had its share of negative press. Even at a time when the melancholy temperament was in vogue, there

were those who were expressing concern. Writing in the year 1586, Timothy Bright described the melancholy person as

> cold and dry; of colour black and swart; of substance inclining to hardness; lean and sparse of flesh . . . of memory reasonably good if fancies deface it not; firm in opinion, and hardly removed where it is resolved; doubtful before, and long in deliberation; suspicious, painful in studies, and circumspect; given to fearful and terrible dreams; in affection sad and full of fear, hardly moved to anger but keeping it long, and not easy to be reconciled; envious and jealous, apt to take occasions in the worst part, and out of measure passionate. From these two dispositions of brain and heart arise solitariness, mourning, weeping . . . sighing, sobbing, lamentation, countenance demisse and hanging down, blushing and bashful; of pace slow, silent, negligent, refusing the light and frequency of men, delighted more in solitariness and obscurity.[39]

Not a very flattering picture, is it? Even today there's a certain stigma attached to the melancholy temperament. Whenever I read about the temperaments, the melancholy temperament is always approached with a great deal of ambivalence. The other three temperaments come off smelling like a rose while the dreaded melancholy temperament sounds awful. We're often seen as analytical to a fault, moody, unsociable, and overly sensitive. What bothers me most is that if you get labeled a melancholic, it is automatically assumed that you are some maladjusted emotional misfit.

RECLAIMING THE ARTISTIC TEMPERAMENT FOR CHRIST

I believe that God has redeemed the artistic temperament. If you're in Christ, you are a new creature. "The old has gone, the new has come!" (2 Cor. 5:17). In Christ there is such a thing as a transformed, well-adjusted, Spirit-filled artist. Imagine what God could do with an artistic temperament that's completely yielded to him. He doesn't look at us as "those strange artsy types." After all, he made us. He loves us and he understands us.

I'll admit we are a little different, but it's a good kind of different. Artists look at things differently than nonartists do. We notice detail; we appreciate nuance and beauty. Some people might look at the evening sky and all they see is a bunch of stars. But an artist looks at it and sees beauty and meaning. Artists want to sit under the stars and soak it all in. They want to gaze at the moon and

be dazzled. They want to paint a picture of it or write a song or a poem. Debussy was so moved by the evening sky that he wrote "Clair de Lune." Van Gogh was inspired and painted *Starry Night*. King David was an artist who looked at the evening sky and wrote this: "When I consider your heavens, the work of your fingers, the moon and the stars, which you have set in place, what is man that you are mindful of him, the son of man that you care for him?" (Ps. 8:3–4).

Artists respond differently to things than nonartists do. For one thing, we tend to be more sensitive. And that's okay. That's how God made us. In Ephesians Paul talks about us having the eyes of our hearts enlightened (1:18). Sensitive people have a lot of heart. We might see things differently because we feel deeply. In *Windows of the Soul*, Ken Gire writes, "We learn from the artists, from those who work in paint or words, or musical notes, from those who have eyes that see and ears that hear and hearts that feel deeply and passionately about all that is sacred and dear to God."[40]

For this reason artists very often speak out against injustice, inequality, and hypocrisy. They take up the cause of those who are suffering. They make us more sensitive to the lost and lonely and to the plight of the downtrodden. Everyone with an artistic temperament has been told at some point in his or her life to develop a thicker skin. That's nonsense! The world doesn't need more thick-skinned people. It needs more people who are sensitive and tender. Have you ever been moved to tears by a powerful piece of music or held spellbound by a beautiful work of art? Have you ever been moved by a scene from a film? It's because an artist felt deeply about something and communicated in such a powerful way that your heart and soul were touched.

THE ARTS IN THE BIBLE

Let's examine briefly what the Bible has to say about the arts and artists. Along with being the infallible Word of God and an agent of life change, the Bible itself is a work of art. People throughout history have studied it as an example of exquisite literature. One such scholar was Frank E. Gaebelein, who wrote, "It is a fact that over and above any other piece of world literature from Homer down through Virgil, Dante, Cervantes, Shakespeare, Milton, and Goethe, no book has been more fully acknowledged as great simply as a book than the Bible."[41]

The Bible is rich in its artistic use of metaphor. My favorite example is the last chapter of Ecclesiastes, in which the aging process is treated metaphorically and likened to a house. "When the keepers of the house tremble, and the strong men stoop, when the grinders cease because they are few, and those looking through the windows grow dim; when the doors to the street are closed and the sound of grinding fades; when men rise up at the sound of birds, but all their songs grow faint" (12:3–4).

The trembling "keepers of the house" refers to hands that shake when one grows old. The "grinders" refer to teeth and our propensity to lose them as we get older. Losing our eyesight is described as looking though a window and having the image grow dimmer. Other references to being bent over, a loss of hearing, and having insomnia are all included in this clever analogy. Instead of describing the aging process in clinical terms, the writer appeals to our imagination and in so doing gets us to feel a sadness about growing old.

The Bible also contains poetry that is written with a great deal of skill and sophistication. The Psalms, the book of Job, and Song of Songs are the most prominent examples of biblical poetry.

Drama is first mentioned in the Bible when Ezekiel is instructed to "act out" a drama depicting the siege of Jerusalem. He even drew the city skyline and used it as a familiar backdrop (Ezek. 4). Jesus spoke often in parables and told colorful and intriguing stories that had their fair share of drama to them.

The visual arts played a major role in building the tabernacle (Ex. 31:1–11). Francis Schaeffer points out that the tabernacle involved every form of representational art known to man.[42] The visual arts also played a huge role in the building of the temple. In fact, the temple was decked out with the finest carvings and engravings (1 Kings 6:15–36; 7:23–39; 1 2 Chron. 3:5–7; 4:1–7). First Kings 6:4 (NASB) says that Solomon "made windows with artistic frames." Some of the artwork in the temple, like the freestanding columns, had no utilitarian significance (2 Chron. 3:15–17). It was beauty for the sake of beauty.

Music is also mentioned quite often in the Bible. Singing was a big part of Hebrew culture. The book of Psalms is actually a hymnbook, and it continually exhorts us to sing to the Lord (Ps. 149:1). The nation of Israel not only sang during worship; they sang while they worked (Num. 21:16–18). David sang a song he wrote at the death of Saul and Jonathan (2 Sam. 1:19–27). And

as you leaf through the pages of the book of Revelation, it's obvious that we're going to be doing a lot of singing in heaven (19:1–8).

There is also plenty of instrumental music in the Bible. The word *selah* that occurs throughout the Psalms (seventy-one times, to be exact) is most likely referring to an instrumental interlude between verses or sections of vocal music. Trumpets were used to summon the nation of Israel for meetings, as a signal to break camp, in feasts, in commemorations, during worship, and in conjunction with various military campaigns (Lev. 23:24; Num. 10:1–10; 29:1; Josh. 6:20; Judg. 3:27; 6:34; 7:19–22; 1 Sam. 13:3; 2 Sam. 2:28; 15:10; 18:16; 1 Kings 1:34; 2 Kings 9:13; Ps. 150:3). Trumpets will also announce the second coming of Christ and the resurrection of the dead (Matt. 24:31; 1 Cor. 15:52). Other instruments mentioned include the flute, lyre, harp, and various percussion instruments (1 Sam. 10:5; 1 Kings 1:40; 1 Chron. 25:1; Ps. 45:8; 92:1–3; 150:3–5; Matt. 9:23).

Dance is also included in the Bible. Psalm 149:3 says, "Let them praise his name with dancing." Psalm 150:4 also says, "Praise him with tambourine and dancing." Miriam led the women in a praise dance in Exodus 15:20. Dancing was also a part of welcoming soldiers home from battle (Judg. 11:34). There was singing and dancing when David defeated Goliath (1 Sam. 18:6), and David danced before the Lord when they brought the ark of the covenant home (2 Sam. 6:14–15).

ARTISTS IN THE BIBLE

Maybe I'm biased, but I think God has a special place in his heart for artists, because so many are mentioned in the Bible. Being an artist is one of the first occupations listed in the early days of the Old Testament, along with agriculture and industry (Gen. 4:21). There are several references to teams of musicians (Neh. 10:28–29; Ps. 150:3–5) and other artists (Ex. 31:2–6; 35:30–35). The worship team serving in the temple during David's reign was made up of 288 vocalists (1 Chron. 25:7). One of the judgments made against Babylon in the book of Revelation was that life would be void of the richness that artists bring (18:22).

Several artists are mentioned by name throughout Scripture. We can't list all of them, so I'll just touch on a few. David was a skillful musician and song-

writer (1 Sam. 16:18), someone whom God described as a man after God's own heart. Solomon wrote over one thousand songs (1 Kings 4:32). Kenaniah was a great vocalist and a song leader (1 Chron. 15:22). There's a group of musicians in 1 Chronicles whom I call the singing percussionists. Their names were Asaph, Heman, and Ethan (15:16–19), and they were vocalists who kept time for everyone by playing the cymbals. Bezalel was cited as a very gifted visual artist (Ex. 35:30–33).

THE POWER OF THE ARTS

The arts can be extremely powerful. They can awaken us to truth and can change lives. In 1 Samuel 10 Saul was exposed to a group of musicians who had a powerful ministry in prophecy. Their ministry affected Saul so deeply that he was "changed into a different person" (v. 6). That's the power of the arts! When *Messiah* premiered in London, Lord Kinnoul congratulated Handel afterward on the excellent "entertainment." Like many of us, Handel bristled at the thought of his music being mere entertainment. "My Lord, I should be sorry if I only entertain them. I wish to make them better," he said.[43]

The arts can have a powerful impact if they're produced with the anointing power of the Holy Spirit. God used an anointed musician to open Elisha's heart to prophecy in a powerful way (2 Kings 3:15). In the same way, an inspired piece of art in the hands of an anointed artist can be extremely powerful. An anointed song sung by a Spirit-filled vocalist results in a holy moment. We Christian artists can't do what we do apart from the one who gifted us. Let's never forget that our message is not in glitzy demonstrations of our own talent but in "demonstration of the Spirit's power" (1 Cor. 2:4). One theme running throughout the book of Ezra is that God's hand was upon Ezra and all that he did. We need the mighty hand of the Lord to be upon artists today.

THE ARTS IN THE CHURCH

What kind of attitude should we artists have toward the church? We need to love the church, the bride of Christ. In spite of all its shortcomings (especially when it comes to the arts and artists), the church is still God's vehicle to redeem a lost world. Charlie Peacock, a Christian songwriter and producer, says, "True artists purpose to love the church despite indifference or opposition to their

work. Though indifference is their enemy they separate it from the brother or sister who is seduced by it. They are eager to find their place in the Body and do not consider themselves exempt from fellowship and church stewardship responsibilities. They love the church and do all they can to build it up, for how can you love Christ and hate his church?"[44]

We live in a time, however, when many artists don't give the church a second thought. Even Christian artists. When we think of using our art to impact the world, we usually don't think of doing it through the local church. Or if we do, we see the church as a stepping-stone to something with a wider audience.

For example, there is a whole generation of young people growing up right now with the idea that real music ministry is found not in the church but in the Christian music industry. In fact, when they hear the term "Christian artist," most people think it refers to someone "in the industry." Yet the alto in the church choir, the Christian actor involved in community theater, and the born-again art professor are each every bit as much a Christian artist as someone in the industry. This opinion never wins me any friends in the Christian music industry, but have you ever wondered if the Christian music industry was God's first choice to reach a lost world, or did we in the church abdicate that privilege because we had no vision for how powerful music could be *in the church*? I don't mean to say that God's blessing is not on the Christian music industry. It has borne a lot of fruit and is still touching lives today. That impact would not be lost if Christian artists were channeled into the church and/or the marketplace.

Those of you who are musicians, I just have to say that if you're doing church music but would really rather be doing something else (like "making it" in the Christian music industry), don't do church music. Do something else. That goes for all of us artists. Don't look at the church as a stepping-stone to something more important.

I want to be careful that people don't conclude that I think the church is the only acceptable avenue for a Christian to use his or her God-given talents. You need to find the right audience for your work, and it may not always be the local church. Not every work of art fits in appropriately with a church service. We should be using our gifts in the church and in the world. We need more Christian artists in the marketplace. We need more talented musicians, actors, dancers,

writers, poets, painters, performers, and film directors out in the world impacting our culture for Christ. We are the salt of the earth (Matt. 5:13). Our light needs to shine in such a way that people see our good works and are drawn to the Lord (Matt. 5:16). I praise God that some of our Christian musicians are crossing over into the secular market. They're influencing our mainstream culture. My advice to young artists today is to consider the church and/or the world as outlets for your work. Don't settle for the Christian music industry or any other field that confines you and your art to a Christian subculture.

I've been involved in music ministry for over twenty-five years now, and I confess that at some of the most difficult points along the way, I've wanted to quit. But when I entertained the thought of doing something else with my life, nothing else came close to captivating my passion. This is what God has called me to do. Doing church music is what God put me here for! My mission in life is to contribute to the advancement of music in the church. You don't have to work for a church to love the church. God is reconciling a lost world to himself through the church, and he invites you and me to be a part of this "ministry of reconciliation" (2 Cor. 5:18). The church is the hope of the world. Serving God in the local church is a high and noble calling.

We need artists in the church today who have a passion for the power of the arts. My personal ministry verse is 1 Corinthians 14:24–25: "If an unbeliever or someone who does not understand comes in while everybody is prophesying, he will be convinced by all that he is a sinner and will be judged by all, and the secrets of his heart will be laid bare. So he will fall down and worship God, exclaiming, 'God is really among you!'"

I love that passage because it describes a ministry experience that is so powerful, everyone knows it's from God. Listen to how it affects even unbelievers: they are convicted of sin; they become vulnerable and face the truth about themselves; they're drawn to God; and finally they leave shaking their heads in amazement and exclaiming, "There really is a God! He is certainly among you!" When God anoints the arts, there is an awesome power that he unleashes to penetrate hearts, minds, and souls. We of all people must never lose sight of how powerful the arts can be *in church.*

Let's look at how the arts can be utilized in the local church by examining the role of the arts in worship, evangelism, encouragement, and celebration.

Worship

The New Testament puts a great emphasis on corporate worship. In Ephesians 5:19 and Colossians 3:16, the early church is instructed to sing "psalms, hymns and spiritual songs." Leland Ryken points out that "music in the New Testament . . . is no longer priestly and professional. It is solidly social, congregational, and 'amateur.'"[45] The work of ministry is no longer done by a few full-time professionals. It is the responsibility of every Spirit-filled Christian to do the work of ministry (Eph. 4:11–13; 1 Peter 2:5, 9). This is a by-product of the new covenant philosophy of a priesthood of believers.

These days a large number of churches are experiencing Spirit-led worship, and it's added a deep richness to the life of the church. The arts can facilitate worship in a very powerful way. A moving piece of worship music, a stirring drama, a dramatic reading, an expressive dance, or a gripping piece of visual art can create those holy moments when we as the body of Christ experience God's presence in a real way.

The resurgence of worship has unfortunately ignited controversies that each local fellowship needs to work through. For example, the issue of spontaneous versus planned worship seems to cause people to take sides over which is more spiritual. Scripture gives us examples of each. When the nation of Israel crossed the Red Sea, right there on the riverbank they erupted with spontaneous worship that included singing, playing, and dancing (Ex. 15). On the other hand, the worship time that accompanied the dedication of the temple was highly organized and choreographed (2 Chron. 5:11–7:7).

The traditional-versus-contemporary controversy also faces the church that wants to grow in worship. I've seen two extremes: churches that throw out all the old hymns in favor of contemporary worship choruses, and churches that hold on to those old hymns so tightly that they don't consider using the new worship choruses. The New Testament church was a healthy blend of both. First Timothy 3:16 is an example of one of those "new" worship choruses for the early church, but believers were also instructed to sing the "old" psalms (Eph. 5:19; Col. 3:16).

I've also seen churches get somewhat narrow-minded about what worship can be by insisting that all forms of worship be addressed to God. In other words, they only sing songs *to* God and not *about* Him. I understand that this

is an attempt to personalize worship and focus on the Lord, and that's good. We are instructed to sing to the Lord (Ps. 33:3), but I don't believe we should be dogmatic about this, because we would eliminate a lot of good worship choruses that can truly edify the church. Also, what many believe to be fragments of hymns found in Scripture (Eph. 5:14; Phil. 2:6–11; Col. 1:15–20) are about the Lord and are not all sung to him.

Evangelism

The arts can be especially effective in evangelism because they often reflect the seeker's hunger and search for God. John Fischer, in his book *What on Earth Are We Doing?* says that "much of the art of thoughtful non-Christians expresses a longing for God." Fischer goes on to say that when

> artists reach into their colors or to the notes of a musical score, into the developing solution in a darkroom tray or to the flow of words on a page, they are interacting with the eternity God has placed in their hearts. They are trying to be significant in their universe—trying to mean something more than a random collision of molecules. Though modern philosophy tells them they are nothing, their hearts tell them something else. Because their minds cannot fathom what their hearts know, they feel the weight of the God-placed burden. Art often seems irrational, because the heart is reaching beyond the mind. A modern art museum displays the heart reaching beyond what the mind knows, trying to find the meaning of its existence.[46]

Indeed, people are longing for God, and we artists can help point seekers to him. I would not dispute the evangelistic potential of Spirit-led worship. Psalm 40:3 says that when we worship, it causes many others to turn to Christ. However, as one who has spent the majority of my ministry years in a seeker-driven church, I would plead for churches to consider using the arts also for strategic evangelism. The arts can play a major role in reaching the unchurched. I've had countless people tell me that they first started coming to a seeker church service because they liked the music. Having said that, though, I should also say that great care must go into selecting artistic expressions that the unchurched person can relate to. When Paul wanted to relate to non-Christians, he would go out of his way to speak to them where they were at. In Athens he used the writings of the people's own secular poets and

philosophers to present the gospel (Acts 17:28). He used their art, the expression of their popular culture, to reach out to them. Without talking down to our lost friends and neighbors, we must learn how to relate to a postmodern culture and speak meaningfully to them. I would avoid music lyrics that have a lot of Christian jargon that the unchurched person wouldn't understand. I would avoid music or drama that treats serious life issues in a trite manner. If you're targeting the unchurched, make sure you're speaking a language they can understand clearly.

Encouragement

The arts can encourage and edify the church. Music, drama, dance, literature, and the visual arts can encourage someone who's down, someone who's struggling in his or her walk with Christ, someone who's facing trials and temptations. David ministered to Saul by playing the harp, and it encouraged and refreshed him (1 Sam. 16:23). Both Job and David talk about God giving "songs in the night," encouragement for the dark times (Job 35:10; Ps. 42:8; 77:6). We must never lose sight of people and their needs. The church can use us to bring encouragement to those who need a touch from God.

I love it when a hymn or a worship chorus stays with me after I've heard it, and the lyrics are some rich gem from God's Word that ministers to me throughout the day. It reminds me of the psalmist who says, "Your decrees are the theme of my song" (119:54). I had that experience the first time I heard the song "Turn Your Eyes upon Jesus" and with the praise chorus based on Matthew 6:33, "Seek Ye First." I couldn't get them out of my head, and I didn't want to. I'm a different person with a different attitude when God's Word permeates my heart. The arts can make that happen.

The arts excel at identifying with people's pain and ministering the truth of God's Word with sensitivity. There are times when a speaker will say something and it falls on deaf ears. Take the same message and put it to a beautiful melody or any other sensitive art form, and it moves people. It's because the arts speak to the heart. The arts make us more sensitive and tender to the voice of God. If you really want to encourage people in the church, consider allowing the arts to assist you.

Celebration

Just as the arts played a significant role in the nation of Israel celebrating special events such as the crossing of the Red Sea or the dedication of the tabernacle or the temple, the arts can play a significant role in helping the church celebrate. I'm not talking about celebrating just Christmas and Easter. We in the local church could celebrate a lot more than we do. We of all people have so much to celebrate. Baptisms, church anniversaries, God's faithfulness, and answers to prayer are all good reasons to celebrate. Don't wait until Christmas and Easter. The church should throw more parties, and when we do, we should pull out all the stops and really celebrate! What better way to celebrate than to let the arts run free with creativity aimed at honoring God.

On New Year's Eve 1989, Leonard Bernstein conducted Beethoven's Ninth in a concert that celebrated the fall of the Berlin Wall. In his book *Letters to My Son*, Kent Nerburn writes about watching it on television and how moved he was by the piece.

> The instruments sang as if with one voice. The music rose and expanded and became pure emotion.
>
> Tears streamed from my eyes. I wept uncontrollably. It was more than I was, and more than I could ever be. It was a healing and a testament to the best of who we are and the worst of who we are. It was confession, it was celebration. It was us at our most human.
>
> By the time the concert was over, I had been transformed. Into my daily life had come a moment of sheer beauty. Though at an electronic distance, I had been in the presence of one of those moments that only art can provide, when we humans bring forth something from nothing, and invest it with a majesty and beauty that seems to rival the visions of the gods.[47]

This is the power of art, and the person who has not experienced it is only half alive.

EXCITING DAYS FOR THE ARTS

These are exciting days for artists in the church because God seems to be awakening the church to the ministry potential of the arts. A few magazines devoted to the arts from a Christian perspective have emerged recently. When I read them, I sense that the arts are alive and well in our local churches. Many

churches today have an arts department or their own programming department. I see good changes on the horizon. For example, the role of the artist is changing, starting with the role of the church musician. Twenty years ago if you told your friends that you were involved in the music ministry of your church, they would assume that you sang in the choir. Twenty years ago if I told people that I worked as a music director in a church, they would assume I directed the choir. Yet there are many churches these days that don't even have a choir. It used to be that if you wanted to use your musical gifts in church, you were out of luck unless you could sing in the choir or play the organ. But today there are guitarists, drummers, sax players, synth players, string players, and vocalists of every style leading or participating in church music ministry. Seeker ministry and the worship movement have brought new life to music in the church. God is calling studio players and jingle singers out of the professional music business to serve in the church. He's also calling nonprofessionals to serve, people from all walks of life who used to play an instrument or sing but ended up in a nonmusic career. They're discovering the joy and reward that comes from using their talent to serve the Lord.

These are exciting days also for drama in the church. It used to be that churches featured drama only at Christmas and Easter. Not only was it locked into being used just a couple times a year, but it was confined exclusively to retelling biblical stories. People used to think of church drama as actors standing around in bathrobes in front of a manger scene. But praise God, more and more churches are using drama, to the point that it's becoming a regular part of their programming. Drama sketches are being used very effectively in many church services today. As a result, the quality of the writing and the acting keeps improving. People who used to do drama in high school and college are experiencing joy and fulfillment in serving God in their local church. Others are discovering drama gifts they never knew they had before.

In the technical area, churches are waking up to how important good sound and lighting are to a church service. We're seeing churches investing money in this area and in some cases even hiring full-time sound and lighting people.

Dance is experiencing a revival in the church, especially as an expression of worship. I've seen reports of churches sponsoring workshops and conferences devoted entirely to dance in the church.

Some churches are displaying the works of their visual artists for people to view as they come into the sanctuary. Others are sponsoring galleries or art fairs.

I'm excited about the progress we're seeing in these areas, because I long for the church to be "the happenin' place" for the arts, as it was during Bach's lifetime just 250 years ago. It used to be that when you wanted to hear great music or experience great art, you went to church. It used to be that when you wanted to play or sing great music, you went to church. We've come a long way from that, haven't we?

I believe we are on the verge of a golden era for the arts in church. I believe we are entering an era in church history when God is calling thousands of artists to use their gifts for him as he never has before. I believe God is trying to raise up a global community of Christian artists who are fully devoted to the lordship of Jesus Christ in their lives. My friend, if that's a desire of your heart, forsake all else and follow him. He's calling us to play a major role in the church. What an honor. What a privilege. Oh, may we be found trustworthy (1 Cor. 4:2)! It's time we take stock of where we are all at spiritually and make sure that we are honoring God not only with our gifts but with our lives as well. Let us make whatever adjustments we need to make to become all that God wants us to be. I think it's time we got just as serious about godly character as we are about our craft or our art. We can't be concerned about the arts in the church without being concerned about the lives of artists in the church. Our character as church artists, our walk with Christ, our spiritual growth are all a vital part of creating the kind of ministry experience in which God unleashes the power of his Holy Spirit. We need artists in the church who are known not only for their talent but also for their walk with Christ.

About the Author

Rory Noland is a composer, songwriter, author, and speaker. He is a graduate of the Chicago Musical College at Roosevelt University and served as the music director at Willow Creek Community Church in South Barrington, Illinois, for twenty years. Currently, Rory is the director of Heart of the Artist Ministries, which is dedicated to serving artists in the church and to turning teams of church artists into communities of grace.

For information regarding Heart of the Artist retreats, consulting, or Rory's speaking schedule, please visit *www.heartoftheartist.org*.

Notes

1. Steve Turner, *Imagine: A Vision for Christians in the Arts* (Downers Grove, Ill.: InterVarsity, 2001), 122.

2. H. R. Rookmaaker, *Modern Art and the Death of a Culture* (Wheaton, Ill.: Crossway, 1994), 231.

3. David Ewen, *The Complete Book of Classical Music* (Englewood Cliffs, N.J.: Prentice-Hall, 1965), 290.

4. Paul Johnson, *Intellectuals* (New York: Harper & Row, 1988), 31.

5. Elisabeth Elliot, *Shadow of the Almighty* (New York: Harper & Row, 1958), 121.

6. James Joyce, *A Portrait of the Artist as a Young Man* (New York: Penguin, 1993), 220.

7. Mary Soames, *Winston Churchill: His Life as a Painter* (Boston: Houghton Mifflin, 1990), 143.

8. Wassily Kandinsky, *Concerning the Spiritual in Art* (New York: George Wittenborn, Inc., 1947), 75.

9. Kathleen Norris, *The Quotidian Mysteries: Laundry, Liturgy and "Women's Work"* (New Jersey: Paulist Press, 1998), 82.

10. Brennan Manning, *The Ragamuffin Gospel* (Portland, Ore.: Multnomah Press, 1990), 44.

11. Kathleen Norris, *Amazing Grace: A Vocabulary of Faith* (New York: Berkley Publishing Group, 1998), 164.

12. Gerald G. May, *The Awakened Heart: Opening Yourself to the Love You Need* (San Francisco: HarperSanFrancisco, 1991), 104.

13. Jean Benedetti, *Dear Writer, Dear Actress: The Love Letters of Anton Chekhov and Olga Knipper* (New Jersey: Ecco Press, 1996), 26.

14. David Bayles and Ted Orland, *Art and Fear* (Santa Barbara: Capra Press, 1993), 118.

15. O. G. Sonneck, *Beethoven: Impressions by His Contemporaries* (New York: Dover Publications, 1967), 229.

16. Anne Lamott, *Bird by Bird: Some Instructions on Writing and Life* (New York: Anchor Books, 1994), 202–3.

17. Madeleine L'Engle, *Walking on Water: Reflections on Faith and Art* (Wheaton, Ill.: Harold Shaw Publishers, 1980), 23.

18. Kathleen Norris, *The Cloister Walk* (New York: Riverhead Books, 1996), 76–77.

19. Henri Nouwen, *The Road to Daybreak* (New York: Doubleday, 1988), 3.

20. Bill Hybels, *Courageous Leadership* (Grand Rapids, Mich.: Zondervan, 2002), 234.

21. Gordon T. Smith, *Courage and Calling: Embracing Your God-Given Potential* (Downers Grove, Ill.: InterVarsity Press, 1999), 151.

22. Matthew Henry, *Commentary on the Whole Bible* (Grand Rapids, Mich.: Zondervan, 1961), 74.

23. Gustave Flaubert, "Selected Letters," in Richard Ellman and Charles Feidelson Jr., *The Modern Tradition, Backgrounds of Modern Literature* (New York: Oxford University Press, 1965), 171.

24. Quoted by Bob Doerschuk in "Super Chops!" *Keyboard Magazine,* November 2003, 27.

25. Michael Card, *Scribbling in the Sand: Christ and Creativity* (Downers Grove, Ill.: InterVarsity Press, 2002), 78.

26. From "A Prologue Spoken by Mr. Garrick at the Opening of the Theatre Royal, at Drury Lane, 1947," by Samuel Johnson.

27. Jeanne Guyon, *Experiencing the Depths of Jesus Christ* (Sargent, Ga.: Seed-Sowers, 1975), 77.

28. Kathleen Norris, *Amazing Grace: A Vocabulary of Faith* (New York: Riverhead Books, 1998), 32.

29. *Selected Essays of T. S. Eliot* (New York: Harcourt, Brace & World, 1960), 346.

30. Francis Schaeffer, *Art and the Bible* (Downers Grove, Ill.: InterVarsity Press, 1973), 59.

31. Donald Davie and Robert Stevenson, *English Hymnology in the Eighteenth Century* (Los Angeles: William Andrews Clark Memorial Library, 1980), 10.

32. "Eve of Destruction," written by P. F. Sloan, recorded by Barry McGuire. ©1965 MCA Records.

33. Bill Hybels, *Courageous Leadership* (Grand Rapids, Mich.: Zondervan, 2002), 23.

34. Pope John Paul II, *Letter to Artists* (Chicago: Liturgy Training Publications, 1999), 15.

35. Quoted in Rudolf and Margot Wittkower, *Born under Saturn* (New York, London: W. W. Norton, 1963), 102.

36. Ibid.

37. Ibid.

38. Ibid.

39. Ibid.

40. Ken Gire, *Windows of the Soul* (Grand Rapids, Mich.: Zondervan, 1996), 20.

41. Frank E. Gaebelein, *The Christian, the Arts, and Truth* (Portland, Ore.: Multnomah, 1985), 124.

42. Francis A. Schaeffer, *Art and the Bible* (Downers Grove, Ill.: InterVarsity, 1973), 12.

43. Patrick Kavanaugh, *The Spiritual Lives of Great Composers* (Nashville: Sparrow, 1992), 6.

44. Charlie Peacock, "The Nine Pursuits of the True Artist," excerpted from the Arthouse website at *www.arthouse.org*.

45. Leland Ryken, *The Liberated Imagination* (Wheaton, Ill.: Harold Shaw, 1989), 51.

46. John Fischer, *What on Earth Are We Doing?* (Ann Arbor, Mich.: Servant, 1996), 122.

47. Kent Nerburn, *Letters to My Son* (San Rafael, Calif.: New World Library, 1994), 139.

Willow Creek Association
Vision, Training, Resources for Prevailing Churches

This resource was created to serve you and to help you build a local church that prevails. It is just one of many ministry tools that are part of the Willow Creek Resources® line, published by the Willow Creek Association together with Zondervan.

The Willow Creek Association (WCA) was created in 1992 to serve a rapidly growing number of churches from across the denominational spectrum that are committed to helping unchurched people become fully devoted followers of Christ. Membership in the WCA now numbers over 10,000 Member Churches worldwide from more than ninety denominations.

The Willow Creek Association links like-minded Christian leaders with each other and with strategic vision, training, and resources in order to help them build prevailing churches designed to reach their redemptive potential. Here are some of the ways the WCA does that.

- **Prevailing Church Conference**—an annual two and-a-half day event, held at Willow Creek Community Church in South Barrington, Illinois, to help pioneering church leaders raise up a volunteer core while discovering new and innovative ways to build prevailing churches that reach unchurched people.

- **Leadership Summit**—a once-a-year, two-and-a-half-day conference to envision and equip Christians with leadership gifts and responsibilities. Presented live at Willow Creek as well as via satellite broadcast to over sixty locations across North America, this event is designed to increase the leadership effectiveness of pastors, ministry staff, volunteer church leaders, and Christians in the marketplace.

- **Ministry-Specific Conferences**—throughout each year the WCA hosts a variety of conferences and training events—both at Willow Creek's main campus and off-site, across the U.S. and around the world—targeting church leaders in ministry-specific areas such as: evangelism, the arts, children, students, small groups, preaching and teaching, spiritual formation, spiritual gifts, raising up resources, etc.

- **Willow Creek Resources®**—to provide churches with trusted and field-tested ministry resources in such areas as leadership, evangelism, spiritual formation, spiritual gifts, small groups, stewardship, student ministry, children's ministry, the use of the arts—drama, media, contemporary music—and more. For additional information about Willow Creek Resources® call the Customer Service Center at 800-570-9812. Outside the U.S. call 847-765-0070.

- *WillowNet*—the WCA's Internet resource service, which provides access to hundreds of transcripts of Willow Creek messages, drama scripts, songs, videos, and multimedia tools. The system allows users to sort through these elements and download them for a fee. Visit us online at www.willowcreek.com.

- *WCA News*—a quarterly publication to inform you of the latest trends, resources, and information on WCA events from around the world.

- *Defining Moments*—a monthly audio journal for church leaders featuring Bill Hybels and other Christian leaders discussing probing issues to help you discover biblical principles and transferable strategies to maximize your church's redemptive potential.

- *The Exchange*—our online classified ads service to assist churches in recruiting key staff for ministry positions.

- **Member Benefits**—includes substantial discounts to WCA training events, a 20 percent discount on all Willow Creek Resources®, access to a Members-Only section on WillowNet, monthly communications, and more. Member Churches also receive special discounts and premier services through WCA's growing number of ministry partners—Select Service Providers.

For specific information about WCA membership, upcoming conferences, and other ministry services contact:

Willow Creek Association
P.O. Box 3188, Barrington, IL 60011-3188
Phone: 847-570-9812
Fax: 847-765-5046
www.willowcreek.com